Clothing Culture
Dress in Egypt in the First Millennium AD
Frances Pritchard

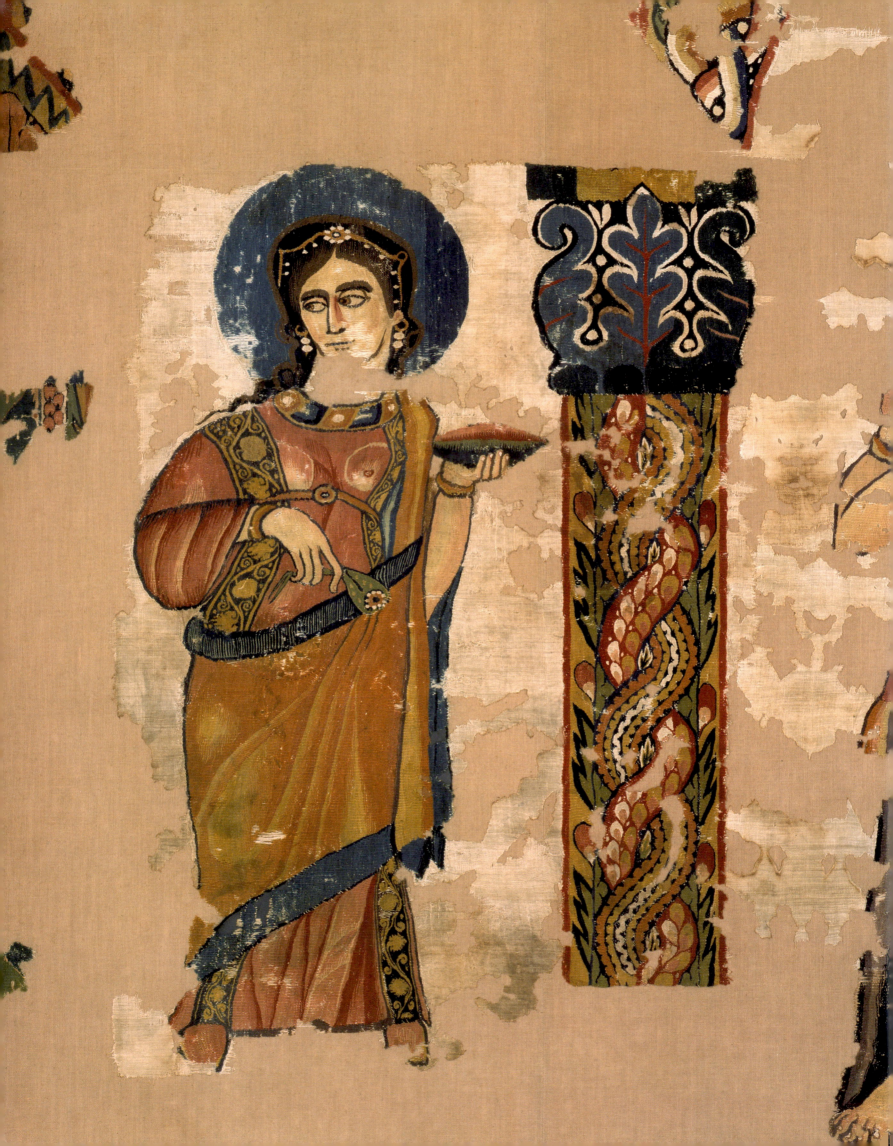

Clothing Culture
Dress in Egypt in the First Millennium AD

Clothing from Egypt in the collection of
The Whitworth Art Gallery, The University of Manchester

Frances Pritchard

TIMELINE Events in Egypt and Britain during the first millennium AD

	EGYPT		BRITAIN

ROMAN PERIOD

			55 & 54 BC	Julius Caesar leads two expeditions to Britain
31 BC	Cleopatra VII and Mark Antony defeated by Octavian at Actium			
30 BC	Egypt becomes a Roman province			
c.AD 40	Evangelisation of Egypt reputedly by St Mark		AD 43	Claudius invades Britain, which becomes a Roman province
AD 130	Hadrian visits Egypt. Foundation of Antinoopolis			
			AD 306	Constantine visits York, where he is proclaimed emperor
AD 313	Edict of Milan; Christianity becomes a permitted religion under Constantine			
AD 380	Christianity proclaimed the state religion by Theodosius I			
AD 392	Theodosius bans pagan religions			
AD 395	Death of Theodosius and partition of the Roman Empire			

BYZANTINE PERIOD / ANGLO-SAXON PERIOD

	EGYPT		BRITAIN
	Egypt is part of the Eastern empire controlled from Byzantium		Britain is part of the Western empire controlled from Rome
		AD 410	Britain, no longer under the political control of Rome, divides into small kingdoms
		AD 597	Æthelbert of Kent converts to Christianity
		AD 601	Augustine is consecrated 1st Archbishop of Canterbury
c.AD 610	Birth of the prophet Muhammad		
AD 622	Muhammad flees to Medina. First year of Islamic calendar		
AD 619–629	Egypt occupied by the Sassanian Persians		
		c.AD 625	Sutton Hoo burial

ARAB PERIOD

	EGYPT		BRITAIN
AD 639–642	Conquest of Egypt by Amr ibn al-'As		
AD 661–749	Umayyad dynasty based in Damascus rules Egypt		
AD 750–868	Abbasid dynasty, based in modern-day Iraq & Iran, rules Egypt	c.AD 800	Viking attacks begin on England
AD 868–905	Tulunid dynasty	AD 871–899	Reign of King Alfred
AD 934–969	Ikhshidid emirs		
AD 969	Conquest of Egypt by Fatimids	AD 959–975	Reign of King Edgar, who is crowned ruler of Britain

Contents

Chapter 1

The collection

THE FOCUS OF THIS STUDY is on clothing from Egypt dating to the first millennium of the Christian era based on material in the collection of The Whitworth Art Gallery, The University of Manchester. The Gallery holds an impressive collection of textiles from Egypt, which it has acquired at various times since its establishment as The Manchester Whitworth Institute in October 1889. Indeed soon after the Gallery first opened its doors to the public, its display of textiles from Egypt was attracting attention and a reviewer, who was probably none other than W. M. Flinders Petrie (1853–1942), commented: 'there is perhaps nothing in this unique gathering more really interesting than the series of Graeco-Roman and Egyptian textiles which have recently been found in Upper Egypt'.[1] This initial collection of seventy textiles had belonged to John Charles Robinson (1824–1913), an eminent connoisseur and collector of textiles who had been the first Superintendent of the South Kensington Museum (now known as the Victoria and Albert Museum) from 1852 to 1869 and was at this time Surveyor of the Queen's Pictures.[2] Most of these textiles reputedly came from Akhmim, a town in Upper Egypt which was situated on the right bank of the river Nile, 140 miles north of Thebes, and known in antiquity as Panopolis. The cemeteries at Akhmim had been identified by Gaston Maspero, a Frenchman who was Director of the Bulaq Museum in Cairo, and excavated by him over many seasons commencing in 1884.[3] Exhumed from these cemeteries *'were hundreds of coffins, still intact in the dry soil, containing mummied corpses; and the extraordinary fact [was] that these mummies had evidently been interred in the dresses they wore in life, literally decked out in their best clothes, and these clothes in many cases were preserved in a most wonderful manner. All at once a vast and varied treasure of antique textile art was revealed in these tattered robes'.*[4]

Museums throughout the world were already collecting Egyptian antiquities and the textiles from Akhmim, many of which were systematically cut up to multiply the quantity available, were quickly dispersed to public and private collections. In England, the South Kensington Museum began acquiring material from this site in 1886 and it was not much later that Manchester followed suit. Unfortunately, it is not possible now to identify many of the textiles that formed part of the Whitworth's initial acquisition, although it ranged from pieces of a patterned silk embroidered with an inscription associating it with Marwan II, the last Umayyad caliph who fled from Syria to Egypt, where he perished

left: Fig 1.2, W. M. Flinders Petrie, *c.*1886.
(© *Petrie Museum of Egyptian Archaeology, University College London*)

1 *The Examiner and Times*, undated, p.10.

2 A. Sumner, 'Sir John Charles Robinson: Victorian collector and connoisseur', *Apollo* 130, No. 332 (1989), p.227.

3 A. F. Kendrick, *Catalogue of Textiles from Burying-Grounds in Egypt, Vol. I* (London, 1920), p.9.

4 Op. cit. in note 1.

Fig 1.1, Piece of the so-called 'Marwan' silk acquired in 1891 from J. Charles Robinson, *T.8496*. It is woven in weft-faced compound twill with a single main warp; repeat: height 132–140mm, width 120–133mm.

in AD 750 (Fig 1.1),[5] to narrow bands used to bind burial garments on to bodies, as well as tunics and tapestry-woven tunic ornaments.

The collection was supplemented in March 1897 by a gift of approximately 260 textiles from W. M. Flinders Petrie himself. Often called the father of English egyptology, Petrie was at this stage in his career Professor of Egyptian Archaeology and Philology at University College London and engaged in regular seasons of excavation in Egypt, where he travelled each year (Fig 1.2). He had already completed an important campaign of excavation at Hawara in the south east Fayum in 1888–9, where he discovered cemeteries that had been used for interments from the Ptolemaic period until at least the sixth century, based on coins placed in jars as funeral offerings.[6] The site is renowned for its gilded cartonnage masks (Fig 1.3) and exceptional series of mummy portraits painted on panels of imported limewood, which range in date from approximately AD 40 to 220 (Figs 1.4 & 4.1).[7] However, the more recent burials yielded examples of

5 A piece of this well-known silk, which is embroidered close to one edge with the inscription (in translation) 'in the tiraz factory of Ifriqiyah', was transferred to the Victoria and Albert Museum in 1958 but a large piece, 485 x 395mm, remains at the Whitworth Art Gallery; see F. E. Day, 'The Tiraz silk of Marwan', in G. C. Miles, *Archaeologica Orientalia in Memoriam Ernst Herzfeld* (New York, 1952), p.40, pl.vi. The silk itself was probably woven in Central Asia.

6 W. M. F. Petrie, *Hawara, Biahmu, and Arsinoe* (London, 1889), p.13.

7 S. Walker and M. Bierbrier, *Ancient Faces. Mummy Portraits from Roman Egypt* (London, 1997), pp.23 and 37.

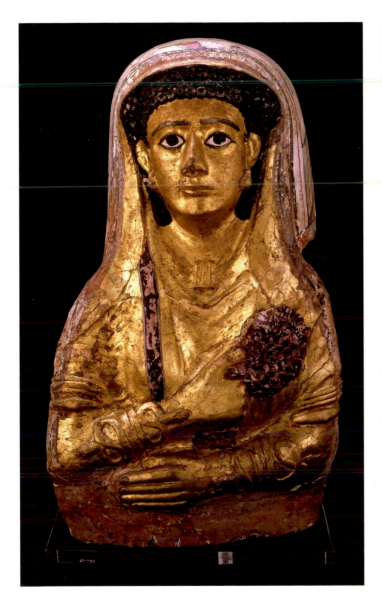

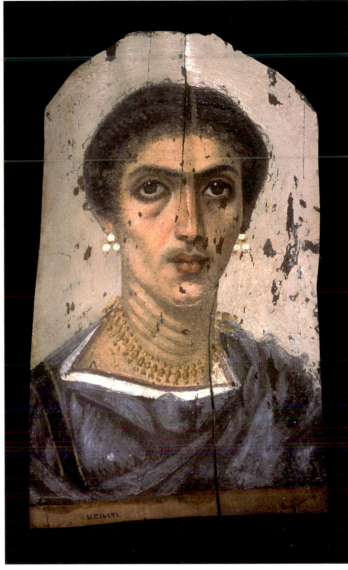

actual clothing, reflecting changes in burial practices that took place in the Roman world particularly with the gradual adoption of Christianity, which a recent estimate suggests was taken up to some degree by between 80% and 90% of the population in Egypt by the late fourth century.[8] To a certain extent, these textiles were recorded by Petrie along with other grave finds, although the amount of information is often very scant. During the 1888–9 season, Petrie also worked on other sites in the Fayum, sometimes walking from one to another the same day. At el-Lahun he uncovered traces of a cemetery dating to 'about the fifth and sixth centuries' in the ruins of the Valley Temple, which was associated with Senwroset II, a pharaoh of the twelfth dynasty. In his notebook for 17 to 23 February 1889 he mentioned recovering 'a good many finely woven pattern stuffs from the burials'. His entry for 9 to 16 March refers to finding 'a prodigious lot of clothing from the bodies buried in the chips of the temple', including a green wool tunic with purple *clavi* and sewn on red and white

Fig 1.3, Painted and gilded cartonnage mask of a woman named Aphrodite aged twenty, AD 50–70. (© *The Trustees of The British Museum*). It was excavated by Petrie at Hawara in 1888 and given by him to his sponsor, H. Martyn Kennard, who immediately donated it to the South Kensington Museum. In 1979 the mask was transferred to the British Museum.

Fig 1.4, Portrait of a woman excavated by Petrie at Hawara in 1888, AD 160–90. (© *Petrie Museum of Egyptian Archaeology, University College London, UC14692*)

8 A. K. Bowman, *Egypt after the Pharaohs* (London, 1986), p.47.

opposite: Fig 1.5(a), Woven-to-shape green wool tunic, *T.8359*. Height of tunic: 1.08m. It has been carbon-14 dated to AD 650–770 (95% probability).

bands at the neck and hem, and the following week Petrie recounts discovering a set of garments in the temple ruins with a coin of Heraclius (610–41). Unfortunately this cemetery was never systematically excavated or recorded as Petrie had very limited time and preferred to concentrate on deposits of the earlier dynastic Middle Kingdom town and, although Petrie did return to el-Lahun in three later seasons (1914, 1920 and 1921), no further work was conducted on the cemetery as it had by then been severely ransacked.

After each season Petrie packed the excavated artefacts and made lists for the authorities to choose which half of the finds they wished to keep in Egypt as required under the terms of his permit. The rest he shipped back to England, where some of the material would be temporarily exhibited in London, for example at the Egyptian Hall, Piccadilly, or a mansion at Oxford Circus.[9] Once he had been appointed to the first Chair of Egyptology at University College London in November 1892, Petrie's annual summer exhibition took place instead on university premises. From 1886 when Petrie began excavating privately, as opposed to working on behalf of the Egypt Exploration Fund, he gave selected items to his financial backers or to museums. Thus the South Kensington Museum received many gifts directly from Petrie as well as material via one of his sponsors, H. Martyn Kennard, who also donated pieces to the Ashmolean Museum, Oxford University. It was not until 1913 that the University of London acquired Petrie's core collection for teaching and study purposes.[10]

In order to supplement his small salary and to help fund the cost of his fieldwork, Petrie frequently undertook lecture tours in Britain. Manchester was a lucrative town for him, with enthusiastic audiences, and it was here that Jesse Haworth (1835–1912), a local textile merchant who was a partner in the firm of James Dilworth and Sons and another of Petrie's chief financial supporters, resided. Haworth was to donate his share of finds from Petrie, which included artefacts and a small number of textiles from Hawara, as well as Middle Kingdom finds from el-Lahun, to Manchester Museum.[11] He also provided much of the money needed to build extensions to the Museum for the display and storage of its collections of egyptology in the early twentieth century.

Petrie appears to have been impressed by the textiles from Akhmim on display at the Whitworth Institute and, wishing to augment the collection, he made a careful selection of textiles to donate to the Gallery. He chose sixteen complete wool tunics, including eleven children's tunics, ten sprang caps, a felt cap and a wool mantle as well as a wide variety of fragments from clothing and furnishings. Many of these textiles appear to have come from the sites he worked on in the Fayum in the late 1880s, principally the cemetery at el-Lahun. The green wool tunic mentioned in his notebook corresponds closely to one given by Petrie to the Whitworth Institute (Fig 1.5) although, as this tunic lacks its neckband, the reference is more likely to relate to a very similar, but slightly smaller, example given by H. Martyn Kennard to the South Kensington Museum in 1890.[12]

9 M. S. Drower, *Flinders Petrie, a Life in Archaeology* (London, 1985), pp.154–5.

10 R. M. Janssen, *The First Hundred Years, Egyptology at University College London 1892–1992* (London, 1992), pp.15–17.

11 Manchester Museum, *Manchester and Egyptology* (Manchester, undated).

12 A. K. Kendrick, *Catalogue of Textiles from Burying-Grounds in Egypt, Vol. II* (London, 1921), p.23, no.337, pl.xvi.

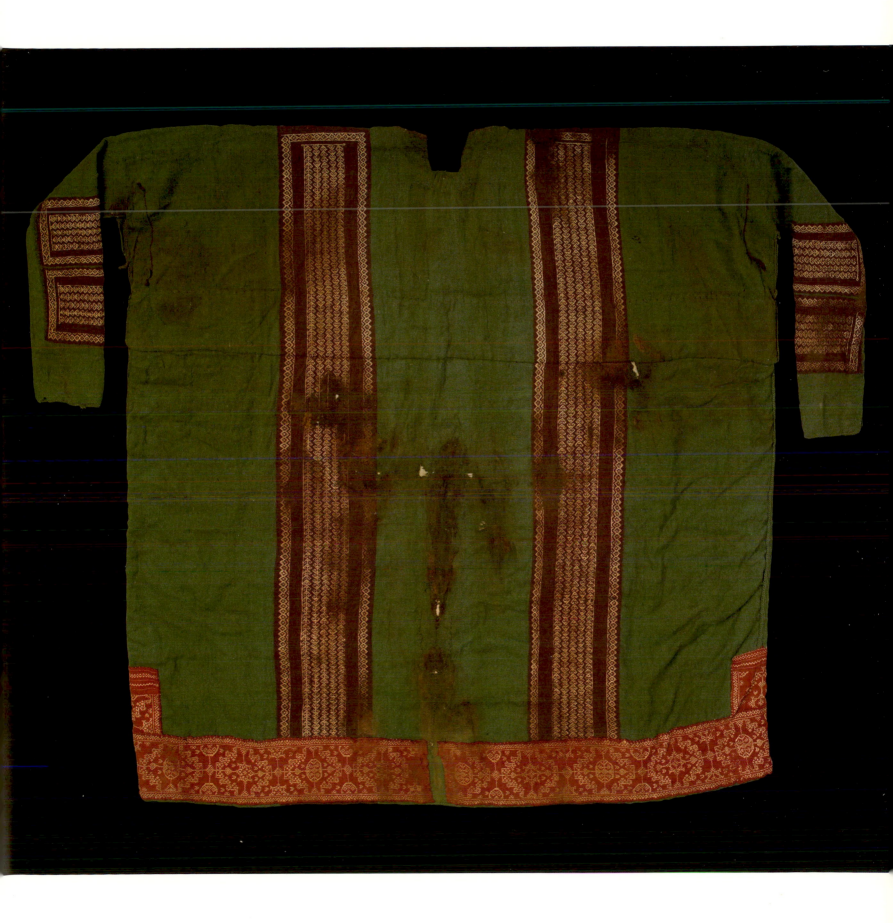

Fig 1.5(b), Diagram of tunic.

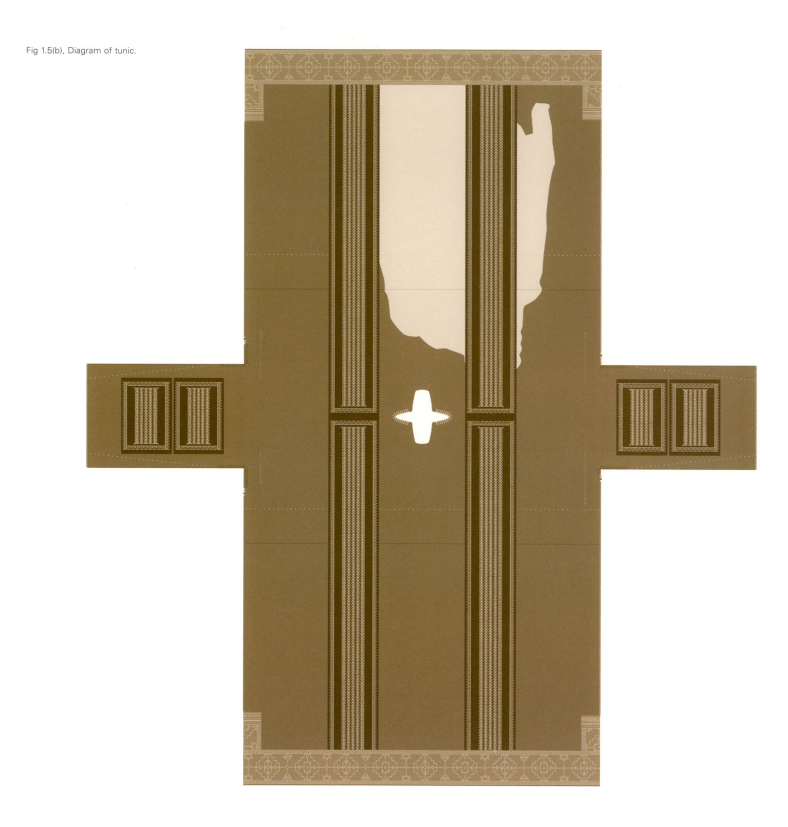

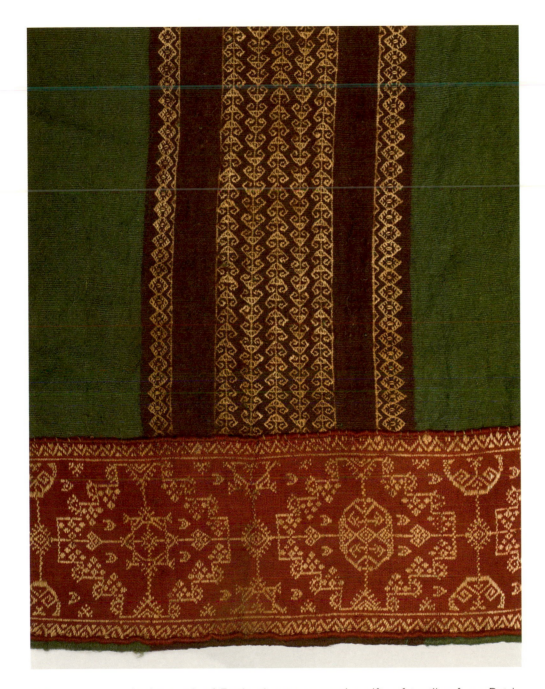

Fig 1.5(c), Detail of *clavus* (width 150mm) and applied hemband (width 105mm).

Other museums in the north of England were to receive gifts of textiles from Petrie as a result of professional connections; they included Bankfield Museum, Halifax, Yorkshire, which acquired pieces from H. Ling Roth, the founder of the museum who had been given the textiles by Petrie in 1901.[13] A few of these textiles match those in the Whitworth, indicating that they have been cut from the same original cloth. Thomas Midgeley, the curator at Bolton Museum who had a special interest in textiles, was also given a group of twenty-seven textiles from el-Lahun by Petrie in August 1911, including ten sprang caps and a felt hat, exactly the same number of items of headwear that he had selected for the Whitworth.[14] Other items of clothing

13 L. E. Start, *Coptic Cloths* (Halifax, 1914), p.1.

14 Angela Thomas, former Keeper of Egyptology and Archaeology, Bolton Museum and Art Gallery, pers. comm.

Fig 1.6, Part of a sleeve from a linen tunic with pile on the inside, *c*.6th century, *T.1968.367*. The Z-spun red wool used for the sleeveband (width 21mm) was dyed with purpurin-rich madder. The textile was excavated by Petrie at Hawara during his 1888–9 season and later donated to Manchester Museum by Jesse Haworth.

from el-Lahun were given by Petrie to supporters of his in America in 1894. They included Mrs John Harrison and Mrs Stevenson, who later donated the textiles, which included fourteen tunics and cloaks, to the University of Pennsylvannia Museum of Archaeology and Anthropology, Philadelphia. It is difficult to reconcile Petrie's practice of presenting textiles to his supporters in different parts of the world with his advocacy of the need for a single national repository for all surplus archaeological material, a suggestion he put forward in his Presidential address to the British Association in Liverpool in 1896,[15] but these gifts did take place before 1913 when his collection was acquired by University College London.

More recently in 1978, a group of 135 textiles collected by Petrie was transferred from the Petrie Museum, University College London, via the Victoria and Albert Museum, to the Whitworth Art Gallery. None of this material is provenanced, and mainly consists of fragments, although it does include a complete wool hood (Fig 6.19).

15 Drower, op. cit. in note 9, pp.336–7.

The Whitworth Art Gallery became part of the University of Manchester in 1958.[16] This resulted in a closer connection with the Manchester Museum and in 1968 the textiles from Hawara housed at Manchester Museum were transferred to the Whitworth Art Gallery. There are thirty pieces that are specifically provenanced as coming from the site, all associated with the 1888–9 season of excavation (Fig 1.6). They include fragments of different styles of wool and linen tunics and part of a linen hairnet but, unfortunately, none can be linked to any of the recorded burials. Among other textiles from Egypt dating to the post-Pharaonic period that were transferred at the same time are two superb late fourth-century embroideries from Akhmim that had at one time belonged to Petrie, who sold them to a discerning collector, Max Robinow (Figs 3.3 & 3.4).[17]

Another collector who donated a small number of textiles from Akhmim to Manchester Museum was the Reverend Greville John Chester (1830–92). He amassed a great many antiquities from Egypt where he often spent the winter and was a noted benefactor to many museums, including the British Museum.[18] In 1888 he gave an album of 55 textile fragments from Akhmim to Wolverhampton Library, and in June 1979 this album was in turn transferred to the Whitworth Art Gallery where, regrettably, it was dismantled soon after acquisition without any photographic record (Fig 1.7). Further material from Akhmim, including a complete wool tunic, was acquired by Manchester Museum from Major Robert G. Gayer Anderson (1881–1945), who worked in the Colonial Service in Egypt in the 1920s.

In addition to material acquired from collectors, a few textiles were also given to Manchester Museum as part of the distribution of finds from excavations sponsored by the Egypt Exploration Fund. Consequently, a few textiles found at Antinoë during the 1913–14 season directed by John de Monins Johnson, including pieces of four sprang hairnets, are now at the Whitworth Art Gallery (Figs 6.6, 6.17 & 6.18). Excavations in 1923 of a cemetery at Qau el-Kebir (Antaeopolis) on the east bank of the Nile, north of Akhmim, also resulted in finds of some

Fig 1.7, *Clavus* from a three-piece linen tunic said to come from Akhmim, *T.1979.38*. It was formerly in an album belonging to the Reverend J. Greville Chester. Dimensions: height 356mm, width 47mm.

16 The Whitworth Art Gallery, *The First Hundred Years* (Manchester, 1988), p.10.

17 J. Allgrove-McDowell, 'Romano-Egyptian Embroidery: Autumn & Winter', *Hali* 57 (1991), pp.120–1.

18 W. R. Dawson and E. T. Uphill, *Who Was Who in Egyptology*, 2nd edition (London, 1972), pp.62–3.

Fig 1.8(a), Part of a wool garment, 12/42
threads per cm, with a silk trimming from Qau
el-Kebir, *T.1994.135*.

textiles, although there are very few compared to other sites, suggesting that the conditions of preservation may have been less favourable. The textiles from this site that are now at the Whitworth Art Gallery consist of part of a narrow wool tablet-woven band and a fine wool garment trimmed with an edging of silk (Fig 1.8), which was recognised even at the time of initial publication as showing Persian influence.[19] Other pieces of the same band and silk border are preserved in the Victoria and Albert Museum since the intention behind the distribution by the Egypt Exploration Fund, which received support from many museums, was to enable the finds to be studied in different parts of the country.

The following chapters present some of the more complete garments from the collection in roughly chronological sequence. The selection is representative; it is not intended as a comprehensive study of every piece. Nevertheless, it is hoped it will enable fragments of garments to be more easily identified, as well as providing an overview of the development of clothing in the first millennium AD through an empirical study of surviving dress.

Fig 1.8(b), Fragment of the silk trimming woven in weft-faced compound twill with a single main warp, front and back, *T.1968.397.* Height: 23mm.

19 G. Brunton, *Qau and Bandari, Vol. III* (London, 1930), p. 26. For an analysis of the tablet-woven band see G. M. Crowfoot, 'A tablet-woven band from Qau el-Kebir', *Ancient Egypt*, 4 (1924), pp.98–100.

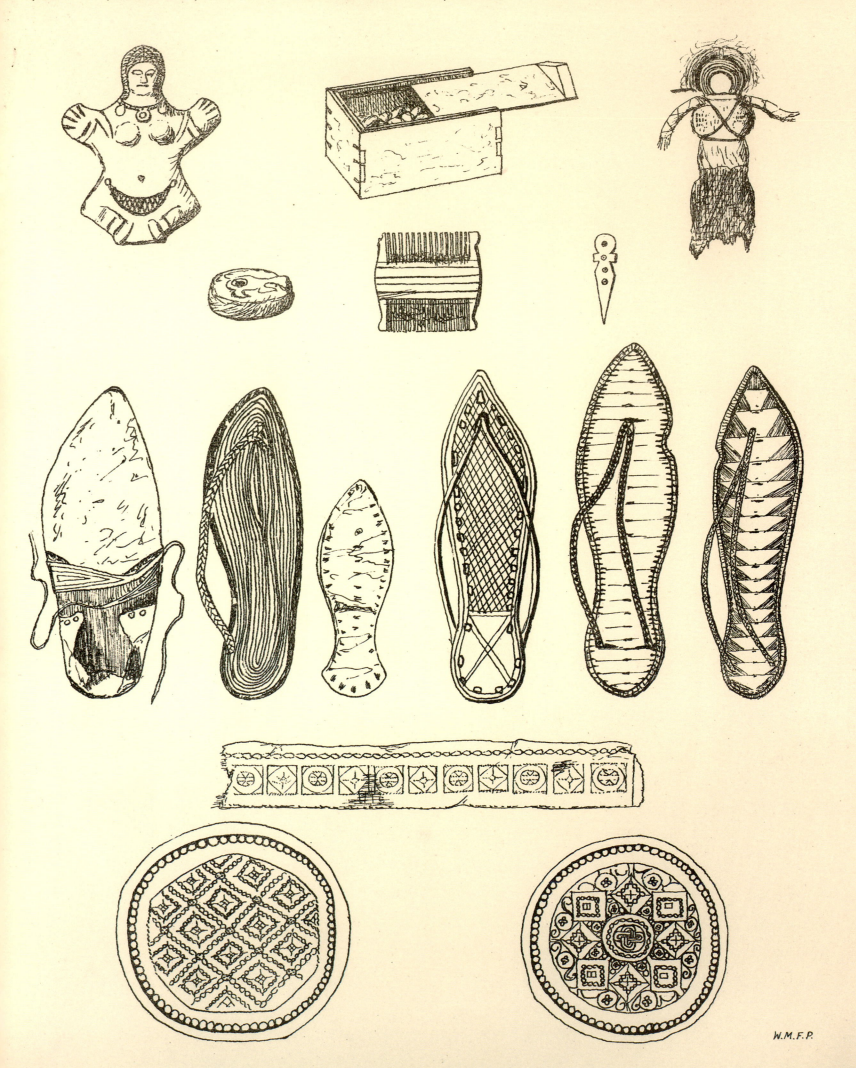

W.M.F.P.

Chapter 2

The dating of the textiles

THE DIFFICULTIES OF DATING the many thousands of textiles from Egypt, that were recovered at the end of the nineteenth and the beginning of the twentieth century, have been the subject of much heated debate.[1] This is because the recording methods used for excavating the burials at sites such as Akhmim and Antinoë were extremely limited and the quantity of the material was exceptional. The cemeteries were in use for centuries and consequently some graves had been disturbed and reused at different periods in the past and grave plots were frequently ill defined. Many graves at Akhmim were very shallow and the bodies were often bound to a plank of sycamore fig (*Ficus sycomorus*) and then laid flat in the sand.[2] Individual site problems were compounded during excavation as graves were opened at a phenomenal speed over a short period of time using locally recruited workmen. Albert Gayet, for example, opened 40,000 graves in the course of his season at Antinoë in 1902.[3] In total Gayet directed seventeen seasons there between 1896 and 1912 and he, thus, amassed a prodigious amount of information about the burials, much of which remains unpublished.[4]

A different problem facing Petrie was that his concession to work on a particular area was restricted by the Egyptian authorities to a single season at a time, which was the normal practice for foreigners other than the French. Thus if a site was unfinished a competitor might be granted the site and its surrounding area the following season. Indeed, Petrie was permitted to work at Hawara for three seasons in 1887–9 and 1910–11 but in the 1890s German teams were granted the concession.[5] Petrie was rigorous in keeping field notebooks, as well as a journal, and when he returned to England he would set to work compiling reports and see them through to publication on a regular basis.[6] His books included specialist reports by experts on papyri, botanical remains and coins while Petrie himself provided information about the site stratigraphy and commented on everyday artefacts ranging from pottery, glassware and basketry to jewellery, shoes and toys. The objects were illustrated with his line drawings and grave groups were kept together. One child's burial at Hawara has become celebrated as a reference point for dating purposes since not only were there remnants of four tunics and an astonishing variety of shoes and sandals in the grave but also, inside a wooden box with a sliding lid containing olives, was a freshly minted coin of one of

opposite: Fig 2.1, Plate xxi from W. M. F. Petrie, *Hawara, Biamhu, and Arsinoe* (London, 1889). It shows some of the finds from a child's grave dated *c.*AD 340.

1 For example J. Trilling, *The Roman Heritage: Textiles from Egypt and the Eastern Mediterranean 300 to 600 AD* (Washington, 1982), p.14; and A. De Moor, 'Dating of coptic textiles', in A. De Moor (ed.), *Coptic Textiles from Flemish Private Collections* (Zottegem, 1993), pp.23–7.

2 A. F. Kendrick, *Catalogue of Textiles from Burying-Grounds in Egypt, Vol. I.* (London, 1920), pp.14–16.

3 M. Erikson, *Textiles in Egypt 200–1500 A.D. in Swedish Museum Collections* (Gothenburg, 1997), p.21.

4 F. Calament, 'Antinoë: Histoire d'une collection dispersée', *Revue du Louvre 5/6* (1989), pp. 336–7.

5 S. Walker and M. Bierbrier, *Ancient Faces. Mummy Portraits from Roman Egypt* (London, 1997), pp.23 and 37.

6 M. S. Drower, *Flinders Petrie. A Life in Archaeology* (London, 1985), p.153.

7 W. M. F. Petrie, *Hawara, Biahmu, and Arsinoe* (London, 1889), pp.12–13 and pl.xxi.

8 M-H. Rutschowscaya, *Coptic Fabrics* (Paris, 1990), pp.149–50.

9 M-H. Rutschowscaya, 'Résurrection des tissues coptes: un choc et une tentation', in Musée Dobrée, *Au Fil du Nil. Couleurs de l'Egypte Chrétienne* (Paris, 2001), pp.177–8.

10 Rutschowscaya, op. cit. in note 9, p.177.

11 F. Calament, 'Une découverte récente: les costumes authentiques de Thaïs, Leukyôné & Cie', *La revue du Louvre et des Musées de France* 2 (1996), p.27.

12 M. Martiniani-Reber, *Musée du Louvre. Textiles et modes sassanides. Les tissues orientaux conservés au département des Antiquités égyptiennes* (Paris, 1997); F. Calament, 'L'apport historique des découvertes d'Antinoé au costume dit de 'cavalier sassanide', in C. Fluck and G. Vogelsang-Eastwood (eds.), *Riding Costume in Egypt: Origin and Appearance* (Leiden, 2004), pp. 37–71; D. Bénazeth, 'Les tissus 'sassanides' d'Antinoé au musée du Louvre', ibid., pp.117–20.

13 C. Fluck, 'Zwei Reitermäntel aus Antinoopolis im Museum für Byzantinische Kunst, Berlin. Fundkontext und Beschreibung', in C. Fluck and G. Vogelsang-Eastwood (eds.), op. cit. in note 12, pp.137–48; A. De Moor, M. Van Strydonck and C. Verhecken-Lammens, 'Radiocarbon dating of two Sasanian coats and three post-Sasanian tapestries', in C. Fluck and G. Vogelsang-Eastwood (eds.), p.184.

the sons of Constantine I giving a date to the burial of around AD 340 (Fig 2.1).[7] The tapestry-woven patterns on the child's linen tunic feature geometric interlace encircled by imitation pearls and, therefore, the associated coin has been used to help date the style. However, only a fraction of the overall quantity of material Petrie excavated at Hawara and other sites could be illustrated or described and consequently much went unpublished and also unrecorded, particularly if it was considered to date after the Arab conquest, which was not a period that Petrie was sponsored or expected to investigate.

It was in the pecuniary interest of some less reticent sponsors and excavators to keep interest alive in the cemeteries through publicising spectacular finds. This was particularly the situation in France where annual displays of the excavated material from Antinoë took place at the Musée Guimet in Paris before the collections were divided between several museums or dispersed more widely through auction sales.[8] Further publicity resulted from the success of the display of *'le Costume en Égypte du III aux XIII siècles d'après fouilles de M. Albert Gayet'* shown in the costume pavilion at the World Fair held in Paris in 1900.[9] Published drawings, as well as reproductions modelled by music hall performers and temporary displays of the excavated clothing, also inspired costume designs for the theatre, thereby increasing popular awareness. A particularly successful vehicle in this respect was a new production of Victorien Sardou's play *Theodora,* performed at the Paris Opera in 1902, starring the celebrated actress Sarah Bernhardt. The play required 300 costumes many of which were based on the recent finds from Egypt by the designer, Théophile Thomas.[10] Another successful publicity trick was to give fictitious names to some of the corpses with characters and storylines being created around them based on their grave clothes and burial goods. Thaïs and Leukyôné were two of the best known from Antinoë and these names have continued to be used to the present day.[11]

Despite their shortcomings, the sketches and notes of burial groups at Antinoë, which were made by Gayet, have informed much recent research on the continent, especially in France where many of the textiles remain, and this has led to a systematic re-examination of some of the clothing, providing a wealth of new information about dress styles. One group of burials from Antinoë that has been particularly thoroughly investigated is that of the Sassanian cavaliers, supposedly members of the elite officer-class who ruled over Egypt in the 620s. The burial clothes of this group of men include distinctive tailored V-necked linen shirts, tight-fitting tapestry-woven leggings or gaiters and sumptuous long-sleeved riding coats made from wool, or wool and cashmere, all of which were trimmed with silk strips or tablet-woven bands.[12] Analytical research into the garments has recently been supplemented by carbon-14 dating to provide a more accurate dating framework. This has included sampling a group of similar garments in Berlin, which were recovered by Carl Schmidt at Antinoë in 1896.[13] As a result comparative material in other collections can now be dated with greater confidence.

The method of carbon-14 dating was developed in the mid-twentieth century as a means of dating prehistoric cultures but its wider application was quickly appreciated. It is based on an understanding of chemistry in the natural world as carbon 14 is a radioactive isotope of carbon formed from nitrogen by cosmic rays in the upper layers of the atmosphere.[14] It subsequently undergoes radioactive decay reverting slowly to nitrogen. As it is present in the atmosphere in the form of carbon dioxide, carbon 14 is absorbed into the tissue of all living things. At the moment an organic material is cut off from the carbon cycle, for example when fleece is sheared from a sheep or flax is harvested, the carbon 14 stops accumulating. It is this moment in time that is fixed and measurable for, as the organism breaks down, the carbon 14 previously absorbed is reduced in quantity, the reduction proceeding at a predictable rate. The age of dead organic material can therefore be calculated from a measurement of its residual carbon 14, which can be plotted against a reference curve that covers thousands of years. The result cannot be calibrated to a single, absolute date but to a range of dates anywhere within which the date of the supply of the raw fibre should lie. The method takes no account of the longevity of use the material (made into a textile) was put to once its carbon intake had ceased.

For many years this method of dating was not widely used for textiles as it was a very expensive, destructive technique that required a large sample and the results often seemed too imprecise. However, with the employment of a less aggressive pre-treatment for removing all possible contaminants together with the improvement of the equipment and especially the development of apparatus called an Accelerator Mass Spectrometer, samples of between 10 and 50 milligrams are now acceptable.[15] Thus textiles have begun to be sampled in greater numbers, and this method is proving to be a significant dating tool for textiles from Egypt that have become separated from their site context, for which no other objective dating method is available.

A further reason for carbon-14 dating groups of textiles of specific types is because similar material has not often been recovered from recent, scientifically conducted excavations. Archaeologists have concentrated on different types of sites rather than re-examining what have now often become highly disturbed cemeteries. Thus other aspects of towns and smaller settlements and their hinterland have been surveyed, in addition to forts, monastic complexes, quarries, road networks and ports. Consequently, the artefacts and other material recovered from the sites differ greatly in character. Textiles are still often found where the conditions are sufficiently favourable for their preservation but it is rare for complete garments to be excavated, and instead recycled rubbish derived from various sources is more typical and plentiful.[16] The rubbish can be important in providing comparative well-dated evidence but frequently there is little similarity, either because the textiles served purposes other than clothing or because they belong to earlier centuries. Further excavations carried out by Italian archaeologists at Antinoë have cast light on some previously recorded burials[17] but in many respects it is too late to remedy the problem of the lost cemetery sequence.

14 S. Bowman, *Radiocarbon Dating* (London, 1990), pp.10–12.

15 M. Van Strydonck, K. van der Borg and A. De Jong, 'The dating of Coptic textiles by radiocarbon analysis', in De Moor (ed,), op. cit. in note 1, pp.65–6.

16 L. Bender Jørgensen, 'A matter of material: changes in textiles from Roman sites in Egypt's Eastern desert', Tissus et Vêtements dans l'Antiquité Tardive, *Antiquité Tardive* 11 (2004), pp.88–97.

17 L. del Francia Barocas, 'Textiles in situ: the evidence of Antinoopolis', in S. Schrenk (ed.), *Textiles in situ. Riggisberg Berichte* 13 (Bern, forthcoming).

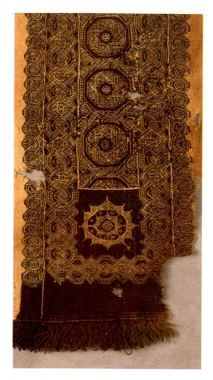

Fig 2.2, Lower section of wool overtunic showing *clavus* (width 150mm) with geometric patterning, *T.1982.177.*

18 Professor Nick Millet pers. comm.

19 K. H. South, M. C. Kuchar and C. W. Briggs, 'Preliminary report of the textile finds, 1998 season, at Fag el-Gamus,' *Archaeological Textiles Newsletter* 27 (1998), pp.9–10.

20 W. Godleweski, 'Les textiles issus des fouilles récentes de Naqlun', in M. Durand and F. Saragoza (eds.), *Égypte, La trame de L'Histoire. Textiles pharaoniques, coptes et islamiques* (Paris, 2002), pp.100–104.

21 R-P. Gayroud, 'La nécropole fatimide du Caire', in Durand and Saragoza (eds.), op. cit. in note 20, pp.171–2.

22 A De Moor, M. Van Strydonck and C. Verhecken-Lammens, 'Radiocarbon dating of a particular type of Coptic woollen tunics', in M. Immerzeel and J. van der Vliet (eds.), 'Coptic Studies on the Threshold of a New Millennium II', *Orientalia Lovaniensia Analecta* 133 (2004), pp.1425–56.

23 S. Schrenk, *Textilien des Mittelmeerraumes aus spätantiker bis frühislammischer Zeit* (Bern, 2004), pp.257–8, no.102, 265–6, no.108 and 477.

Indeed survey work at el-Lahun undertaken in the 1990s by the Royal Ontario Archaeological Mission under the directorship of Nicholas Millet decided against any excavation of the post-Roman cemetery as the stratigraphy had already been destroyed.[18]

Some cemeteries and burials have been excavated in recent years. They include part of a cemetery at Fag el-Gamus on the north-east edge of the Fayum oasis, which was excavated in 1998 by the Brigham Young University, Utah, USA, but only preliminary details are at present available.[19] The burials (111 in total), which date from the first to the fifth century AD, were placed in shafts up to three metres deep in the sand and bodies, wrapped in linen shrouds that were tied with ropes, torn strips of linen or woven bands, were placed one on top of another. The orientation of the burials changed according to their depth in the shaft. However, as preservation was variable, only a few garments were recovered, although they included tunics with hoods attached and sprang headwear. Christian tombs within the perimeter of a monastic complex at Naqlun, which is located in the south of the Fayum, have also been excavated but, although the monastery was established in the second half of the fifth century, the tombs in the ruins of a church date to the late twelfth and early thirteenth centuries and, therefore, lie outside the scope of this book.[20] In addition, some high status Islamic burials discovered in a necropolis on the edge of Cairo in 1985 date to the early Fatimid period at the end of the tenth century and the beginning of the eleventh century.[21]

A great step forward in the carbon-14 dating of textiles from Egypt resulted from a programme of work instigated by Professor Antoine De Moor in Antwerp in conjunction with the laboratory of the Royal Institute for Cultural Heritage, Brussels. Rather than picking random samples in isolation, a group of twelve wool tunics with stylistic and technical features in common that had previously proved difficult to date was selected from the collection of Katoen Natie. Indeed, dates between the sixth and the twelfth centuries had been suggested by different authors for tunics of this type, which are characterised by full-length *clavi* decorated with either intricate geometric patterns or with a multitude of small figures and animals often edged with geometric borders and finished with thick, weft-loop fringes or cords. The results gave a 95% probability date range of AD 350 to 740 with a middle range of between AD 450 and 650.[22] These results, which have been boosted by two further samples from the Abegg-Stiftung, Riggisberg, Switzerland,[23] have been used to date similar wool tunics in Manchester (Figs 2.2, 2.3 & 4.23).

Some different types of wool tunics, which also posed questions concerning their dates of production, were sampled from among the complete tunics donated by Petrie to the Whitworth Art Gallery and the work was undertaken by Mark Van Strydonck in the same laboratory in Brussels that had carried out the carbon-14 dating mentioned above. The garments sampled comprised one adult, woven-to-shape wool tunic (Fig 1.5), three children's tunics made from narrow widths of cloth folded double and seamed at the sides, one of which has short sewn-on sleeves (Figs 2.4, 4.46 & 4.47), and two

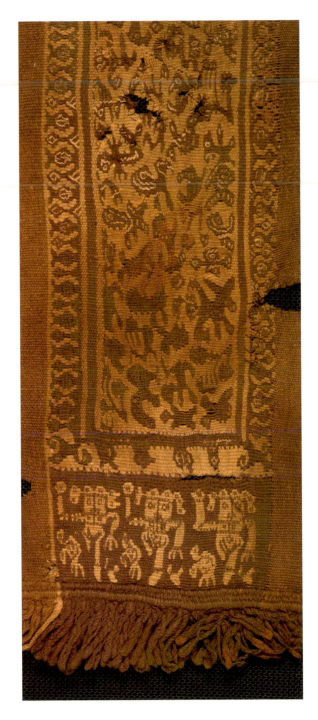

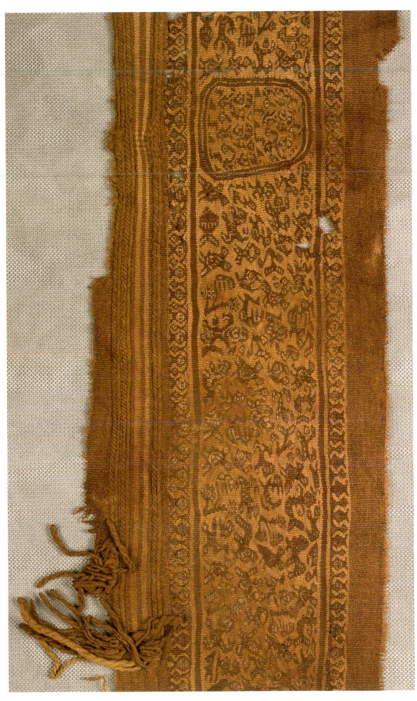

children's tunics that had been shaped by adding triangular gores at the sides, gussets under the arms and an extra flap at the neckline to provide a better fit (Figs 2.5 & 4.51). The calibrated results divided the tunics into two groups with the first four possessing an overall 95% probability date range of AD 650 to 780 (Fig 2.6).[24] The latter two tunics are not quite as old, with the long-sleeved red tunic having a wider 95% probability date range of AD 770 to 970 as it fell on a 'wiggle' in the carbon-14 reference standards. The tunic made from a check-patterned cloth is dated by this

Fig 2.3(a), Lower edge of wool overtunic showing *clavus* (width 110mm), *T.1982.180*.

Fig 2.3(b), Shoulder section of *clavus*.

[24] M.Van Strydonck, Radiocarbon dating report, 9 May 2005.

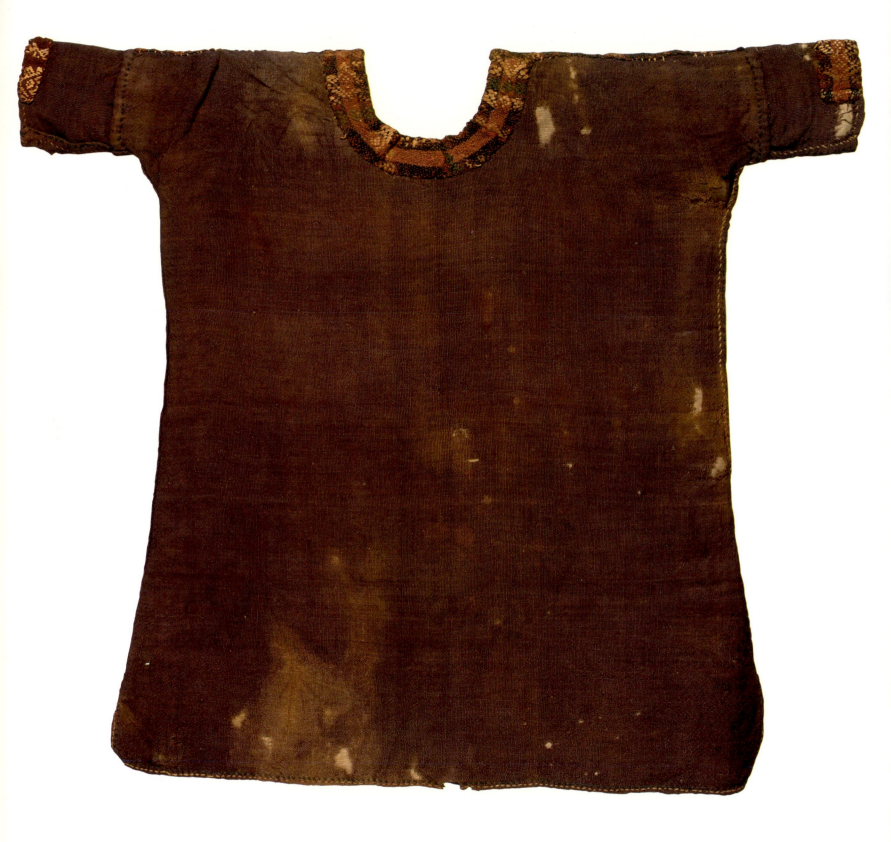

method to AD 880 to 990 and it, therefore, falls at the very end of the period surveyed in this book. The dating provided by these six tunics has consequently been used as a guide for dating other similar tunics in the collection.

Carbon-14 dating has also been carried out on a number of other comparable textiles to those considered here. They include a polychrome tapestry-woven ornament showing scenes from the life of the Joseph, in the collection of the Abegg-Stiftung, Riggisberg, which has a date range of AD 776 to 972.[25] Joseph was a significant Biblical character, who was sold into slavery in Egypt and rose to become an adviser to the pharaoh; consequently he was particularly venerated by Christians in Egypt. The round medallion in Manchester, which is stitched to a tunic of red wool, has a similar series of scenes to the two *orbiculi* in Riggisberg detailing episodes in the life of Joseph when he was in Egypt (Fig. 2.7). They, therefore, form a contrast to the better-known scenes showing Joseph as a youth with his father, Jacob, and his envious older brothers, although they would all have been produced in a few workshops at much the same time.[26]

Dating information from other sources is helpful for some of the decorative textiles especially those woven from silk, or with patterns that copy silk textiles for which good dating exists. The latter include tapestry-woven roundels with plain linen edges similar to the Joseph *orbiculi* mentioned above. Among them is an imperial figure on horseback holding a lance with small erotes hovering in the background surrounded by a border of a heavily stylised scroll of lotus buds, which was applied to a tunic of green wool (Fig 2.8). The colour scheme of white linen on red wool, as well as the design, is copied from a group of silks often referred to as the 'red group'.[27] Originally assigned by Otto von Falke, who was a noted scholar on early silks working at the beginning of the twentieth century, to Alexandria and the sixth century subsequent research has refined the dating of the silks to the ninth century, and indicates that they were produced at more than one centre in the eastern Mediterranean.[28] Tapestry-woven roundels enclosing pairs of birds, such as a pair of pheasants with colourful plumage (Fig 2.9), similarly copied silks of nearly contemporary eighth- and ninth-century date, although these prototypes were mainly Central Asian in origin.[29]

The constraints associated with dating the clothing considered in the following chapters, therefore, must be borne in mind but every effort has been made not to distort the evidence or mislead the reader.

opposite: Fig 2.4(a), Child's mauve wool tunic with sewn-on sleeves and applied trimmings, *T.8508*. It has been carbon-14 dated to AD 650–780 (95% probability). Height of tunic: 530mm.

left: Fig 2.4(b), Diagram of tunic.

25 S. Schrenk, op. cit. in note 20, pp.335–7, no.154.

26 See, for example, De Moor (ed.), op. cit. in note 1, pp.255–6.

27 A similar red and white tapestry-woven ornament is preserved in the Gemeentemuseum, The Hague, A. C. Lopes Cardozo and C. E. Zijdeveld, *Koptische Weefsels* (The Hague, 1982), p.62, no.74.

28 D. King, 'Patterned silks in the Carolingian empire', *Bulletin du liaison CIETA* 23 (1966), p.47.

29 King op. cit. in note 28, pp. 48–9; D. G. Shepherd, 'Zandaniji revisited', in M. Flury-Lemberg and K. Stolleis (eds.), *Documenta Textilia: Festschrift für Sigrid Müller-Christensen* (Munich, 1981), pp. 110–18.

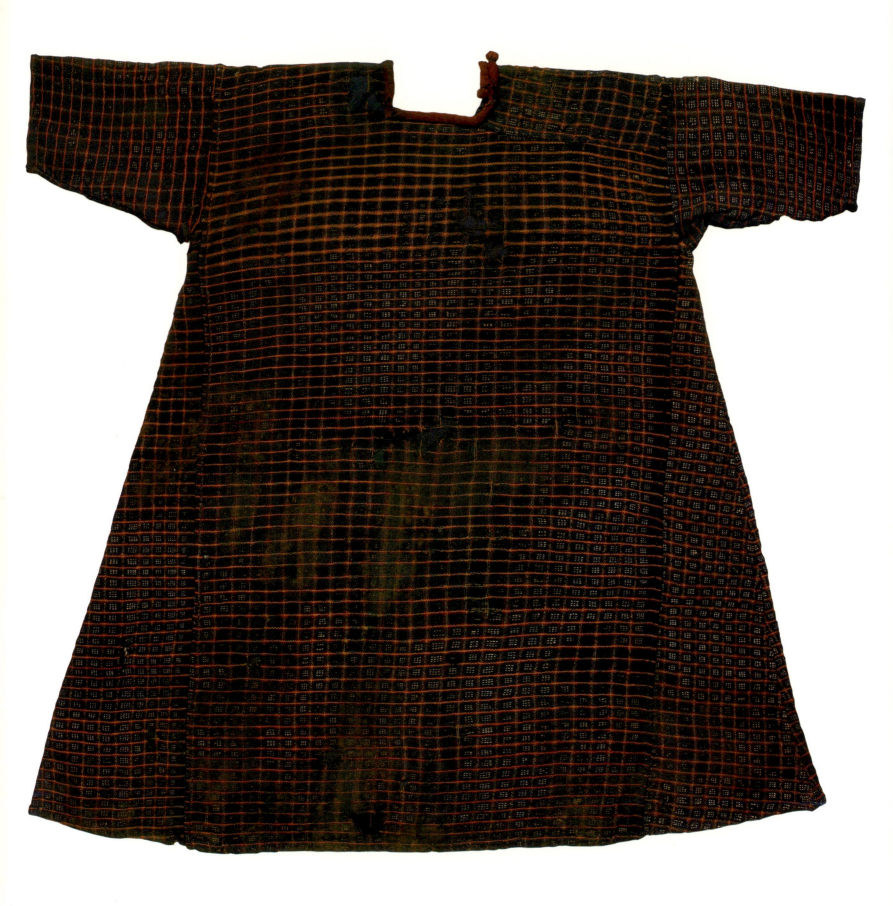

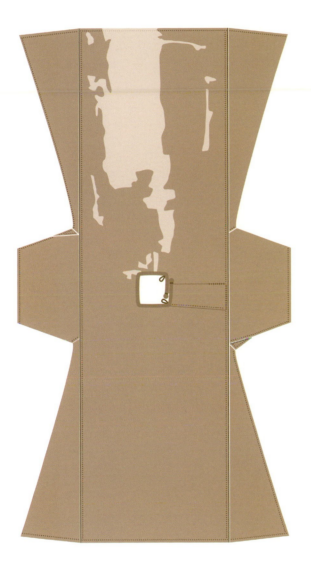

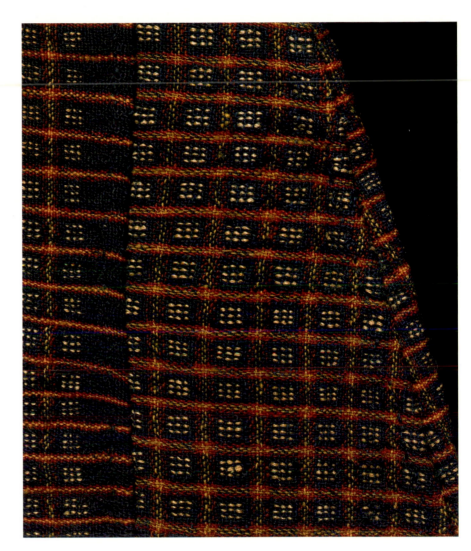

opposite: Fig 2.5(a), Child's check-patterned tailored tunic, *T.9885*. It has been carbon-14 dated to AD 880–990 (95% probability). Height of tunic: 740mm.

Fig 2.5(b), Diagram of tunic.

Fig 2.5(c), Detail of check-patterned cloth, 13/14 threads per cm. The paired white threads in the middle of each square are linen.

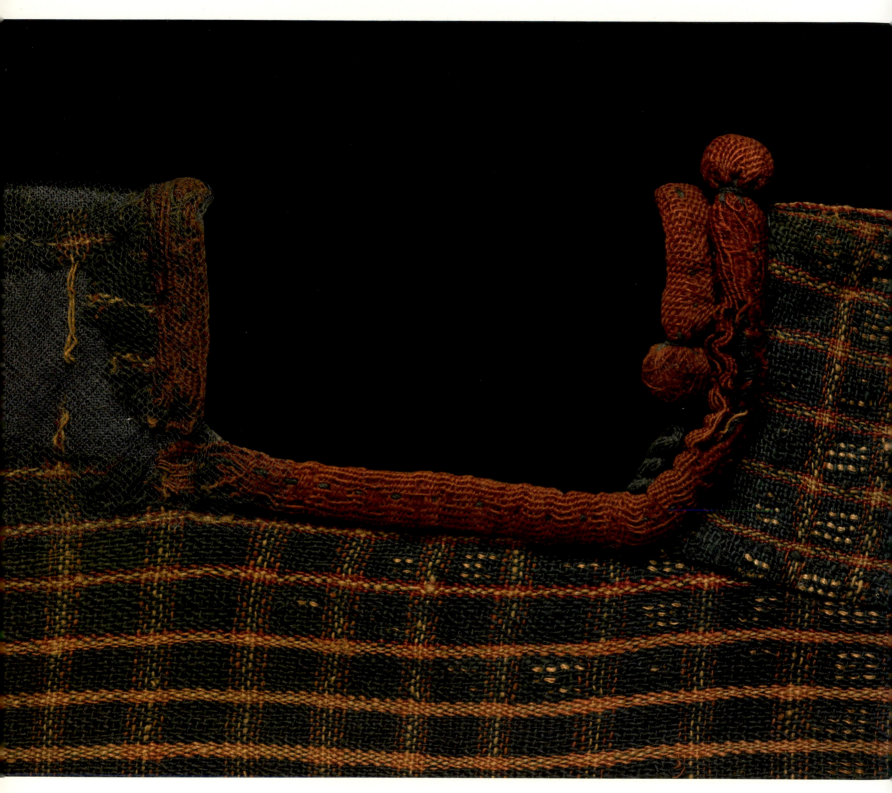

Fig 2.5(d), Detail of neckline.

opposite: Fig 2.6, Table showing carbon-14
dating of six wool tunics given by Petrie to the
Whitworth Art Gallery.

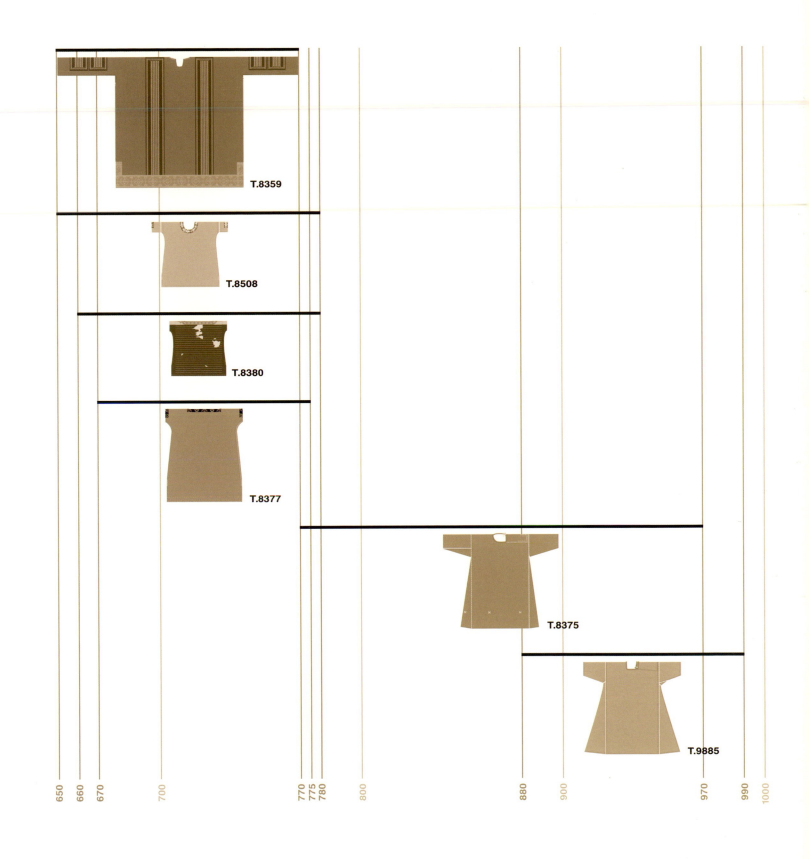

T.8359

T.8508

T.8380

T.8377

T.8375

T.9885

600 650 660 670 700 770 775 780 800 880 900 970 990 1000

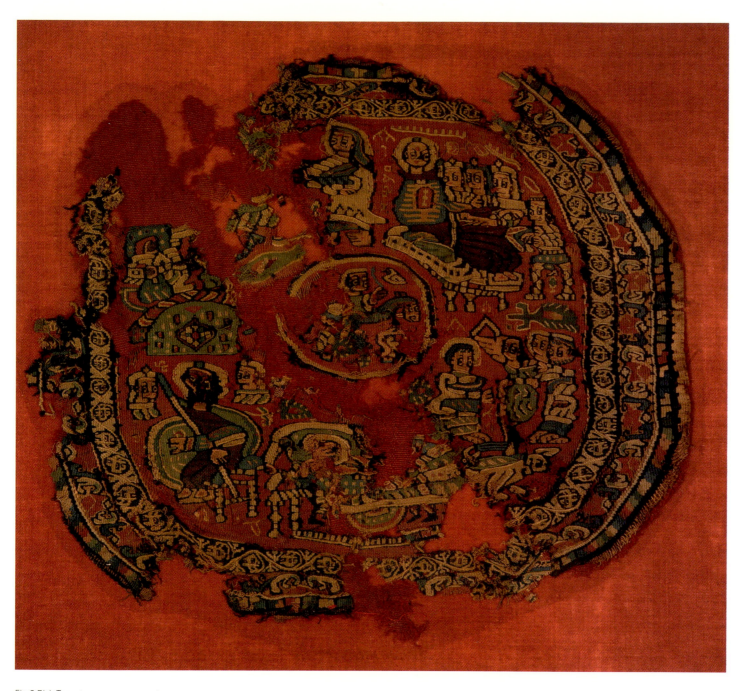

Fig 2.7(a), Tapestry-woven ornament
(maximum diameter 360mm), which was
formerly applied to a red wool tunic, depicting
scenes from the story of Joseph, *T.8441.1.*

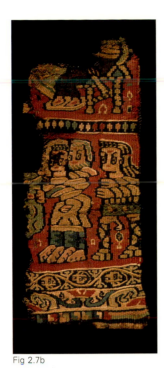

Fig 2.7(b), Fragment of matching sleeveband (height 170mm), *T.8441.2*.

Fig 2.8, Tapestry-woven panel in linen and wool formerly applied to a green wool tunic, *T.8570*. Dimensions, excluding plain edges: height 245mm, width 260mm.

Fig 2.9, Part of a tapestry-woven ornament patterned with pairs of pheasants in roundels, *T.1968.395*.

Fig 2.7b Fig 2.8

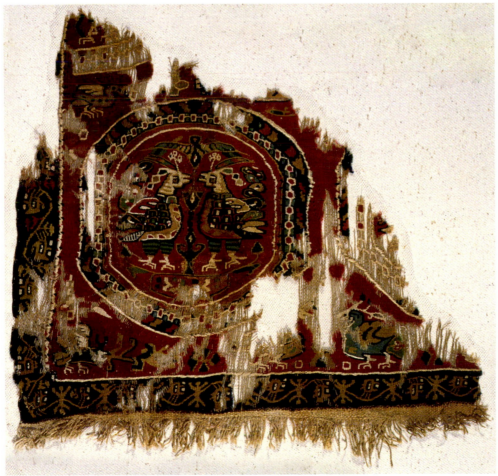

Fig 2.9

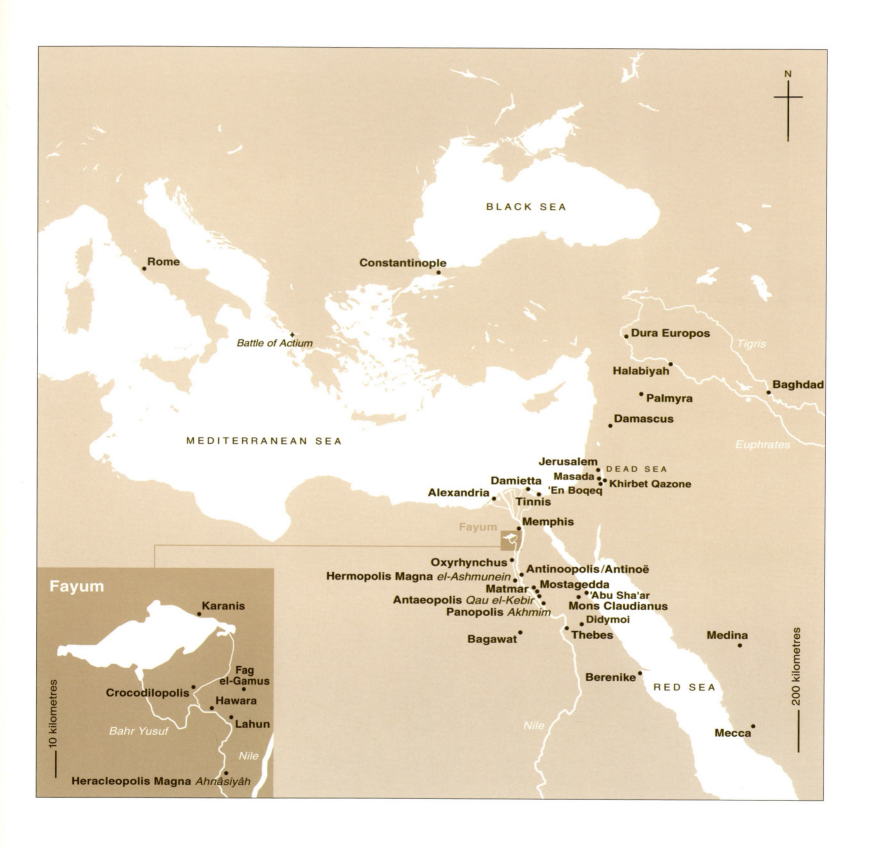

Chapter 3

Historical background

opposite: Fig 3.1, Map of the Mediterranean and Near East showing places mentioned in the text.

EGYPT BECAME A PROVINCE OF THE ROMAN EMPIRE following the defeat of Antony and Cleopatra VII by Octavian (subsequently known as the emperor Augustus) in a naval battle at Actium, off the coast of western Greece in 31 BC. The province was placed under the rule of a prefect, who was the emperor's personal representative, and its administration was organised superficially in much the same way as it had been under the previous Ptolemaic dynasty.[1] The transference of power, therefore, entailed little disruption for the mass of the population. The province's most important city was Alexandria, a cosmopolitan port situated on an isthmus beside the Mediterranean, close to the Nile delta (Fig 3.1). Its location enabled it to control most of Egypt's imports and exports, as well as the trade routes south to Nubia and India. Already by the middle of the first century BC, Alexandria was described as the 'first city of the civilised world, certainly far ahead of all the rest in elegance, extent, riches and luxury'.[2] The city's political and cultural influence extended widely and, in the eastern Mediterranean, it came to be rivalled during the first millennium AD only by Constantinople, which was founded by the emperor Constantine in AD 330. Among its many commercial activities, Alexandria was renowned in the Roman period as a weaving centre specialising in such commodities as linen garments. Pliny, the Elder, also singled out Alexandria as the place where a special patterned textile, *polymita*, was first produced. It has been suggested that these patterned textiles, which were described by the poet Martial as being designed for use in the bedroom (*cubicularia polymita*), were woven in weft-faced compound tabby. This is a complex weave with two warp systems and a weft of at least two contrasting colours, which fits the description *'plurimis liciis texere'* (woven with many heddle rods), and is known to have been made at the time since a few examples dating to the first century have recently been excavated from sites in the Near East, including Masada in Israel.[3] Later, under Arab rule, Alexandria retained its reputation for textiles of good quality, which by then included luxury silks. Indeed, in the *Liber Pontificalis* of Pope Gregory IV (827–44) Alexandrian silks with designs of men and horses are listed among the ecclesiastical furnishings of churches in Rome.[4]

The economy of Egypt was based on agriculture and in particular its grain harvest, most of which was shipped to Rome. The success of the crop depended on the annual

1. A. K. Bowman, *Egypt after the Pharaohs* (London, 1986), p.37.

2. Diodorus of Sicily quoted in Bowman, op. cit. in note 1, p.204.

3. A. Sheffer and H. Granger Taylor, 'Textiles from Masada. A preliminary selection', in *Masada IV. The Yigael Yadin Excavations 1963–1965 Final Reports* (Jerusalem, 1994), pp.213–5.

4. A. Muthesius, *Byzantine Silk Weaving AD 400 to AD 1200* (Vienna, 1997), pp.65–6.

flooding of the river Nile in July and August linked to a well-developed irrigation system, which extended the fertility of the land. One area of Egypt that had been vastly improved for agriculture during the Ptolemaic period was the Fayum, a low-lying semi-oasis some 1,200 km² in Upper Egypt with a shallow lake, which was connected to the Nile by a long canal, the Bahr Yusuf.[5] Through careful cultivation, and particularly its unified network of steep radial irrigation canals, this region became one of the richest agricultural zones in Egypt with many gardens, orchards and vineyards as well as cereal crops and vegetables, especially beans. It was distinctive for its mixed population, many of whom were immigrants from other parts of Egypt, as well as from Greek areas of the empire, resulting in a strong Hellenistic tradition.[6] By the end of the third century some parts of the Fayum appear to have undergone a population decline. Houses were abandoned and became submerged under the encroaching desert sand. However, 'under Roman and Byzantine rule Egypt as a whole attained a level of prosperity and development which was not matched again until the nineteenth century'.[7]

Textile production played a less important role in the Egyptian economy but it was still significant. Information relating to the organisation of the industry and its output can be obtained from a variety of sources. A major written source is the Edict of Diocletian, which is a detailed list of maximum prices permitted for consumer goods produced within the empire, issued in AD 301 in an unsuccessful attempt to combat rising inflation.[8] It includes the prices fixed for raw and processed materials, finished garments, furnishings and napery, as well as the minimum wages for different types of skilled workers – spinners, weavers, fullers and tailors. A very different type of information derives from papyri, fragmentary sheets of reed covered in writing mainly in a form of Greek, and from *ostraca*, broken sherds of pottery also covered in script, which tended to be thrown away in quantity on rubbish heaps once they were no longer required. Although piecemeal in character and often difficult to decipher, the enormous quantity of these documents, including fragments of letters, contracts, accounts and receipts, is providing a wealth of new insights into daily life. Much remains to be read and reassessed and, consequently, the stockpile of information is steadily becoming more substantial.[9] In 1960, Professor A. H. M. Jones relied on information from written sources, especially papyri, for an influential article, 'The cloth industry under the Roman Empire' (1960) and subsequently Ewa Wipszycka used them for her book, *L'Industrie Textile dans l'Égypte romaine* (1965).

It is clear from the Edict of Diocletian that textile production was well organised and highly regulated within the Roman empire, with different regions specialising in the output of particular commodities as the empire was run as a unified economic entity. Commerce flourished and finished wares were traded extensively or travelled as part of the movement of troops and their supply trains. Towns in Egypt singled out in the Edict of Diocletian included Alexandria for its production of linen garments and Antinoopolis for its linen mattresses and pillows. As well as specialised production in large towns, cheaper clothing was also manufactured in smaller regional centres.

5 D. Rathbone, 'Towards a historical topography of the Fayum', in D. Bailey (ed.), *Archaeological Research in Roman Egypt, Journal of Roman Archaeology*, supplementary series 19 (1996), p.51.

6 R. S. Bagnall, 'The Fayum and its people', in Susan Walker and Morris Bierbrier, *Ancient Faces. Mummy Portraits from Roman Egypt* (London, 1997), pp.17–20.

7 Bowman, op. cit. in note 1, p.19.

8 E. R. Graser, 'The Edict of Diocletian on maximum prices', in T. Frank, *An Economic Survey of Ancient Rome, Vol. V* (Baltimore, 1940), pp.307–421.

9 J. P. Wild, 'Textile production and trade in Roman literature and written sources', in D. Cardon and M. Feugère (eds.) *Archéologie des Textiles des origines au Ve siècle de notre ere. Actes du colloque de Lattes, octobre 1999* (Montagnac, 2000), p.211.

Even villages had guilds of wool and linen weavers, which sometimes numbered no more than seven men, but they were composed of the owners of workshops not the workers.[10] Garments could be bought ready made, as well as specially ordered. One letter found among the many hundreds of papyri recovered from Oxyrhynchus, a prosperous provincial town situated on the Bahr Yussuf some 80km south of the Fayum, mentions 'If I can buy a cloak for you privately, I will send it at once, if not I will have it made for you at home'.[11]

Textile manufacture was divided into many different stages, from the production and processing of raw materials to the finished product.[12] The raw materials encompassed more than the fibres, for dyestuffs were required to add colour and cleansing agents were used in fulling, which was a finishing process associated with wool fabrics whereby the cloth was shrunk to give it a firm, felted texture. The vast quantity of spun yarn needed for textiles meant that handspinning was a household chore undertaken by a great many women and young girls (see Fig 6.2.). Tombstones identifying the deceased as a spinner show that some women earned their living by this means, but on large rural estates run almost like factories spinning was carried out by slave labour. Written evidence survives concerning an enterprise producing wool goods in Memphis in the mid third century BC, which included more than 40 female slaves processing fleece in one branch of the business but this was owned by one of the wealthiest officers of state and was probably exceptional in Egypt at the time.[13] Sheep rearing was generally practised on a small scale in Roman Egypt with flocks divided and leased out to various tenant farmers in different villages in order to minimise the risk and perhaps also as a tax avoidance measure. Consequently, a flock often comprised no more than 100 sheep, although a total of 4241 sheep was recorded for one village situated near Oxyrhynchus.[14] Much attention was paid to the quality of the fleece and, in common with animal husbandry practised in other Roman provinces, some sheep wore purpose-made leather jackets to protect their wool.[15]

A significant characteristic of spun yarn is that it may be twisted in one of two directions, either clockwise or anti-clockwise. Yarn spun in a clockwise direction results in a Z-twist, whereas yarn spun anti-clockwise is described as S-spun. Studies have shown that S-spun yarn was typical for Egypt from earliest antiquity and it is linked with the fact that flax naturally rotates in this direction.[16] All the linen featured in this book is woven from S-spun yarn. However, there is more variety among the direction of twist of wool yarn. Most of it is S-spun like the linen, suggesting that the bulk of it was probably spun within Egypt. Wool yarn with a Z-twist is also used for some of the tapestry-woven decoration on linen tunics (Fig 3.2), although it is not used for this purpose on any of the wool tunics. Foreign-born slaves may have been allotted the task of spinning wool in this manner by some specialist producers but most Z-spun yarn was probably imported from other provinces within the empire to be used in better-class workshops. Z-spun wool yarn was typical not only of the western provinces of the Roman empire but also Syria, and the latter province is often claimed to be the

Fig 3.2, Detail of linen tunic, 35/21 threads per cm, with tapestry-woven *clavus* (width 25mm), *T.1968.321*. The linen yarn is S-spun and the purple wool yarn is Z-spun.

10 A. H. M. Jones, 'The cloth industry under the Roman Empire', *The Economic History Review*, second series, 13, 2 (1960), pp.187–8; Bowman, op. cit. in note 1, p.110.

11 Bowman, op. cit. in note 1, p.119.

12 For a more detailed discussion of this topic see J. P. Wild, 'The eastern Mediterranean, 323 BC–AD 350,' in D. Jenkins (ed.), *The Cambridge History of Western Textiles, Vol.I* (Cambridge, 2003), pp.103–16.

13 A. Loftus, 'A textile factory in the third century BC Memphis: Labor, capital and private enterprise in the Zenon archive', in D. Cardon and M. Feugère (eds.), op. cit. in note 9, pp.173–5.

14 Loftus, op. cit. in note 13, pp.183–4.

15 Loftus, op. cit in note 13, p.175; Wild, op. cit. in note 11, p.105.

16 Rosalind Hall, *Egyptian Textiles* (Princes Risborough, 1986), p.12.

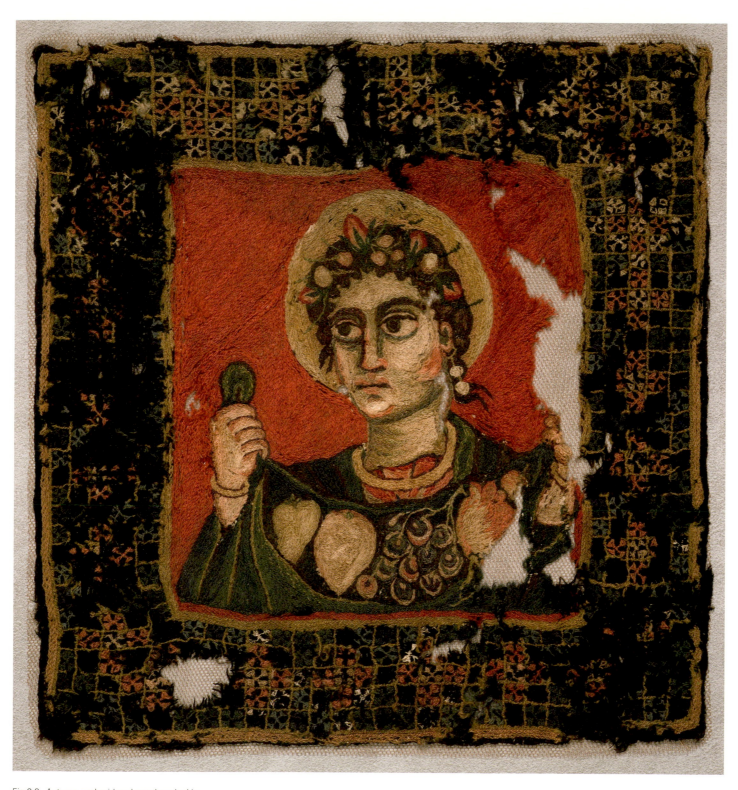

Fig 3.3, *Autumn*, embroidered panel worked in
chain stitch and couching in coloured wools and
linen thread on a linen ground with a border of
wool 2.2 twill, 10/10 threads per cm, *T.1968.252*.
Dimensions: height 275mm, width 265mm.

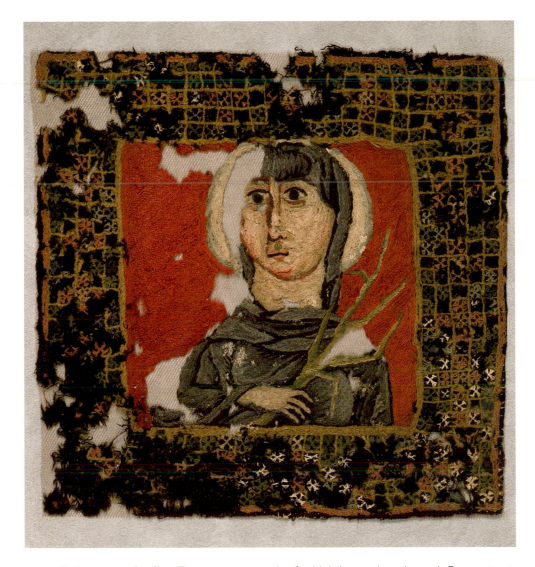

Fig 3.4, *Winter*, embroidered panel, *T.1968.253*. Dimensions: height 280mm, width 280mm.

most likely source for fine Z-spun yarn, much of which is purple-coloured. By contrast, fragments of warm, heavy garments such as wool cloaks woven in 2.2 twill using thicker Z-spun yarn are considered more likely to be the products of north-western provinces such as Gaul.[17] Strips of this distinctive cloth were selected to form the borders of two embroidered panels, which date to the fourth century, but it is otherwise unrepresented amongst the material from burials considered here. The panels, which were found at Akhmim, show personifications of the seasons, Autumn and Winter, with their respective attributes of fruit and a bare branch (Figs 3.3 & 3.4).[18]

Weaving was a complex activity and, in order to meet the exacting standards required, an apprenticeship system was followed. Surviving contracts of apprenticeship indicate that a term of apprenticeship varied from as little as one year to five years depending partly on the specialist skills of the master weaver. It was also fairly common for a child to be apprenticed outside the family unit, even though the craft was sometimes practised within the same family for several generations and census returns for Egypt

17 L. Bender Jørgensen, 'A matter of material: changes in textiles from Roman sites in Egypt's Eastern desert', Tissus et Vêtements dans L'Antiquité Tardive, *Antiquité Tardive* 11 (2004), pp.94–7.

18 J. Allgrove McDowell, 'Romano-Egyptian Embroidery: Autumn & Winter', *Hali* 57 (1991), pp.115 and 121–2; the wool borders are mistakenly described as Z-spun, S-plied.

Fig 3.5, Detail of tapestry woven hemband in dark pink on black, *T.8772.1*. The pink is dyed with lac and the black is a combination of blue (indigotin) and brown (tannin).

indicate that small family-run weaving workshops were not unusual.[19] Finding an apprenticeship was not always easy, a letter states 'if you know that the little girl can be sent to you to weave, send me word, since no one here has taken her'.[20] The size of workshops varied considerably; a lease from Heracleopolis dating to the mid-third century refers to a weaver leasing two thirds of a house where he was permitted to set up three looms and a fourth one, if he was weaving a garment for his own use.[21] A loom took up a lot of space for, as will be shown, clothing, as well as furnishings, was usually made from a single loompiece, which was frequently more than two metres wide. A trained weaver, who was not a slave, could subsequently hire out his labour. Wages fixed by the Edict of Diocletian indicate that weavers in wool *(lanarii)* were paid by the weight of the wool at rates varying according to the quality, with tapestry-weavers being paid per ounce of wool rather than per pound.[22] Linen weavers *(linyphi)* were paid by the day according to the quality of their product with 40 *denarii* per day being paid for 'first-quality work', compared with 25 *denarii* per day that was paid to weavers of plain silks.

Some textiles and textile-related products were imported from outside the Roman empire. Most dyestuffs were sourced locally, especially those obtained from plants, including madder (*Rubia tinctorum* L.), wild madder (*Rubia peregrina* L.), weld (*Reseda luteola* L.) and woad (*Isatis tinctoria* L.). By using different mordants, which are metallic salts such as alum or iron that are usually needed for the chemical process of dyeing to take place, a wide range of different hues could be obtained. These tints were supplemented by overdyeing one colour with another, or blending together dyed wool of two or more different shades especially for imitation purple. Tannin from the bark of certain trees and lichens were also plentiful in the region. However, the very expensive and highly desirable shellfish purples obtained from the ink-glands of three muricid whelks, *murex brandaris, murex trunculus* and *purpura haemostoma*, were gathered in other coastal areas of the Mediterranean and were particularly associated with the ports of Sidon and Tyre.[23] Red dyes extracted from specific species of insects also had to be imported either as a dyestuff or dyed product. A type of lac, probably *Kerria lacca* (L.) Kerr, which is a dyestuff obtained from a scale insect that is native to the Indian sub-continent, has been identified on textiles excavated from Palmyra in Syria dating to no later than AD 273.[24] However, it was not employed commercially, if at all, in Egypt until after the Arab conquest of AD 642, when it became popular for dyeing wool various shades of red and dark pink. This lac-dyed wool was used for separately woven tapestry ornaments, which were then applied to tunics (Fig 3.5), as well as for entire garments where it was used selectively for more conspicuous weft threads (Fig 4.41). Supplies of certain fibres, especially silk, were also acquired from merchants trading with the orient. Silk came overland from China and central Asia, or was shipped via India, as sericulture was not practised in the west until the sixth century. Cotton too was imported from India as well as Nubia, although a different variety, probably tree cotton (*gossypium arboreum* L.), which was suitable for cheap clothing, began to be cultivated in the Nile valley and Kharga Oasis by the second century AD.[25]

19 Bowman, op. cit. in note 1, pp.109–10.

20 J. G. Winter, *Life and Letters in the Papyri* (Ann Arbor, 1933), p.69.

21 Jones, op. cit. in note 10, p.188.

22 Graser, op. cit. in note 8, pp.378–9.

23 Wild, op. cit. in note 11, pp.115–6.

24 A. Stauffer, 'The textiles from Palmyra : technical analyses and their evidence for archaeological research', in D. Cardon and M. Feugère (eds.), op. cit. in note 9, p.251.

25 J. P. Wild, 'Cotton in Roman Egypt: some problems of origin', *Al-Rafidan* 18 (1997), p.289.

The ups and downs of the economy, monetary reforms and the introduction of new methods of assessing taxation in the late third and fourth centuries took place alongside momentous religious upheavals as Egypt underwent far-reaching religious change under the Romans. As with the introduction of so many other religions, the impetus came from further east, and it was partly the presence of a large hellenised Jewish community in Alexandria that provided an initial foothold for Christianity and its subsequent propagation.[26] In AD 202, Christians in Egypt began to be martyred and by the mid-century Christianity had made sufficient converts to be considered a threat to the state and persecution became government policy. Persecution was particularly rampant under Diocletian (284–305), who was the last reigning Roman emperor to visit Egypt, which he did at a time of unrest and rebellion in AD 298 and 302. The situation changed considerably in the second decade of the fourth century. Christianity became tolerated under the Edict of Toleration followed by the Edict of Milan in AD 311 and 313 respectively and in 380 it was proclaimed the state religion. As a consequence the Church was allowed to acquire property, thereby enabling its organisation and administrative structure to develop so that it became a powerful force in the land. Bishoprics were established with the Patriarchy in Alexandria taking the lead and monasteries, some of which consisted of up to 1000 monks, came to dominate much of the landscape.[27] By the time of the Arab conquest of Egypt in AD 641/642, the country was almost entirely Christianised and the term 'copt' was applied to native Egyptian Christians.[28]

Christianity was not suppressed after the Arab conquest and textiles reveal that Christian symbols continued in widespread use (Fig 3.6). Crosses appeared as decoration on tunics from at least the fifth century. Initially tapestry woven, they later also came to be brocaded or stitched into the fabric in a counted thread technique. Some garments

26 Bowman, op. cit. in note 1, p.190.

27 Bowman, op. cit. in note 1, pp.129 and 192–7; A. Cameron, *The Mediterranean World in Late Antiquity* (London, 1993), p.71.

28 M-H. Rutschowscaya, *Coptic Fabrics* (Paris, 1990), p.8.

Fig 3.6, Sleeve from a wool tunic, 11/33 threads per cm, patterned with small tapestry-woven crosses, *T.1968.117.*

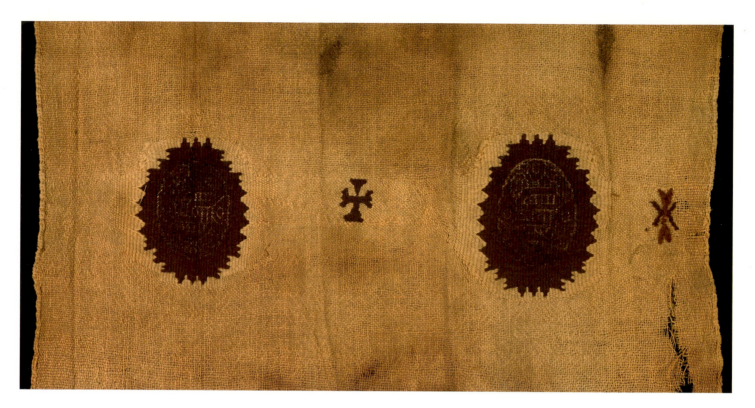

Fig 3.7, Detail of scarf or stole (maximum width 340mm) with cross in the centre, *T.8492*.

29 Cameron, op. cit. in note 27, pp.111 and 164–5.

30 I am grateful to Cäcilia Fluck and Professor Terry G. Wilfong for their comments on the 'inscription'. For patterns on textiles in North Africa used to combat the 'evil eye' see C. Spring and J. Hudson, *North African Textiles* (London, 1995), pp. 44–5.

patterned with small crosses, including a hood and pieces of scarves or stoles, may represent liturgical dress of the period, which is a subject that merits separate investigation (Figs 3.7 & 6.19). Biblical figures and scenes featured on tapestry-woven ornaments applied to tunics in the eighth and ninth centuries so that the Christian identity of the wearer would have been very obvious. Scenes from the life of Joseph have been identified (Figs 2.7 & 3.8) but others, which are less easy to determine, may relate to stories in the Apocrypha or in special versions of the Gospels that circulated in Egypt (Fig 3.9). Intriguingly, often mingling within the designs are conspicuous blue birds that appear to look back to earlier Egyptian cults.

A low life expectancy was typical in antiquity and the high mortality rate among children is reflected by the large quantities of children's clothing recovered from burials. In addition to the wide range of illness and disease that afflicted the population, the mid sixth century was marked by the arrival of the bubonic plague, which had a devastating effect on the people living in the provinces bordering the eastern Mediterranean.[29] As well as religion, popular superstitions, magical spells and amulets offered comfort at this time and it is probably into this category that an inscription on a child's wool overtunic falls. The tunic is distinctive for having a sleeve divided into two halves, each woven in a different colour, and across the width is added an inscription in Greek letters (Fig 3.10). No sense can be made of either of the two similar sequences of letters and, although the lettering may be decorative in part, it is so unusual that it may have possessed a special protective, prophylactic property and magical formula to ward off harm from the child as is customary in some cultures even today.[30]

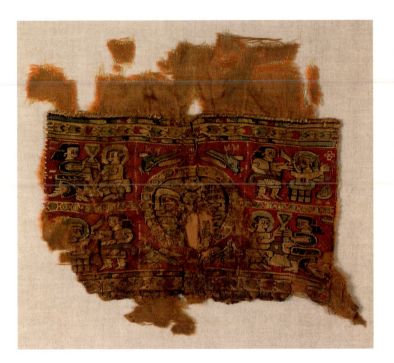

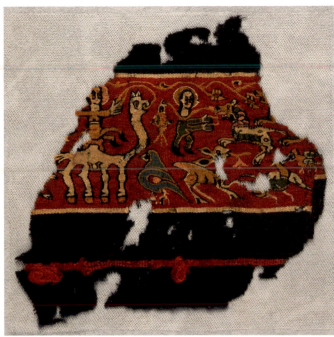

The division of the Roman empire into two parts on the death of Theodosius I in AD 395 led to a shift in focus for the provinces in the east. They increasingly came into conflict with the expansionist aims of the Sassanian empire based in Persia and Syria, in particular, was repeatedly subjected to invasion and siege warfare.[31] In 619 Egypt succumbed to Persian rule for a period of ten years. The Byzantine emperor, Heraclius, then recaptured the province following the assassination of the Persian king, Khusrau II, but the whole region was severely destabilised and in 641 Egypt was overrun by the Arabs, who were a confederation of Bedouin tribes united by their belief in Islam, which was still at a formative stage.[32] As a symbolic gesture, the new caliph Omar had the renowned library at Alexandria burnt to heat the public baths but on the whole the Arab rulers and their officers kept themselves apart from their Egyptian, Christian subjects, who were obliged to pay a heavy poll tax. The Arab court was based outside the country with Damascus becoming the capital under the Umayyads in 661 followed by Baghdad under the Abbassids in 762. The vast size of this Islamic empire meant that it too gradually fragmented and in 969 the Fatimids established a Shi'ite caliphate in Egypt with Cairo as their capital.[33]

Apart from a new system of taxation, everyday life under Arab rule continued much as before in Egypt. Occasionally there were religious crackdowns but on the whole the country flourished as a multi-cultural society, although integration was not encouraged. The Arab empire was an influential force in the transmission of ideas and inventions in the early medieval period. The size of it also encouraged far-reaching trade and it was after the Arab conquest of Egypt that supplies of the dyestuff lac greatly increased. Silk production became more widely established in the eastern Mediterranean with Alexandria gaining a growing reputation for its silk fabrics. Some silks with small repeating

Fig 3.8, Tapestry-woven sleeveband (height 165mm) depicting scenes from the story of Joseph, *T.1994.140*. Note the blue birds round the central medallion.

Fig 3.9, *Clavus* (width 92mm) with a nimbed figure astride a camel, wild animals and a blue bird in the foreground, *T.15521*.

31 Cameron, op. cit. in note 27, pp.109–10.

32 C. Rogers, 'Early Islam – an historical background', in C. Rogers (ed.), *Early Islamic Textiles* (Brighton, 1983), pp.18–20.

33 Rogers, op. cit. in note 32, p.28.

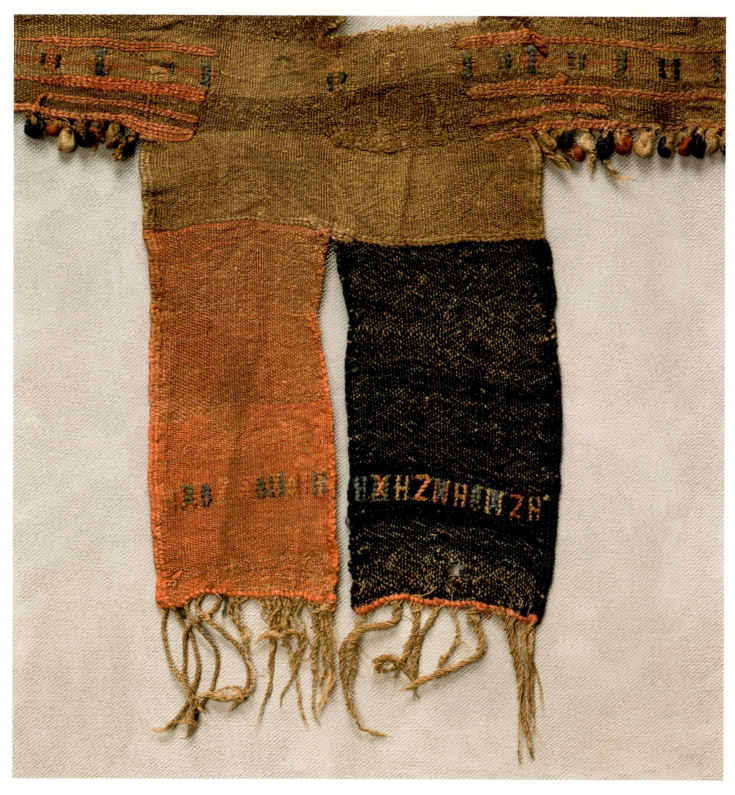

Fig 3.10(a), Two-part sleeve from a child's wool
overtunic with an inscription, or pattern, in
Greek letters, *T.1968.169*. Width of sleeve
panels: red 80–85mm, blue 88–97mm.

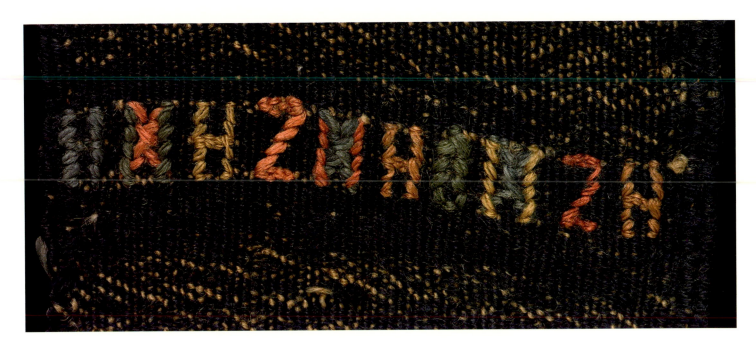

Fig 3.10(b), Detail of 'inscription'.

patterns in only two colours are likely to have been among those produced locally (Fig 3.11).[34] These designs were then sometimes copied in tapestry-weaving workshops, suggesting the existence of flourishing, interactive urban enterprise (Fig 3.12).

Gifts of clothing formed an important ritual at the Arab court and specialist workshops, which produced honorific garments adorned with inscriptions, were patronised for this purpose.[35] Often referred to as *tiraz* textiles from the inscriptions woven or embroidered as a band across the fabric, the vast quantity required for court retainers meant that some were produced in Egypt. A state-run factory was established at Alexandria and workshops based at Tinnis and Damietta in the Delta region included highly refined *tiraz* textiles among their products that were widely acclaimed.[36] Private workshops in the Fayum were also renowned for their fine wool turbans and shawls and a few have been identified by means of their inscriptions.[37] However, although the products were made for muslim rulers, the weavers were predominantly Christians and the working conditions were sometimes harsh.

Most of the population did not aspire to this opulent life style and continued to wear their old clothing for as long as possible. Adults' clothes were cut down and recycled for children (Fig 3.13). An increasing use of needlework resulted in extensively darned clothes (Fig 3.14) and this practical method for extending the life of a garment was then exploited for decorative effect by means of pattern darning, which was used on tunics made from recycled cloth as well as on smart new linen clothes where silk thread of a contrasting colour was employed (Fig 3.15).

Egypt in the first millennium AD was therefore a rich cultural melting pot and the clothing of the people reflected some of this diversity.

34 M. Martiniani-Reber, *Lyon, musée historique des tissus. Soieries sassanides, coptes et Byzantines V^e-XI^e siècles* (Paris, 1986), pp.61 and 80–1; Muthesius, op. cit. in note 4, p.81.

35 R. B. Serjeant. *Islamic Textiles. Material for a History up to the Mongol Conquest* (Beirut, 1972), p.7.

36 Serjeant, op. cit in note 35, pp. 138–48.

37 M. Durand and S. Rettig, 'Un atelier sous contrôle califal identifié dans le Fayoum: le tiraz privé de Tutun', in M. Durand and F. Saragoza (eds.), *Égypte, la trame de l'Histoire. Textiles pharaoniques, coptes et islamiques* (Paris, 2002), pp.167–70.

Fig 3.11, Silk weft-faced compound twill used as a trimming probably from the sleeve of a garment, *T.8498*. Maximum height: 270mm. The warp threads are red and the two weft yarns are white and faded purple.

Fig 3.12, Two tapestry-woven ornaments with similar patterns imitating a silk design, *T.8462* (height 225mm) and *T.11968* (height 240mm).

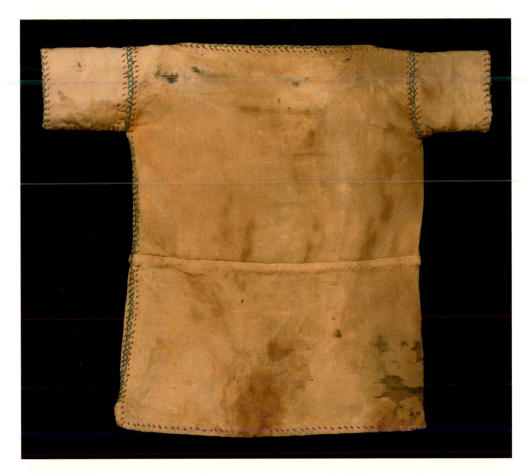

Fig 3.13(a), Child's wool tunic made from recycled cloth, 11/56 threads per cm, *T.8550*. Height of tunic: 430mm.

Fig 3.13(b) Detail of sleeve.

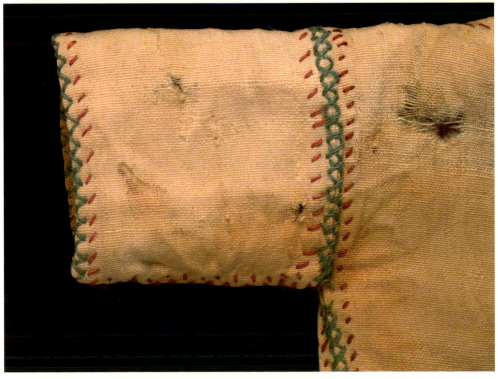

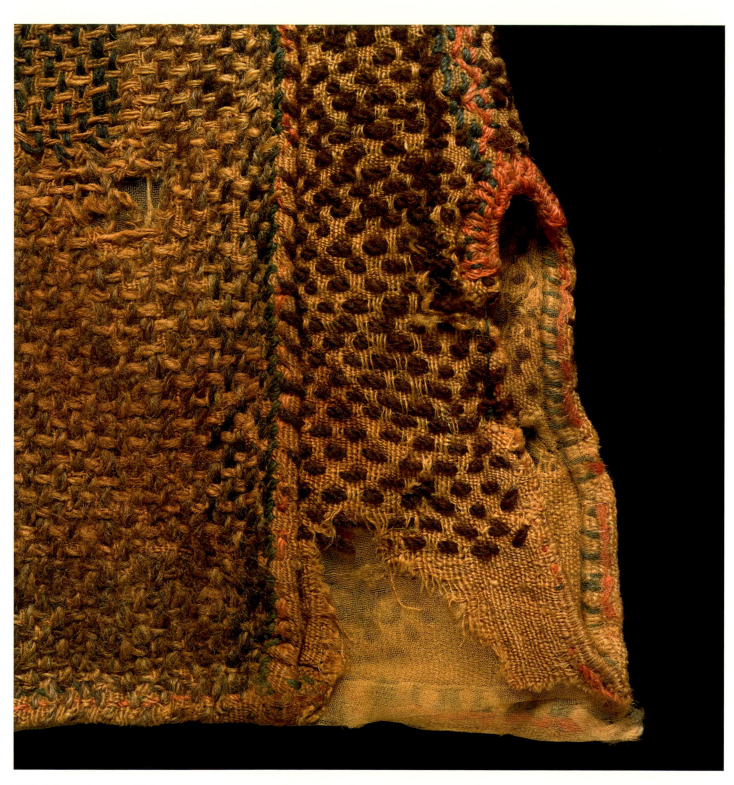

opposite: Fig 3.14(a), Child's wool tunic with
small side gores and applied trimmings darned
in at least ten different sewing threads,
T.8505. Height of tunic: 460mm.

Fig 3.14(b), Detail.

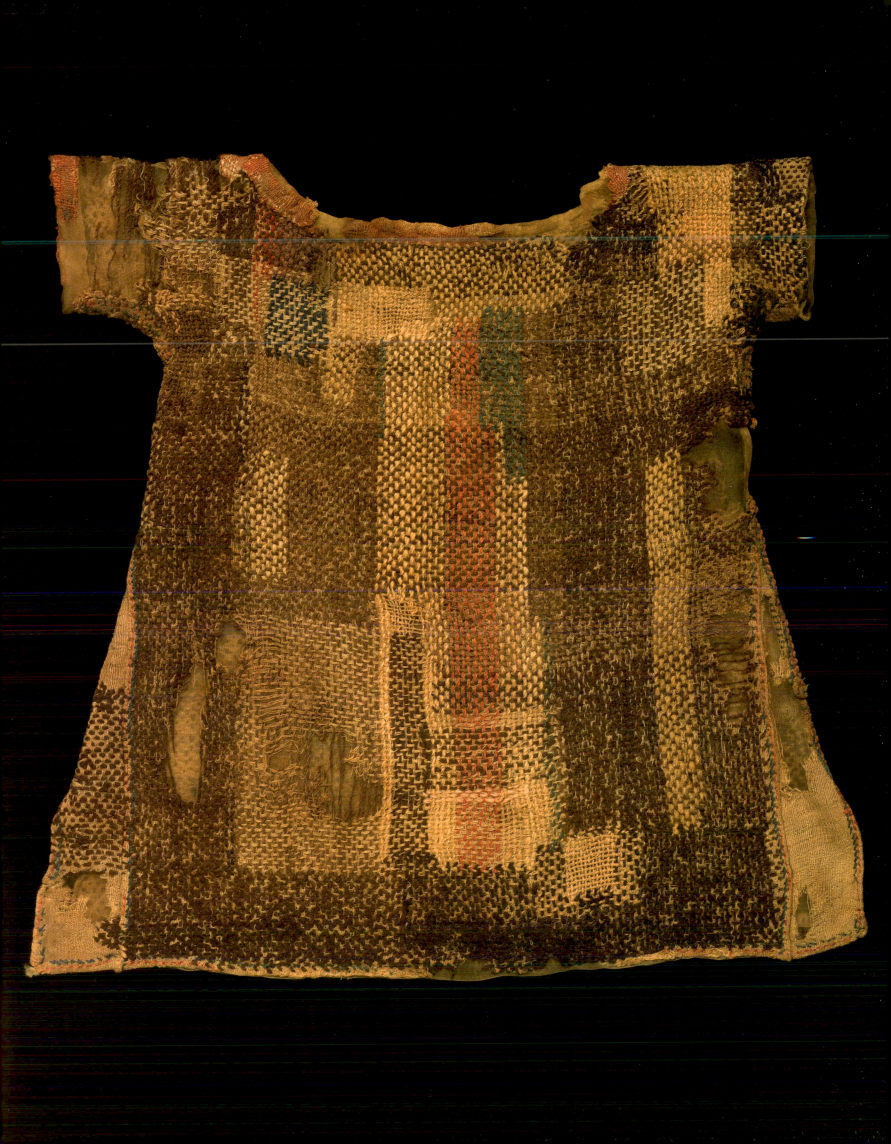

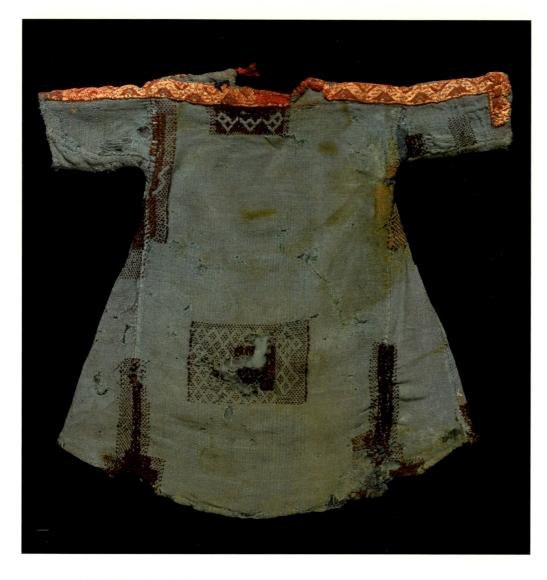

opposite: Fig 3.15(a) Child's wool tunic with pattern darning, *T.8549*. Height of tunic: 455mm.

above: Fig 3.15(b) Back of tunic.

above right: Fig 3.15(c) Diagram of tunic.

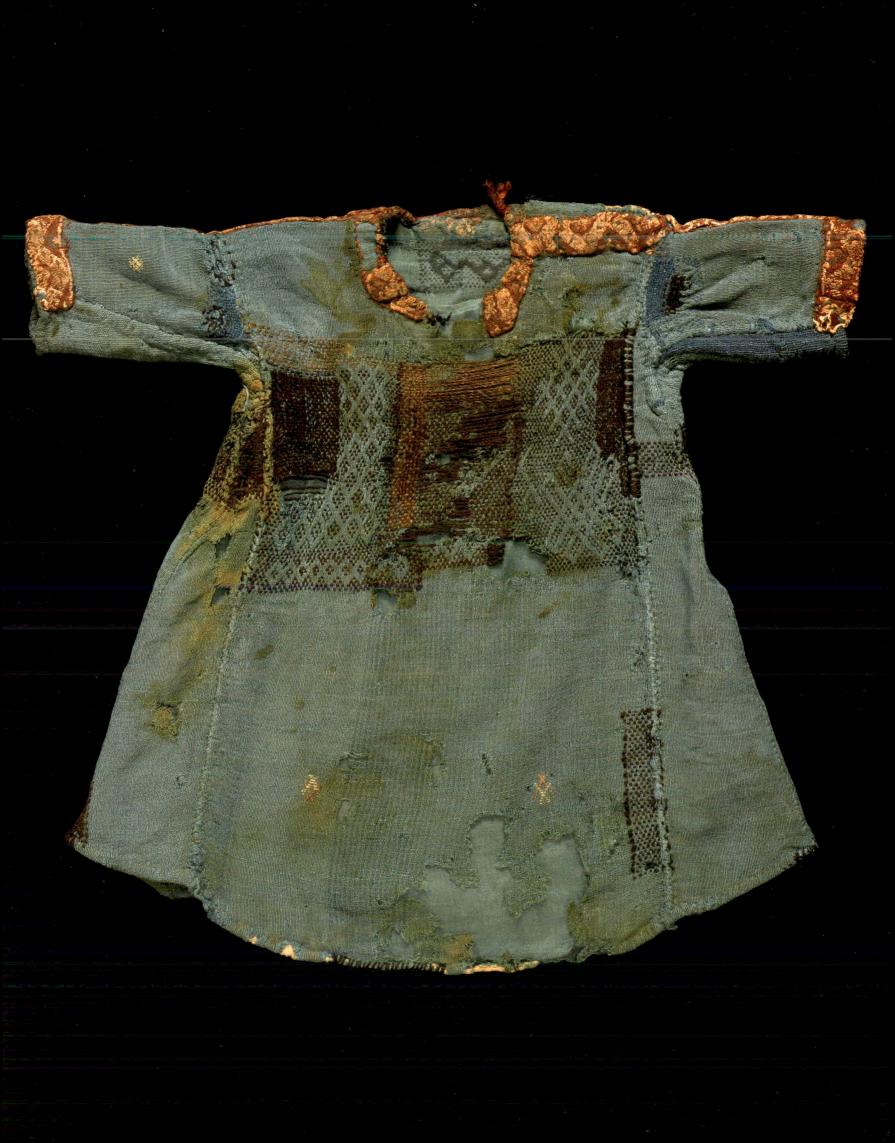

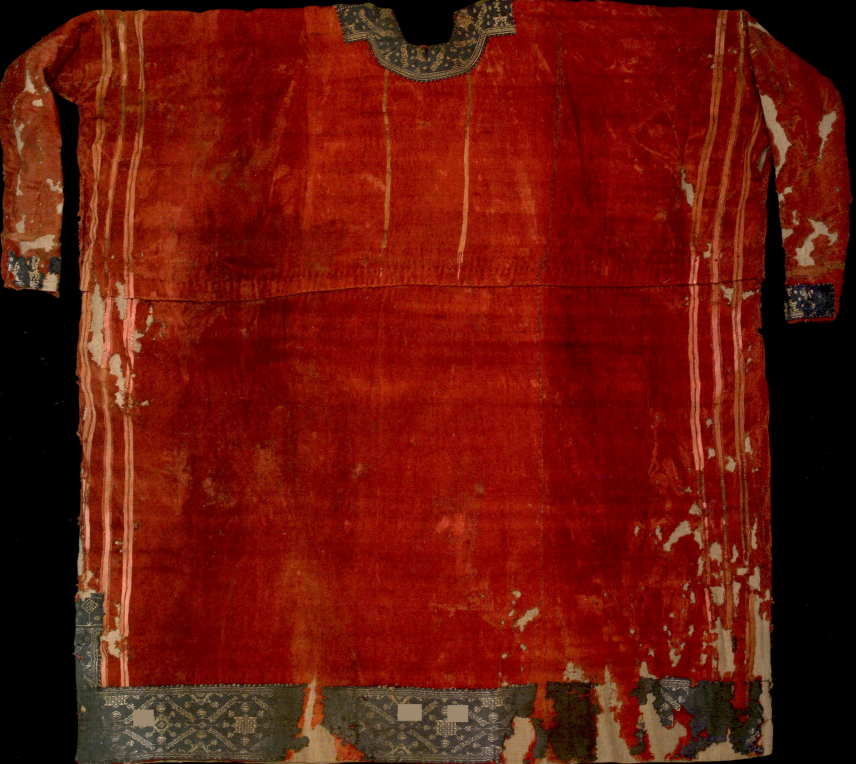

Chapter 4
Tunics and Overtunics

STUDIES OF SURVIVING TEXTILES AND GARMENTS from the Roman world show that clothing was dominated by a tradition of weaving to shape.[1] This was carried out by mounting a warp on a loom in a special way so that each garment was made to a predetermined size. The seams of a garment still had to be stitched together but there was no need for cutting cloth as is usual today.

Tunics were produced in two basic forms depending upon whether they had sleeves. Sleeveless tunics were made in three ways. Two identical loompieces could be seamed together across the shoulders leaving an opening for the head. This style is represented in considerable detail on a late Etruscan, life-size bronze statue, known as the Arringatore, which is dated to between 130 and 80 BC and is housed in the Archaeological Museum in Florence.[2] Complete tunics of this type are preserved among finds of textiles from Roman provinces in the Near East, including Israel and Jordan.[3] An alternative method was to weave a tunic as a single loompiece. The full length of the garment ran in the weft direction on the loom so that it extended to a considerable width.[4] It, therefore, required two people to weave it working side by side. The neck opening was often constructed on the loom by dividing the warp into two halves and this became a simple process with two weavers. It is this type of one-piece tunic that appears to have been most common among the sleeveless tunics from Roman Egypt. However, it is not always easy to distinguish between the two types so far mentioned particularly if a fragment derives from a side or body section of a tunic rather than from the shoulder or neck area.[5] The third method of making a sleeveless tunic was to fold a single narrow width of cloth lengthwise, which is sometimes referred to as a 'bag-tunic'. Full-length linen tunics made in this manner were often worn by men and women in Pharaonic Egypt during the New Kingdom period (1570–1070 BC).[6] The neck opening usually took the form of a simple horizontal slit with a rolled and whip-stitched hem, or occasionally a vertical neck slit was made as well and provided with cords to tie at the neck.[7] Sleeveless tunics of this type mainly disappeared from Egypt when it was under Roman rule[8] and it was not until the Islamic period that they returned to widespread favour.

left: Fig 4.35(a), Wool tunic, 9/56 threads per cm, with applied bands, *T.8361*. Height of tunic: 1.22m.

1 D. K. Burnham, *Cut My Cote* (Ontario, 1973), pp.2–5.

2 H. Granger-Taylor, 'Weaving clothes to shape in the ancient world: the tunic and toga of the Arringatore', *Textile History* 13/1 (1982), p.3.

3 Y. Yadin, *The Finds from the Bar-Kokhba Period in the Cave of Letters* (Jerusalem, 1963), pp.204–7; A. Sheffer and H. Granger-Taylor, 'Textiles from Masada. A preliminary selection', in *Masada IV. The Yigael Yadin Excavations 1963–1965 Final Reports* (Jerusalem, 1994), p.173; H. Granger-Taylor, 'The textiles from Khirbet Qazone (Jordan)', in D. Cardon and M. Feugère (eds.), *Archéologie des textiles des origines au Ve siècle de notre ere. Actes du colloque de Lattes, octobre 1999* (Montagnac, 2000), p.151.

4 J. P. Wild, 'Tunic No.4219: An archaeological and historical perspective', *Riggisberger Berichte* 2 (1994), pp.21–23.

5 U. Mannering, 'Roman garments from Mons Claudianus', in D. Cardon and M. Feugère, op. cit. in note 3, p.284–5.

6 G. Vogelsang-Eastwood, *Pharaonic Egyptian Clothing* (Leiden, 1993), pp.130–49.

7 Eastwood, op. cit. in note 6, pp.135–6.

8 E. Crowfoot, 'A Romano-Egyptian dress of the First Century B.C.?', *Textile History* 20/2 (1989), pp.124–6.

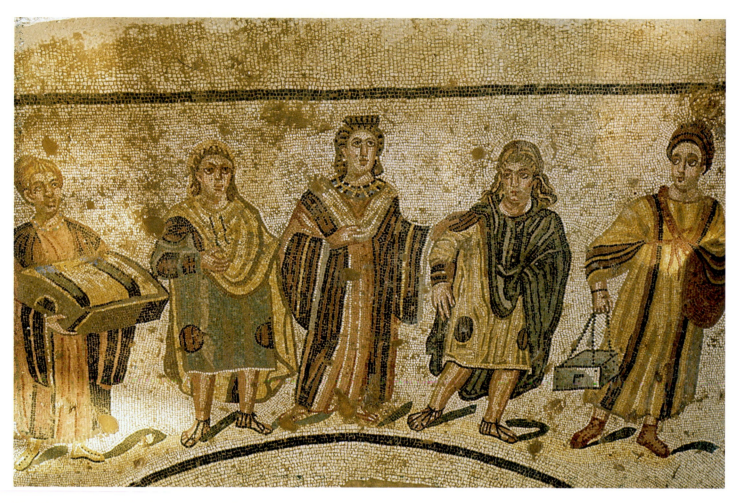

Fig 4.1, Mosaic showing a high-ranked woman with her sons and two female slaves, Piazza Armerina, Sicily, 4th century, (© *Sonia Halliday photographs*)

Both men and women wore sleeveless tunics as part of their everyday dress and although lacking sleeves, the width of many sleeveless tunics meant that the cloth draped over the arms. When worn by a woman, a girdle was tied under the bust creating the illusion of wide sleeves (Fig 4.1), whereas men more often wore a belt round the hips. From studies of written sources it appears that these wide-fitting sleeveless tunics can be equated with the Latin term *colobia*.[9]

Tunics with sleeves were made from a single loompiece woven to a T-shape by starting with one sleeve, then progressing to the main body section with the neck slit frequently being woven by dividing the warp into two halves and creating two internal selvedges, and finally finishing with the opposing sleeve. Special features were built in to the weaving of these tunics to assist with the shaping and to guide the weavers in the layout of the patterning. It is sometimes these details that can help to identify different workshop practices. Most of the tunics described in greater detail below have sleeves but this maybe because they are easier to identify.

Status was indicated less by the shape of the garment than by the quality of the materials used and the decoration. A few examples of tunics made from patterned

9 Wild, op. cit. in note 4, p.27.

fabrics of wool, wool and mohair mixtures, silk, and silk and wool mixtures have been preserved thereby providing a better impression of the range of materials listed in the Edict of Diocletian. No doubt some tunics made from these expensive textiles would have been worn by elite members of the ruling class in Egypt, although many were probably manufactured elsewhere in the Roman world, especially Syria. A notable example, possibly of local manufacture because of its use of S-spun wool, is a wide sleeveless wool tunic woven in a twill damask with a pattern of small checks in red and yellow, that has been carbon-14 dated from AD 50 to 232.[10] Fragments of other tunics in this distinctive damask weave are known from several relatively remote sites in Egypt where the Roman army was garrisoned. The earliest example currently recorded was thrown away, after recycling, on a rubbish heap at Didymoi, a small Roman fortress (*praesidium*) in the Eastern Desert during the reign of the emperor Domitian (81–96).[11] It is part of an off-white sleeveless tunic woven from Z-spun wool, the spin of the wool suggesting that the yarn at least was imported. Another patterned wool tunic, made in a similar sleeveless style but probably dating to the second half of the fourth century, is woven in compound tabby from S-spun wool yarn with wefts of two contrasting colours forming an all over figurative pattern of hunting scenes in bluish-green on a red ground interrupted only by a pair of plain shoulder bands (*clavi*).[12] However, as fragments of this tunic are now deposited in at least ten different collections throughout the world, its former stunning appearance is hard to visualise.

Less complex weaves often incorporating colour effects such as checks and dog's tooth twills were a feature of wool tunics and, more often, cloaks produced on the warp-weighted loom in the northern Roman provinces. They are almost completely unrecorded from graves in Egypt, although fragments have been noted from settlement sites.[13] Predominant among the fabrics used for tunics in Egypt in the Roman and Byzantine periods are plain, tabby-woven linen and wool. The quality of the linen is very varied. The earlier tunics represented here are made from warp-faced linen, which has twice as many warp threads (ends) as weft threads (picks) per cm but from the fifth century the weave is usually more balanced. By contrast, the wool cloth is generally woven in weft-faced tabby with at least twice as many picks as ends per cm. Indeed there are often approximately 10 ends per cm indicating a consistent spacing of the wool warp when it was mounted on the loom over a very long period of time. Weft-faced wool fabrics were very warm and hardwearing and they could be fulled and napped if so desired making them even thicker. Three-shed twills are not represented among the tunics discussed here (as opposed to the cloaks) with the exception of a heavily darned child's tunic, which was probably made from recycled cloth and dates to after the Arab conquest. However, some further fragments possibly from tunics show that the weave was not discontinued and a beautiful, navy blue sleeveless tunic in weft-faced 1.2 twill from Petrie's cemetery site at el-Lahun is preserved at Philadelphia.[14]

Tunic decoration conformed to a specific layout with the back mirroring the front. Matching bands called *clavi* ran either side of the neck. They could be full length or

10 S. Schrenk, *Textilien des Mittelmeerraumes aus spätantiker bis frühislamischer Zeit* (Riggisberg, 2004), pp.158–62, no.53.

11 D. Cardon, 'On the road to Berenike: a piece of tunic in damask weave from Didymoi', in P. Walton Rogers, L. Bender Jørgensen and A. Rast-Eicher (eds.), *The Roman Textile Industry and its Influence* (Oxford, 2001), pp.13–14.

12 Schrenk, op. cit. in note 10, pp.173–6.

13 L. Bender Jørgensen, *North European Textiles until AD 1000* (Aarhus, 1991), pp.134–5; L. Bender Jørgensen, 'A matter of material: changes in textiles from Roman sites in Egypt's Eastern desert', Tissus et Vêtements dans L'Antiquité Tardive, *Antiquité Tardive* 11 (2004), p.99.

14 University of Pennsylvannia Museum E 16804.

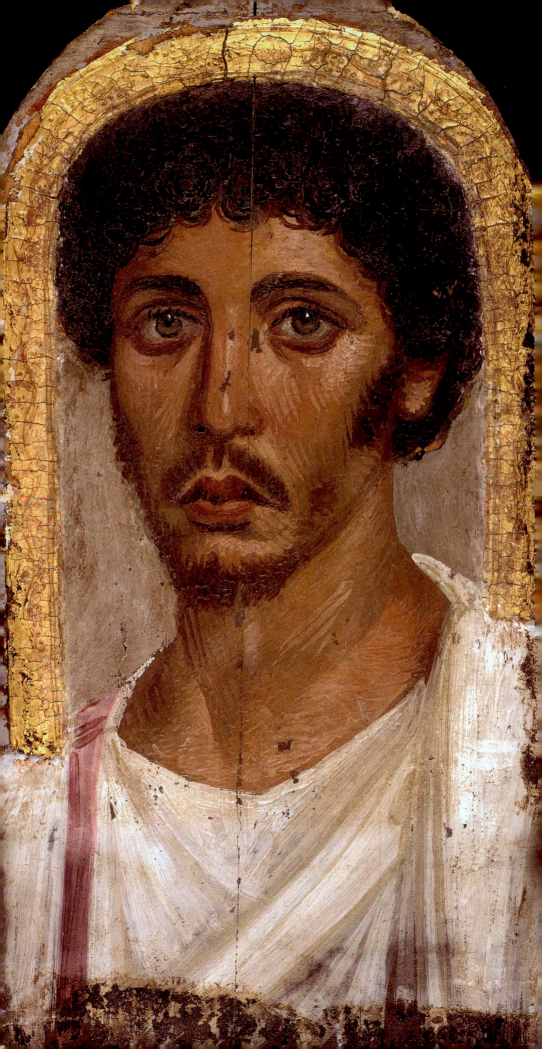

stop above the waistline. Shoulder ornaments, usually round (*orbiculi*) or square (*tabulae*), lay close to the *clavi* and matching them were similar patterned ornaments, although much smaller in size, marking out the knees above the lower edge. Each sleeve was decorated with a pair of sleevebands above the wrist. In addition some tunics were decorated at the neck and less often at the 'hem'. Until about the seventh century all the decoration on a tunic was generally woven into the web of the cloth and formed a matching set. It is, therefore, often possible to identify pieces from tunics that have subsequently been cut up and are in different collections. Sets of ornaments were also sometimes recycled in antiquity and sewn to another tunic, which might also be made from reused fabric. A few purpose-woven ornaments of exceptionally high quality were made separately and applied to tunics in the late Roman and early Byzantine periods but these are very rare.[15]

Gender distinctions can be made between tunics on the basis of size, decoration and colour. Women's tunics extended to the ankle whereas men's tunics were generally knee length in the Roman period (Fig 4.1), with some exceptions in respect of more formal wear. Both sexes wore belts or girdles with their tunics and this also enabled some variation in style. Colourful wool tunics were the preserve of women, at least for most of the Roman period. This is very apparent from Egyptian mummy portraits in which men are consistently portrayed wearing white tunics (Fig 4.2). It is probable too that different shades of colour went in and out of fashion for women's clothes as hinted at by poets especially Ovid, who lists among many alluring cheaper colours – pale sky-blue, sea green, myrtle leaf, amethyst purple, the grey of a Thracian crane and almond blossom.[16]

The Late Roman Period

It was not until the third century with the spread of Christianity in Egypt that it became common to bury the dead in their clothing, a practice that aroused criticism from leading churchmen, including St Jerome and St Ambrose, in the fourth century.[17] Consequently, early Roman garments are preserved in small numbers apart from fragments mainly recovered from excavations of settlements conducted relatively recently. None are represented in this collection and it does not include many tunics from the third and fourth centuries that can be fully reconstructed. However, three linen tunics all woven in warp-faced tabby weave with wide sleeves offer a glimpse into styles at the time. Their most important characteristic is that they are woven to shape in one piece, as described above, and their sleeves are nearly as wide as the central part of the tunic, or even wider. No starting or finishing borders are preserved along the sides of the tunics or at the edges of the sleeves as the ends have been cut and an interlocking thread has been sewn round the raw edges to prevent any fraying.[18] The raw ends were folded inwards and the side edges were seamed. Close to the side edges and sleeve ends of two of the linen tunics are bands of bare ends. They indicate where a rod or string would have been positioned when the warp was

left: Fig 4.2, Portrait of a young man AD 150–70, excavated by Petrie at Hawara in 1888. He wears a white tunic with plain, purple *clavi*. (© The Trustees of The British Museum).

15 L. H. Abdel-Malek, 'Deities, saints and allegories. Late antique and coptic textiles', *Hali* 72 (December 1993/ January 1994), pp.83–85; Schrenk, op. cit. in note 10, pp.197–9 no.66.

16 Ovid, *Ars Amatoria* 3, lines 171–84; J. P. V. D. Balson, *Roman Women. Their History and Habits* (London, 1962), pp.253–4.

17 A. F. Kendrick, *Catalogue of Textiles from Burying-Grounds in Egypt, Vol. I.* (London, 1920), p.20.

18 M. Erikson, *Textiles in Egypt 200–1500 AD in Swedish Museum Collections* (Gothenburg, 1997), pp.77 and 79, fig. 1.

on the loom, which would have helped with tensioning the web and keeping the edges even. Both these features – the use of an interlocking thread to finish raw edges and bands of bare warp ends – are characteristic only of linen.

The layout of the decoration and the positioning of the neckline were carefully worked out by the weavers with selfbands formed from groups of more than one weft thread in a shed acting as guidelines. They are woven into cloth at specific points in the weaving: next to the sleevebands, where the cloth was widened to form the central panel thereby helping to reinforce the side edges, next to the inner edge of each *clavus* and also beside the neck opening. Usually the selfbands next to the neck do not extend the full length of the cloth and they include a section of twining which helped to strengthen both ends of the neck opening, where considerable stress was exerted when the tunic was pulled on and off over the head.

The decoration woven into the tunics is carried out in fine linen thread against a background of 'imitation' purple wool made here by blending together red and dark blue wool before it was S-spun. The patterns are geometric with elaborate fretwork on the shoulder and knee ornaments and interlace chiefly on the *clavi* and sleevebands. In style, therefore, they resemble the interlace ornament on a child's linen tunic from a burial at Hawara dated by a coin to AD 340 (see above, p.14).

Probably the earliest of these three tunics with a finished length of 1.22 metres is the plainest with unpatterned purple *clavi* woven in extended tabby (Fig 4.3). The greater bulk of the wool thread and the change from a warp-faced to a weft-faced weave meant that it was necessary to drop some of the linen warp threads, which would not be seen, on the back of the tunic. For the two *clavi* this was achieved by dividing the warp threads into two layers with only one end in five actually binding the weft.[19] However, for the matching octagonal-shaped ornaments at the shoulders and knees, which are tapestry woven, some threads were crossed while others were dropped. This involved inserting a supplementary shed rod between the warp threads to enable the threads to be regrouped for the short sections of tapestry.[20] Another feature of the tapestry-woven decoration on this tunic is the arrangement of the floating threads on the back, which also throws light on the weaving techniques employed.[21] Before the purple wool weft is introduced, the ground weft does not interlace with the warp threads but floats on the reverse over an area determined by the width of the decoration. Once half the ornament has been defined in this manner, the weaving of the ground temporarily stops and the decoration is woven in. The weft threads of the ground weave are then cut in the middle on the reverse. Next a supplementary shed rod is reinserted across the width of the ornament to regroup the warp threads and, once the complete decoration is woven in, the supplementary rod is removed and the ground weave alongside the upper section of the ornament is woven. Here too the ground weft floats on the back of the tapestry area but the threads are not cut as they do not impede the weaving process.

19 F. Pritchard and C. Verhecken-Lammens, 'Two wide-sleeved linen tunics from Roman Egypt', in Walton Rogers, Bender Jørgensen and Rast-Eicher, op. cit. in note 11, p.23.

20 D. De Jonghe and M. Tavernier, 'Le phénomène du croisage des fils de chaîne dans les tapisseries coptes', *Bulletin de liaison du CIETA* 57–58 (1983), pp.174–86.

21 Pritchard and Lammens, op. cit. in note 19, pp.23–24, fig. 3.2.

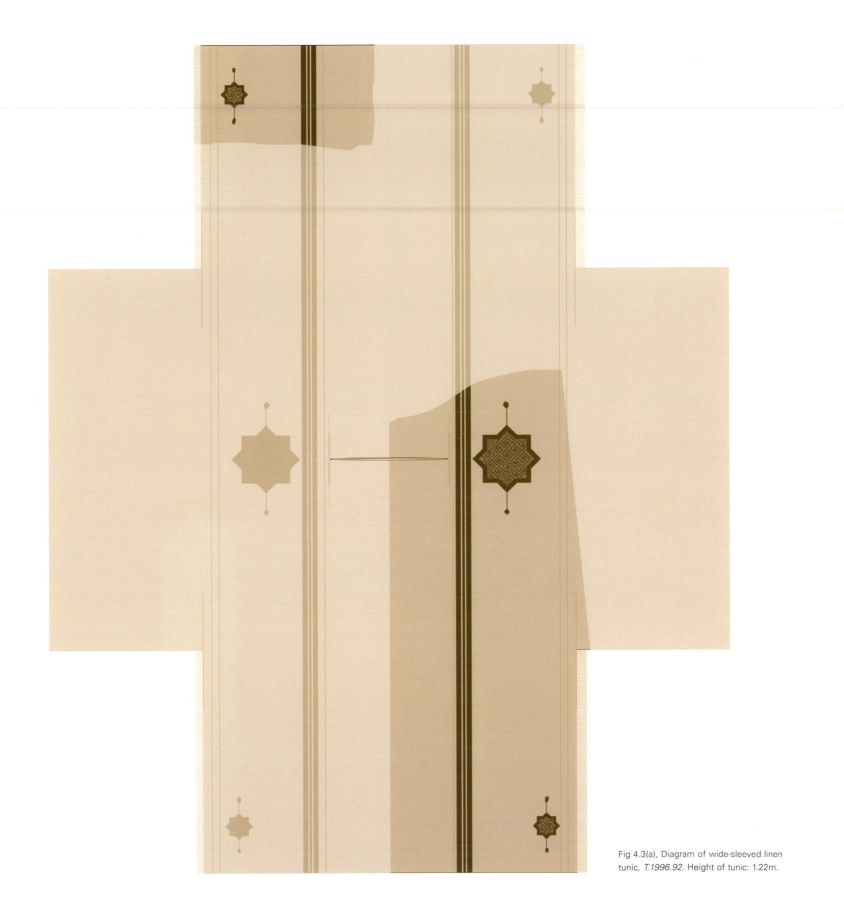

Fig 4.3(a), Diagram of wide-sleeved linen tunic, *T.1996.92*. Height of tunic: 1.22m.

Fig 4.3(b), Detail of neckline, *clavus* and octagonal shoulder decoration. The linen ground has 23/11 threads per cm.

Fig 4.3(c), Detail of octagonal knee decoration and selfbands.

The combination of plain *clavi* and tapestry-woven ornaments indicates this was a tunic at a transitional stage of development moving towards a more highly decorative ensemble. A similar combination can be observed on another wide-sleeved tunic in a private collection in Israel.[22] Plain *clavi* are more typical of earlier Roman tunics, and many fragmentary examples have been excavated from rubbish deposits in settlements.[23] However, a group of well-preserved linen tunics for adults and children, including some with plain purple *clavi* and sleevebands, recovered from Bagawat cemetery in the Kharga Oasis in the 1930s provides a better impression of these forerunners to tunics with patterned decoration.[24]

A second linen tunic, which is slightly smaller and shorter, 0.93 metres in length with sleeves 455mm wide, has a more lavish amount of matching tapestry-woven decoration (Fig 4.4). The *clavi* are not full-length; instead they extend approximately to the waist, and further areas of tapestry are woven at the neck and 'hem'. For the tapestry, the warp threads were crossed to form ribs of alternately two and three ends and the ground weft turned back at the edge of the tapestry area rather than floating on the back.[25] This was required by the position of the decoration, which forms part of the neckline as well as the lower edge. The long slits that were created between tapestry and the ground weave, therefore, had to be oversewn together. Further evidence of sewing is preserved by the sideseam and underarm seam, which were formed from

22 A. Baginski and A. Tidhar, *Textiles from Egypt 4th–13th centuries C.E.* (Tel Aviv, 1980), pp.36–37 no.1.

23 Mannering, op. cit. in note 5, p.285.

24 A. Stauffer, *Textiles of Late Antiquity* (New York, 1995), p.7, fig. 2; N. Kajitani, 'The textiles and their context in the AD third to fourth century cemetery of el-Bagawat, Kharga Oasis, Egypt', in S. Schrenk (ed.), *Textiles in situ. Riggisberger Berichte* 13 (forthcoming).

25 Pritchard and Lammens, op. cit. in note 19, pp.25–26.

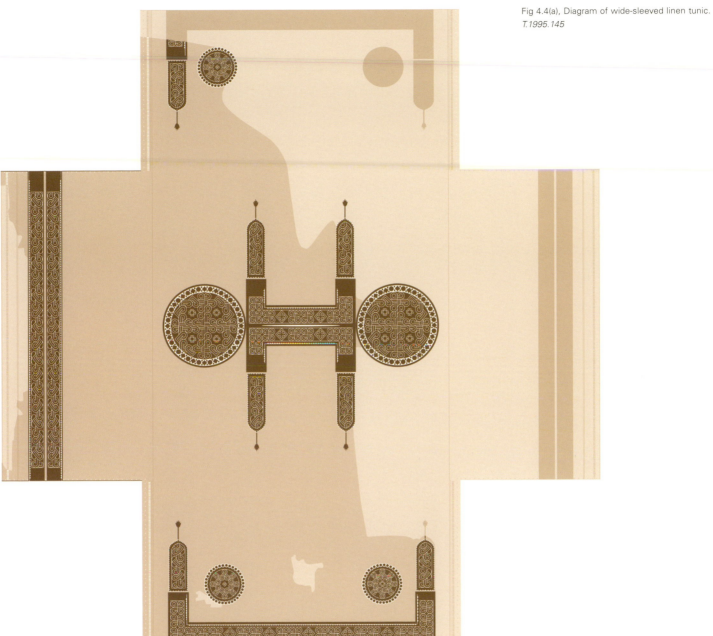

Fig 4.4(a), Diagram of wide-sleeved linen tunic. *T.1995.145*

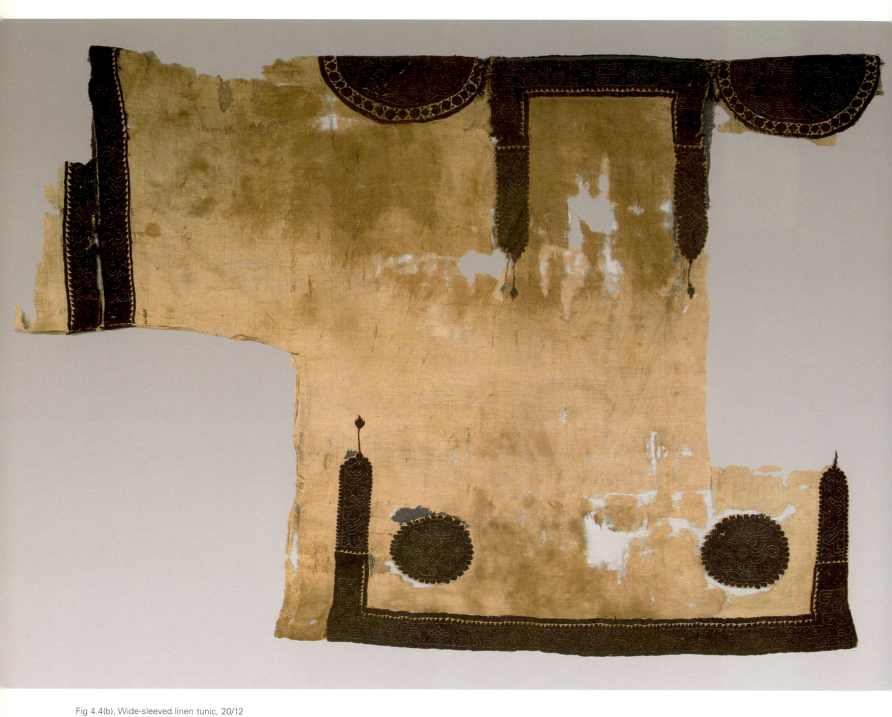

Fig 4.4(b), Wide-sleeved linen tunic, 20/12
threads per cm, *T.1995*.145. Height of tunic:
930mm.

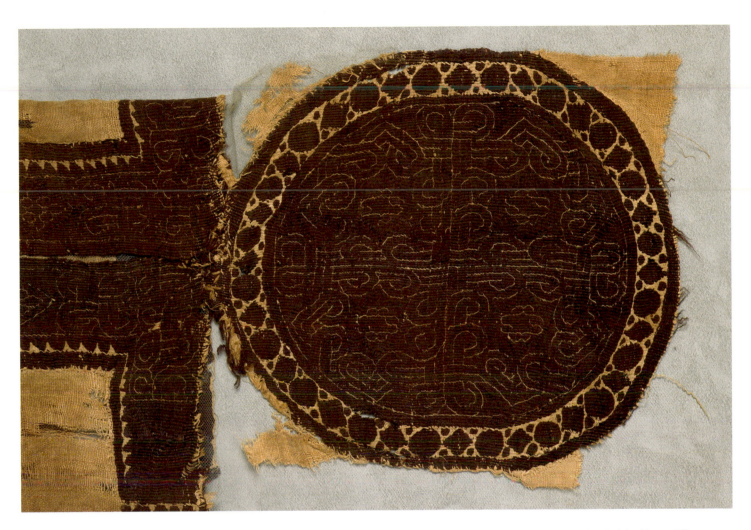

Fig 4.4(c), Detail of shoulder medallion.

overlapped edges sewn in running stitch while the tunic was folded inside out. In addition to the large running stitches, the underarm angle was reinforced with slip stitches worked in fourfold linen thread similar to that used for the seam of the sleeve. Another distinctive, but discrete, feature of this tunic is the addition of a purple thread beside the bands of bare ends on the sleeve and at the side. The tunic shows signs of wear as it has been repaired at the most vulnerable section between the medallion and the neck opening on both shoulders on different occasions. Thus the tunics were not woven specifically as burial garments but had previously been worn in life.

The third wide-sleeved linen tunic, 1.19 metres in length with sleeves 565mm wide, has full-length *clavi* and sleevebands tapestry-woven with matching interlocking heart-shaped buds between bands of delicately outlined two-strand interlace. The large circular shoulder medallions (approximately 260mm in diameter) again show the prevailing taste for complex geometric patterning (Fig 4.5). The warp threads were crossed to form ribs of alternately two and three ends for the areas of tapestry and additional ends were left to float on the back of the *clavi*. The change of tension on the *clavi* was not dealt with very satisfactorily and consequently the linen does not lie flat. This

Fig 4.5(a), Diagram of wide-sleeved linen tunic, *T.1994.129* and *T.1968.80*. Height of tunic: 1.19m.

Fig 4.5(b), Detail of neckline, *clavi* and shoulder medallions. The linen ground has 24/12 threads per cm.

Fig 4.5(c), Detail of sleeve, *T.1968.80*.

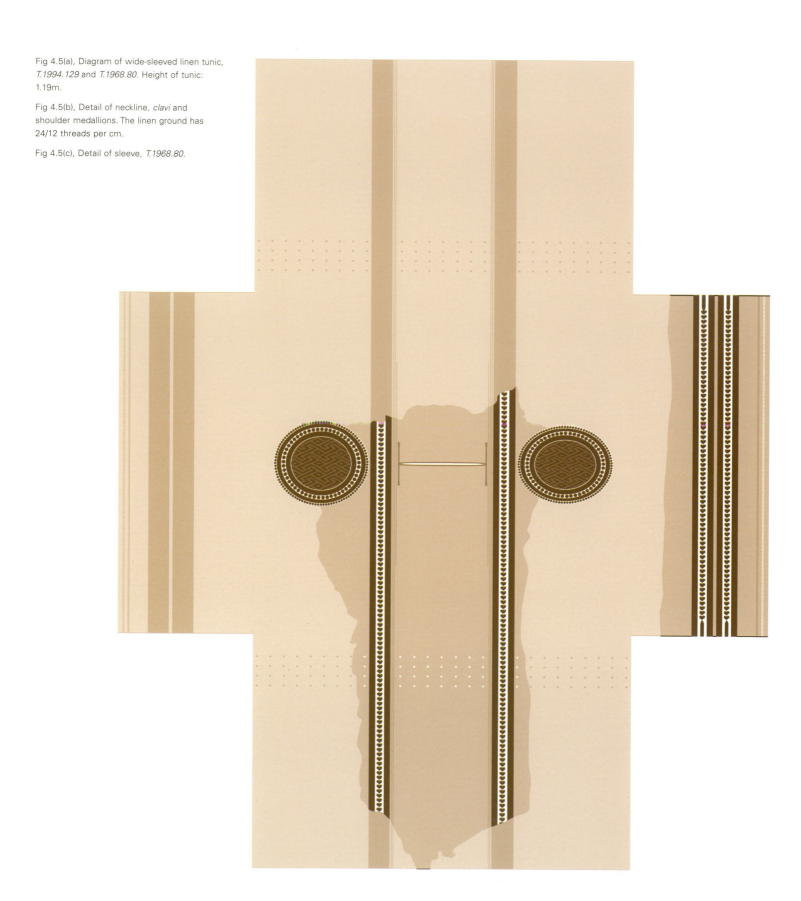

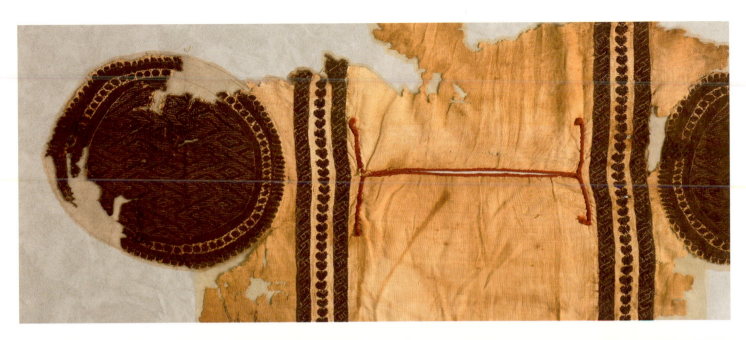

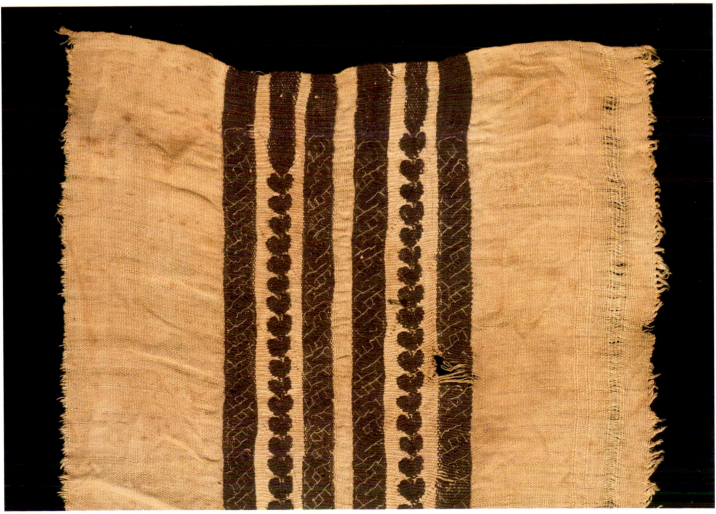

Fig 4.6, Mosaic with two huntsmen, a groom and a boy wearing tunics with different styles of decoration, Piazza Armerina, Sicily, 4th century, (© *Sonia Halliday photographs*)

feature has also been noted on a fragment that has an identical pattern and may possibly even come from the same tunic, which is now in the musée Dobrée, Nantes in France.[26] The neck opening of the tunic was reinforced and emphasised by sewing on a braided cord made from red wool, which conceals the internal twining woven in the linen cloth. Traces of a waist tuck are also visible, which would have originally shortened the garment by as much as 100mm. As with many other garments found in graves in Egypt this tuck appears to have been unstitched before it was used as a burial robe. The use of the tunic for burial is very apparent from the lattice impression made by the bands binding the tunic round the body.

It is not known for certain from what site in Egypt any of these three tunics were recovered. Akhmim is the most probable source since more textiles reached England from this site than from Antinoë. At least one other wide-sleeved tunic with similar geometric patterning is recorded as coming from Akhmim, although it is a higher quality tunic with tapestry-woven decoration in Z-spun purple wool and a short band on one side interwoven with gold thread.[27]

Wide-sleeved tunics (*dalmatica*) were associated with women at all levels of society from the second century. Third- and fourth-century wall paintings and mosaics show women wearing wide-sleeved tunics caught up under the bust with a girdle fastened

26 Musée Dobrée, *Au fil du Nil. Couleurs de l'Égypte chrétienne* (Paris, 2001), p.42, no.15.

27 Kendrick, op. cit. in note 17, pp.40–41; D. King, 'Roman and Byzantine dress in Egypt', *Costume* 30 (1966), pp.2–4.

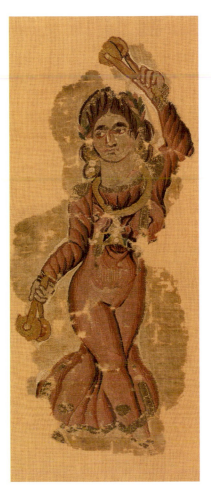

at the front, but many are likely to represent wide, sleeveless tunics (Fig 4.1). The *clavi* on women's tunics at this period usually extended the full length of the garment whereas tunics with shoulder and knee medallions and more decoration at the lower edge tended to be worn by men. For example, a silver dish preserved in The Hermitage, St Petersburg, shows the emperor Constantius II (337–61) on horseback wearing such a tunic but with tighter fitting sleeves.[28] Many of the men depicted on the magnificent series of fourth-century mosaics at Piazza Armerina in Sicily, which were laid at the villa under the supervision of African craftsmen almost certainly based in Carthage, can also be seen wearing short tunics with a similar arrangement of decoration at the neck and 'hem' (Figs 4.6 and 4.7).[29] It has been argued that this arrangement of decoration was influenced by military dress and shows cross-cultural influence from Western Asia during the third century.[30] Soldiers' uniforms have, indeed, proved perennial sources for fashion inspiration and it would not be surprising if they were influential also in antiquity. The relatively short length of the most highly decorated of the three tunics also supports the contention that it was a man's garment. However, generalisations are risky and a dancing maenad portrayed on a woven hanging is dressed in a dusky pink tunic that is decorated at the neckline and lower edge, as well as having short *clavi*, together with shoulder and knee medallions (Fig 4.8).

Fig 4.7, Mosaic showing two men, who wear tunics decorated with large shoulder medallions, encouraging a rhinoceros to move, Piazza Armerina, Sicily, 4th century, (© *Sonia Halliday photographs*)

Fig 4.8, Part of a tapestry-woven hanging showing a maenad dancing with a pair of *crotala*. She wears a pink tunic decorated at the neck, shoulders, sleeves and lower edge, 4th–5th century. (© *Abegg Stiftung, CH-3132 Riggisberg, 2003. Photo: Christoph von Viràg*)

28 J. P. C. Kent and K. S. Painter (eds), *Wealth of the Roman World AD 300–700* (London, 1977), p.25, no.11.

29 R. J. A. Wilson, *Piazza Armerina* (London, 1983).

30 King, op. cit. in note 27, p.4.

The Byzantine Period

The basic construction of tunics remained the same throughout this period, although radical changes in the cut and tailoring of garments were beginning to seep in to the region through outside influences, especially from contact with the Sassanian empire in the Middle East, that in the long term were to have a lasting impact. In the short term the most significant development was the introduction around the fifth century of linen tunics made in two, or more often three, pieces with a horizontal seam in the centre positioned slightly above the waist. The resulting tunic looked superficially very little different from those made in the traditional manner from a single loompiece with a waist tuck. This new departure, nevertheless, reveals a growing trend for stitching clothing together from several pieces of cloth.

More visually striking was the increasing use of figurative decoration on both linen and wool tunics by the late fourth century when, in contrast to the previous period, designs were usually worked on light coloured backgrounds.[31] They, thus, made bold statements about personal taste and form a contrast with less flamboyant clothing worn in the western provinces of the Roman empire. Popular subjects were scenes from classical mythology and Dionysian revelries showing dancing maenads, satyrs and frenzied festivities associated with the grape harvest (Fig 4.9). They reflected a deepseated interest in Greek culture among some sections of society, which did not diminish with the growth of Christianity. Themes with a stronger Egyptian identity also featured on tunics. Among them were Nile riverscapes with nereids, fish and waterfowl, pastoral scenes and wild animals and birds associated with hunting, in particular lions, antelopes or gazelles, dogs, hares, ducks and partridges or quail. Latin influence is less evident in the choice of decorative motifs but can be detected in the representation of portrait busts. Christian symbols, mainly in the form of a cross, also began to appear. Initially these symbols were positioned relatively discretely on top of the shoulder but many were more prominently placed at the centre front of a neck panel. Often Christian symbols were combined with Dionysian iconography showing a duality of religious belief that persisted for a while to the annoyance of the official church. Indeed, Dionysos was seen as a symbol of rebirth and renewal among followers of Neoplatonism and at a popular level Dionysos and Christ were frequently thought of in similar terms.[32] These figurative subjects continued into the sixth century, although sets of ornaments were often recycled from one tunic to another providing further evidence for the longlived popularity of some subjects as well as the existence of trade in secondhand clothing, which operated on more than a domestic scale.

The period was also characterised by a greater variety of coloured wools in the tapestry decoration of linen tunics. Purple remained the predominant hue but shades of red, orange, yellow and green became more common. Sometimes only a few details were added in a second colour, a touch of yellow to represent gold for a necklace (Fig 4.10), or animals' tongues and birds' beaks worked in red (Fig 4.11), but increasingly

Fig. 4.9, Fragment from the neck section of a linen tunic decorated with Dionysian figures woven in Z-spun purple wool, *T.1968.251.*

31 King, op. cit. in note 27, p.5.

32 H. Granger-Taylor, 'The decoration of Coptic tunics', in A. De Moor (ed.), *Coptic Textiles from Flemish Private Collections* (Zottegem, 1993), p.16; Stauffer, op. cit. in note 24, p.13.

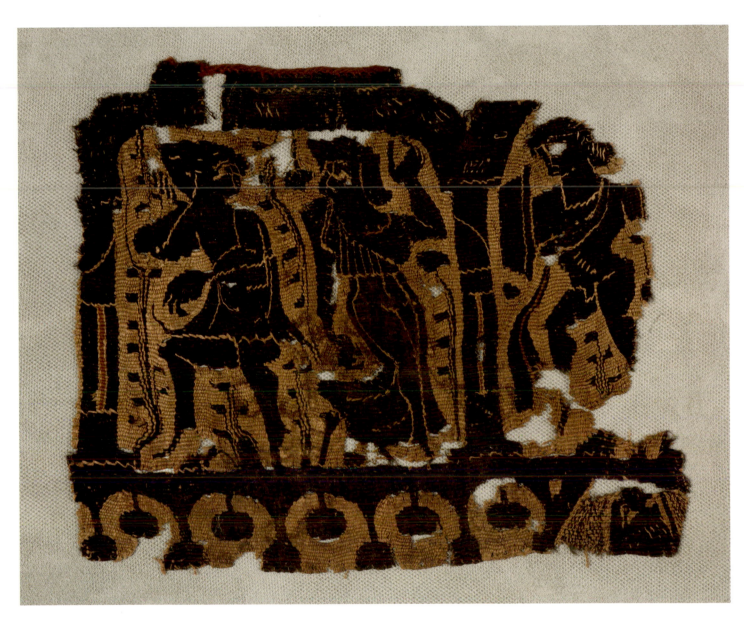

the whole pattern was carried out in a different colour indicating a new mood and a less rigid and puritanical attitude towards colour.[33]

Tunics were produced in a tremendous range of quality pointing to the existence of large numbers of weaving workshops supplying different clientele. Some linen is remarkably fine with exquisitely refined tapestry decoration while some is coarse, unbleached and poorly woven with sketchily outlined tapestry-woven figures. They, nevertheless, show that there was a desire for certain designs to be copied and emulated at different levels of society. At the top end of production were tunics with designs woven from cartoons drawn on papyrus, which were particularly necessary when a new style was introduced. The cartoon would have been placed behind the warp threads during the tapestry weaving so that the weavers could refer to it.[34]

Fig 4.10, Neck panel from a linen tunic, *T.1968.345*. The tapestry-woven decoration includes a few details in yellow wool.

33 Granger-Taylor, op. cit. in note 32, p.15.

34 A. Stauffer, 'Cartoons for weavers from Graeco-Roman Egypt', in D. M. Bailey, *Archaeological Research in Roman Egypt*, *Journal of Roman Archaeology*, supplementary series19 (1996), p.224.

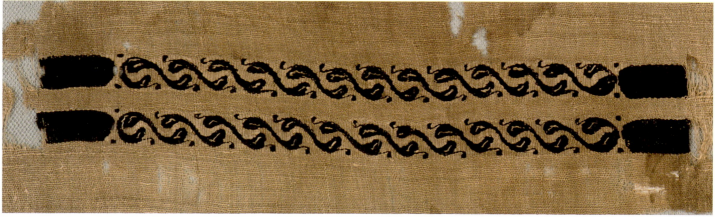

Fig 4.11, Sleevebands from a linen tunic, *T.8397.* Red wool is used for the tongues of the hares and lion and the beaks and feet of the birds.

Fig 4.12 Part of a sleeve from a linen tunic, 27/16 threads per cm, *T.1968.257.* Most of the purple wool is Z-spun but a small amount is S-spun.

However, weavers in most workshops probably worked mainly from memory and experience, although not all were equally competent.

Often an indicator of higher quality clothing is the use of fine, Z-spun wool for areas of tapestry-woven decoration. Wool with this spin direction was not very common in Egypt and suggests the spun yarn may have been traded from another province of the Roman world such as Syria. Frequently the wool is purple in hue, although wool dyed other colours such as red or blue is also sometimes Z-spun. Many of the latter textiles have other distinctive features in their design or technique suggesting that at

least some of them were of foreign manufacture. Nevertheless, both S-spun and Z-spun purple wool were evidently sometimes available in the same weaving workshop in Egypt as shown by a sleeveband from a lightweight linen tunic that uses both types of wool in its tapestry-woven decoration, the S-spun yarn being used for just a short section probably after the Z-spun yarn had run out (Fig 4.12).

A popular colour effect used mainly for the backgrounds of tapestry-woven decoration on linen tunics, as well as on soft furnishings, was to combine purple and linen threads to create an impression of 'hatching' (Fig 4.13). This was achieved by alternating threads of wool and linen in a variety of ways. They included using a double yarn which combined one thread of linen with one of wool, sometimes in an alternating sequence, ie linen and wool, wool and linen, linen and wool, etc, or a threefold yarn with two threads of linen to one of wool, or a single yarn with two throws of linen alternating with two of wool (Fig 4.13b). Often more than one method of false hatching was combined in an ornament revealing considerable dexterity and ingenuity on the part of the weavers, which would have required careful preparation before weaving commenced. Fine examples in this technique have occasionally been dated as early as the third century, but the evidence rests chiefly on comparative stylistic material in other media, and most appear to date to the late fourth and fifth centuries.

Fragments from a high quality tunic with this type of patterning, for which an early date has been proposed, were recovered at Antinoë in 1902–1903.[35] The tapestry decoration, in this instance, is very detailed featuring mythological scenes, including the battle between the Lapithae and the centaurs, symbolising the victory of civilisation against

Fig 4.13(a), Part of a linen tunic, 20/15 threads per cm, with recycled ornaments woven using Z-spun purple wool yarn, *T.1994.127*. The lattice impression on the linen resulted from the bands tying burial wrappings round the corpse.

Fig 4.13(b), Detail of 'false hatching'.

35 Musée Dobrée, op. cit. in note 26, pp.112–3, no. 77.

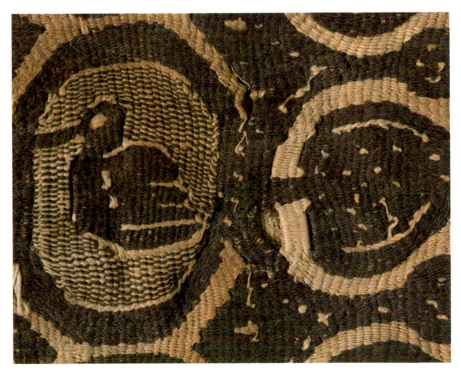

Fig 4.14, Recycled neck panel on a linen tunic, 29/20 threads per cm, width of neck opening 255mm, *T.1968.343*. The purple wool yarn is Z-spun.

right: Fig 4.15, Part of a *clavus* from a two or three-piece linen tunic, 20/24 threads per cm, with a waist seam, *T.1968.274*. The purple wool yarn is Z-spun.

the barbarians, and unusually the neck panels are not identical; on one probably from the back of the tunic a Greek is portrayed triumphing over the Amazons and on the other there is a series of pairs of men and women, including Perseus rescuing Andromeda and Hercules pursuing Auge. The decoration is exceptional in using false-hatching throughout the background instead of being limited to contrasting scenes, although a *clavus* fragment from a similarly finely patterned tunic recovered from Akhmim and now in the State Pushkin Museum of Fine Arts Moscow and pieces of tunics now in London, Paris and Washington show it was not unique in this respect.[36] Fragments of further ornaments of this type and quality, which probably derive from a tunic, even use golden silk thread for details within the patterning.[37] Complete tunics, which partly use false-hatching for background decoration, include examples now in Moscow, New York, and Washington.[38] The layout of the decoration on each tunic differs, reflecting in part the gender and taste of the wearer, but all include mythological scenes and the purple wool yarn is consistently Z-spun.

There are only fragments of tunics with false-hatched backgrounds preserved in the collection in Manchester. Nevertheless, they possess characteristics of interest. Two examples, both using Z-spun wool in their tapestry-woven decoration, have recycled ornaments (Figs 4.13 and 4.14). The ground linen to which they have been sewn lacks the carefully positioned selfbands that acted as guidelines to the weavers and presumably large plain pieces of sheeting were used. The stitching has been carefully done and the necklines are strengthened with narrow twined braids showing a level of expertise more often associated with new tunics. Indeed, the purple and white neck braid on one of them is similar to the neck edging on the tunic from Antinoë

36 R. Shurinova, *Coptic Textiles. Collection of Coptic Textiles State Pushkin Museum of Fine Arts Moscow* (Moscow, 1967), no. 6; Kendrick, op. cit. in note 17, p.73, no. 91, pl. 21; A. Lorquin, *Les Tissus Coptes au musée national du Moyen Age – Thermes de Cluny* (Paris, 1992), pp.96–98, no. 24; J. Trilling, *The Roman Heritage. Textiles from Egypt and the Eastern Mediterranean 300 to 600 AD* (Washington, 1982), pp.48–49, no. 27.

37 Schrenk, op. cit. in note 10, pp.367–70, no. 174.

38 Shurinova, op. cit. in note 36, no. 5; Stauffer, op. cit in note 24, p.26, no. 31; Trilling, op. cit. in note 36, p.47, no. 26.

39 C. Rizzardi, *I tessuti copti del museo nazionale di Ravenna* (Ravenna, 1993), pp.66–67, no. 15.

40 R. Cortopassi, 'Un *amphimallon au musée du Louvre*', *Bulletin du liaison de CIETA* 79 (2002), p.33.

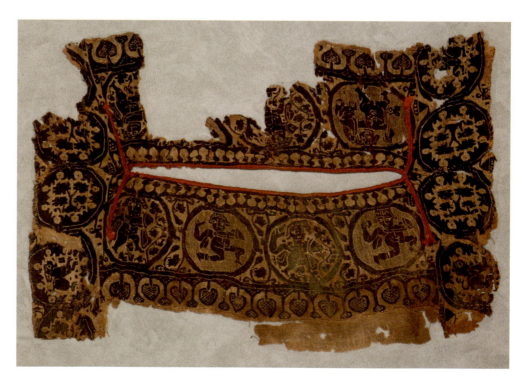

referred to above. The identical pair of recycled square shoulder *tabulae* on this tunic show a mounted warrior brandishing an axe, and it is the background to these figures and the ducks on the clavi and neck panel that features false hatching. On the second tunic fragment only alternate roundels on the neck panels are worked in this technique. Bunches of grapes on the lower edges of both the neck panels are scarcely recognisable, showing a decline in design that probably resulted from the weaving being carried out in less accomplished workshops rather than that a long time had elapsed between the production of more naturalistic patterns and the crude stylisation of form.

Another tunic fragment with false hatching, which also uses Z-spun purple yarn, comes from a tunic that was seamed at the waist (Fig 4.15). This is indicated by a row of stitch holes 5mm above the selvedge, as the bottom edge of a tunic was not hemmed at this period. A second *clavus* fragment from the other side of the tunic has a hare running in the opposite direction positioned next to the selvedge at the waist seam. A more complete example of a three-piece tunic with false-hatched background decoration, that was recovered from Antinoë in 1902 and is now in the Museo Nazionale Ravenna, Italy, has short *clavi* that stop above the waist seam so that the problem of matching and aligning the decoration was avoided.[39]

False hatching was also carried out in less accomplished workshops producing coarsely woven tunics, indicating that the technique was for a time widely practised. Red wool was frequently used instead of imitation purple wool in these coarser tunics, probably because it was a cheaper option as no blending of different colours was needed. However, the technique of false hatching appears to have gone out of fashion by the early sixth century and it quickly disappeared from the weaving repertoire.

A different type of tunic, which sometimes included false-hatched tapestry-woven backgrounds, was woven with loops of linen pile resulting in a garment with a shaggy texture. Literary sources, notably the writings of Pliny the younger (died AD 113), enable the production of these tunics to be traced back to the first century in the Roman empire and possibly to much earlier in ancient Greece.[40] Wool tunics with pile on both the inside and outside were known as *amphimalla* while cloth with long pile just on one side was referred to as *gausapum*. The method of weaving in the pile varies considerably but it was a technique with a long tradition in Egypt where looped pile furnishings had been produced since the Pharaonic period.

Fragments from the sleeves of two tunics with weft-looped pile and false-hatched tapestry patterning are among the pieces of linen garments preserved in Manchester. One is from a sleeve approximately 360mm wide and seamed in two-ply yellow wool sewing thread so that it tapered to a narrow wrist opening of approximately 210mm. It has short pile, 5mm in length, on the front inserted every fourth row, which extends to the edges of the sleeve, and longer pile, 20–22mm, on the back inserted every

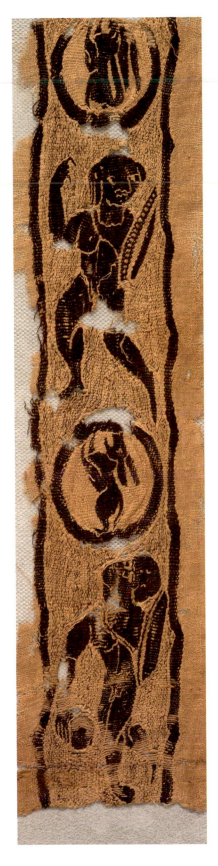

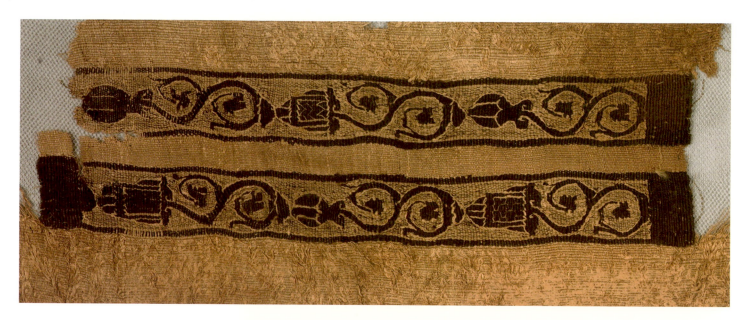

Fig 4.16(a), Part of a sleeve from a linen tunic with pile, 32/16 threads per cm, *T.1968.308*. The purple wool yarn is Z-spun.

Fig 4.16(b), Detail of reverse.

41 Stauffer, op. cit. in note 24, p.46, no. 42.

42 Cortopassi, op. cit. in note 40, pp.38–39.

43 A high quality linen tunic at The Ashmolean Museum, University of Oxford, has short, weft-looped pile inserted every fourth row on the outside face only, accession number 1942.126.

ninth row (Fig 4.16). The sleeveband of this tunic is patterned in classical style with a vine scroll springing from an urn (*cantharus*) worked in Z-spun wool yarn against a background of false hatching and, as the warp-faced linen has a high density of warp ends, some ends are dropped and float on the back for the areas of tapestry weave. The complexity of weaving this velvet-like tunic would have made it very costly, like some others with double-sided pile. They include a tunic in New York, which is said to have come from Akhmim, that has a plain neckline and a restrained amount of decoration giving it a greater elegance than many other tunics of the period.[41]

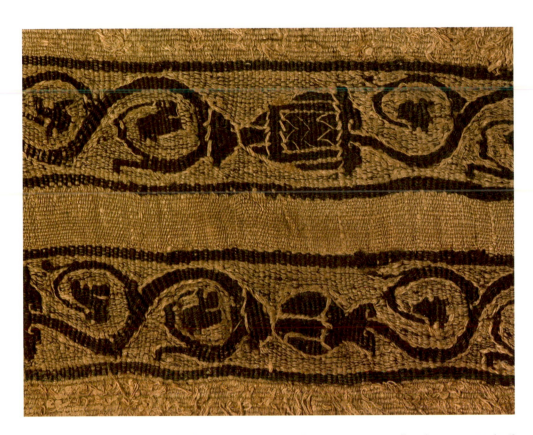

Fig 4.16(c), Detail of sleeveband and pile.

Linen tunics with pile on both sides (*amphimalla*) were not confined to one style.[42] Similarly tunics with pile on one face, which was usually the inside,[43] were made in considerable variety over a wide timespan. However, examples with false-hatching using purple wool in the tapestry decoration are unlikely to date later than the fifth century and it is into this category that the second sleeve from Manchester falls. The sleeve, 375mm wide before it was seamed, has rows of looped pile, 13mm in length, inserted every seventh row on the inside face only and the pile does not extend the full width of the sleeve, so little of the pile was wasted within the seam allowance. Male Dionysian figures separated by a hunting dog feature on the sleevebands and the false-hatched background uses double yarn, pairing one thread of linen with one of S-spun purple wool in an alternating sequence.

Semi-circular necklines are characteristic of certain linen tunics of good quality at this period, including some distinctive examples with looped pile on the inside, which recent dye analysis suggests may have come from another region in the Near East.[44] This is because one of the dyestuffs used for colouring the wool red that is used in the tapestry decoration derives from a species of *Porphyrophora*, either Armenian cochineal or Polish cochineal, and both of these insects have a restricted distribution.[45] Pastoral or hunting scenes are depicted with a variety of animals, often with speckled bodies.[46] However, some of the tunics may be local copies woven in Egypt and part of a purpose-woven curved neck panel worked in red wool, which is preserved among the textiles in Manchester, is perhaps an example. It shows a hunter in the top corner, a panther

44 R. Cortopassi and C. Verhecken-Lammens, 'Carbon-14 analysis of piled tunics from the Louvre and Katoen Natie', in C. Fluck and S. Schrenk (eds.), *Textiles and Methods of Dating* (forthcoming).

45 A. Verhecken and J. Wouters, 'The coccid insect dyes: historical, geographical and technical data', *Bulletin Institut Royal du Patrimoine Artistique* 22 (1988/89), p.222–9.

46 C. Nauerth, *Die koptischen Textilien der Sammlung Wilhelm Rautenstrauch im Stadtischen Museum Simeonstift Trier* (Trier, 1989), p.181, taf. 61; M. Durand and F. Saragoza (eds.), *Égypte, la trame de l'Histoire. Textiles pharaoniques, coptes et islamiques* (Paris, 2002) p.136, no.103.

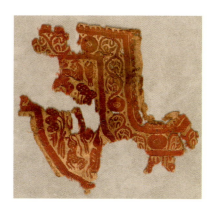

Fig 4.17, Part of a semi-circular neck panel from a linen tunic, *T.1968.147.*

Fig 4.18, Part of a short *clavus* and oval shoulder ornament from a two or three-piece tunic with waist seam, 17/18 threads per cm, *T.1994.29.*

and running cloven-hoofed beasts (Fig 4.17). While too little of the textile is preserved to be certain whether the tunic ever had pile, the shaping of the neck hints at foreign influence and illustrates the start of a new style in Egypt.

Another significant development was the production of linen tunics made in three pieces rather than from a single, uncut loompiece. Surprisingly this aspect of tunic construction has attracted scholarly attention only relatively recently, due especially to the rigorous analytical work undertaken by Daniel De Jonghe in Belgium.[47] The main T-shaped panel of the tunic continued to be woven in one piece with the sleeves but it was narrower in width. The same warp was sometimes used for the lower section, but even if it was not, the spacing and weight of the cloth had to be similar so that the seam at the waist joining the pieces of linen together was less conspicuous. Three-piece tunics of this type include examples with full-length tapestry-woven *clavi* (Fig 4.15). However, tunics with shorter *clavi*, which stopped above the line of the waist tuck, were in many respects easier to construct (Fig 4.18). Like many other linen tunics, three-piece tunics were produced in a great range of qualities and styles showing that the change in weaving practice was adopted in many workshops.

Two linen tunics in Manchester, both probably sixth century in date, offer some further insights into the making of three-piece tunics. One is the upper section of a tunic with a traditional layout of design and full-length *clavi* (Fig 4.19). The tapestry-woven neck patterning is arranged in three registers below a straight neckline, which is strengthened with a twined purple braid. Six roundels on each side of the neck opening feature in turn a hare, *cantharus* or a three-fold spray of flowers, and the position and spacing of the roundels was marked for the tapestry-weavers by a series of five short discontinuous selfbands in the linen ground. Two colours of S-spun wool are used: imitation purple and dark pink, the latter identified by dye analysis as purpurin-rich madder, which may have been obtained from the roots of wild madder.[48] This dark pink wool is used for the rather awkward leaf scroll, which is quite often seen on other tunic ornaments worked in red,[49] and for details in the roundels (Fig 4.19c).

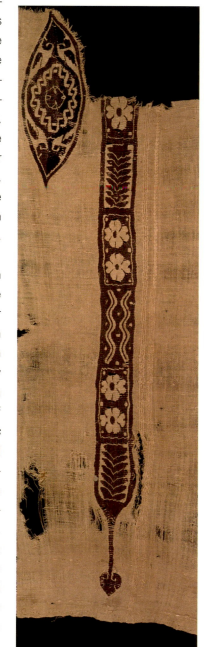

47 D. De Jonghe, 'Aspects Technologiques', in J. Lafontaine-Dosogne, *Textiles Coptes* (Brussels, 1988), pp.28–29.

48 P. Walton Rogers, 'Dyes in red/pink yarns in textiles from Egypt, c. 5th to 8th century', Textile Research Associates Report to the Whitworth Art Gallery, 19 June 2002.

49 Lorquin, op. cit. in note 36, p.33, where the evolution of the leaf scroll is illustrated.

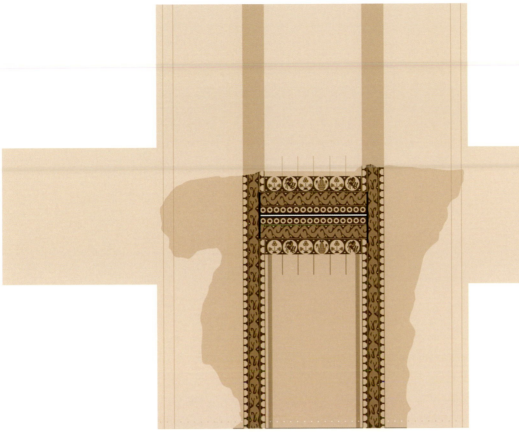

Fig 4.19(a), Diagram of upper section of a two or three-piece linen tunic with waist seam, *T.1995.151*. Height of tunic panel: 625mm.

Fig 4.19(b), Detail of neck decoration and *clavi*. The linen ground has 15/14 threads per cm.

Fig 4.19(c), Detail of hare.

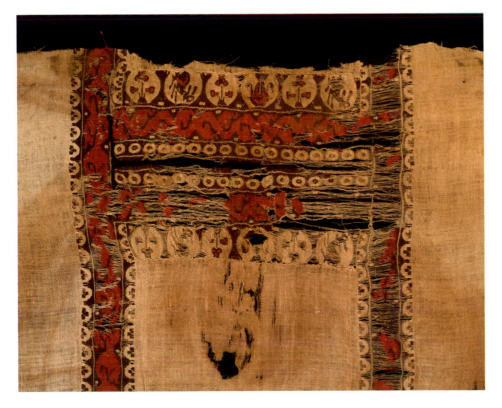

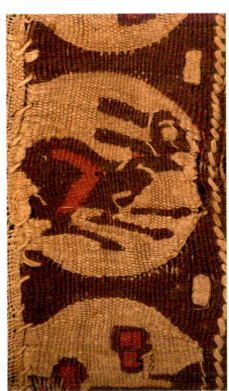

right: Fig 4.20(a), Diagram of three-piece linen tunic, *T.1994.132*. Height of tunic: 1.29m.

The second tunic is more complete, although lacking both sleeves, and the linen, which is by now a more balanced weave, is of a finer grade (Fig 4.20). It has a finished height of 1.29m and its decoration is limited to a pair of full-length *clavi*, 26mm wide, edged on each side with full-length selfbands. The neckline is finished with a tiny rolled hem worked in linen thread and strengthened in blanket stitch at either end immediately next to a narrow, discontinuous band of twining (Fig 4.20b). Below the neck are two short threads of red wool, the significance of which is uncertain. The position of the sleeves can be determined by bands of bare ends next to the side seams, which stop just below the point where the sleeves join the centre section of the tunic. The *clavi* are patterned with a series of male and female busts. However, not only do the busts differ in sequence and appearance on each side of the upper section but they also differ on the two lower panels, showing that each weaver in the workshop possessed a slightly different style and some were more artistically adept than others. Consequently the tunic panels do not form a perfect match. In addition a bluish-green wool yarn was used for the border of the *clavus* on one side of both skirt panels and for both borders of the *clavus* on the opposite side, which focuses further attention on the mismatch (Fig 4.20d). A particularly interesting style of headdress depicted on some of the busts on the lower panel of the tunic shows a woman's arched headpiece, which probably held in place a veil for the hair. Examples of these headpieces made in various ways from stuffed wool, densely packed threads of different coloured wools strung together, or bound lengths of plant fibres, were found in a number of well-furnished graves at Antinoë and were immortalised by Albert Gayet in his watercolour of Thaïs.[50] A ceramic figurine found in a girl's grave at Antinoë was also modelled wearing a similar type of headdress, which must have been a distinctive regional style.[51]

Only linen tunics have been considered so far in this section but wool tunics were produced in different workshops in equally large numbers. They often had very similar designs to those on linen tunics but the character of the fibre meant that most of the tunics were a lot bulkier and the zones of tapestry weaving were less complex to adapt on the loom as the wider spacing of warp threads meant that there was no need for any ends to be crossed and then dropped on the back of the tunic and subsequently cut away. Thus the weaving could proceed at a faster pace. Even the beating in of the weft threads on the loom was often not much greater for the areas of tapestry as the fabrics were invariably weft faced. Also, in contrast to linen tunics, the distinctive starting and finishing edges were not cut off as they provided firm edges to the wool garments. Reinforced selvedges similarly formed sturdy edges as well as helping to withstand the considerable tension placed on the web during weaving. Other weaving features are also very visible, especially the rows of discontinuous twining next to the neck opening, which were often emphasised by using wool of a contrasting colour and turning the end loops into tassels (Fig 2.3b).[52] Another difference between the wool and linen tunics was that no Z-spun wool was used, not even in the decoration, with the exception of foreign-woven garments.

50 A. Gayet, *Antinoé et les sépultures de Thaïs et Sérapion* (Paris, 1902); F. Calament, 'Une découverte récente: les costumes authentiques de Thaïs, Leukyôné & Cie', *La revue du Louvre et des Musées de France* 2 (1996), pp.28–31; Museé Dobrée, op. cit. in note 26, p.76, no. 46; Durand and Saragoza, op. cit. in note 46, p.127, no. 91.

51 F. Calament, 'Antinoë: histoire d'une collection dispersée', *Revue du Louvre* 5/6 (1989), p.339.

52 These features are very clearly described in C. Verhecken-Lammens, 'Two Coptic wool tunics in the collection of the Abegg-Stiftung: a detailed analysis of the weave techniques used', *Riggisberger Berichte* 2 (1994), pp.73–103.

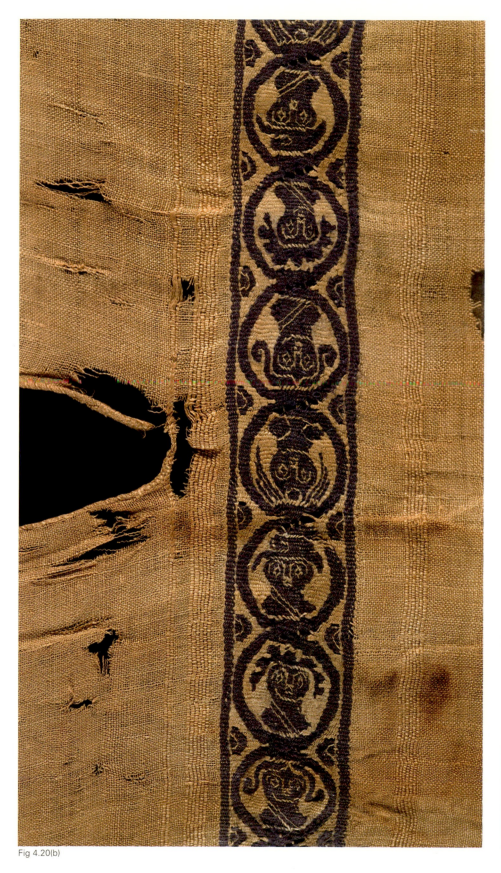

Fig 4.20(b)

Fig 4.20(c)

Fig 4.20(d)

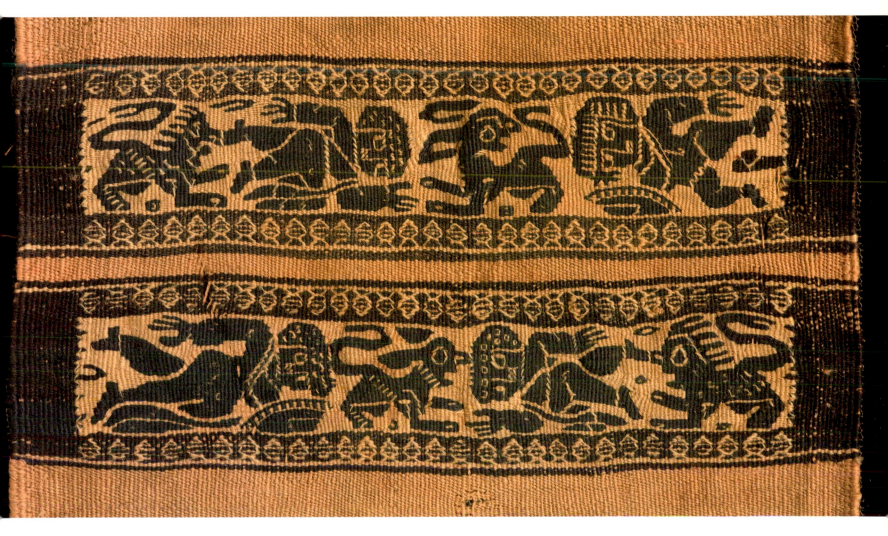

As wool was much easier to dye than linen, wool tunics were produced in many different hues and bands of contrasting colour were sometimes woven close to the sides. However, tunics of undyed wool were also widely worn with the tapestry decoration providing a focus of colour. The layout of the decoration was the same as on linen tunics and the designs were often similar too. Thus in the fifth and sixth centuries Dionysian scenes with dancing figures and wild animals were extremely popular (Fig 4.21), as well as vine scrolls, urns and an increasing quantity of Christian symbols. A neck panel from a tunic patterned in purple and dark red wool illustrates this similarity of design for it has rows of dancing maenads, alternating with scrolls of running animals and small warriors (Fig 4.22). The *clavi* feature further Dionysian bacchanalia with small amphorae positioned between each interlinked roundel. The layout of the pattern in semi-circular registers simulates the shape of a necklace and, therefore, it may be deduced that this tunic was intended for a woman.

Among the many fragments from wool tunics of this general type in Manchester are several long strips that match to form nearly full-length *clavi*. Thick fringes at their

left: Fig 4.20(b), Detail of neck opening and clavus. The linen ground has 23/20 threads per cm.

left: Fig 4.20(c), Detail of *clavus* on one side of the front upper panel.

left: Fig 4.20(d), Detail of waist seam showing mismatching *clavus* bands.

above: Fig 4.21, Sleevebands from a wool tunic, 12/34 threads per cm, *T.11140*. Width of sleeve: 198mm.

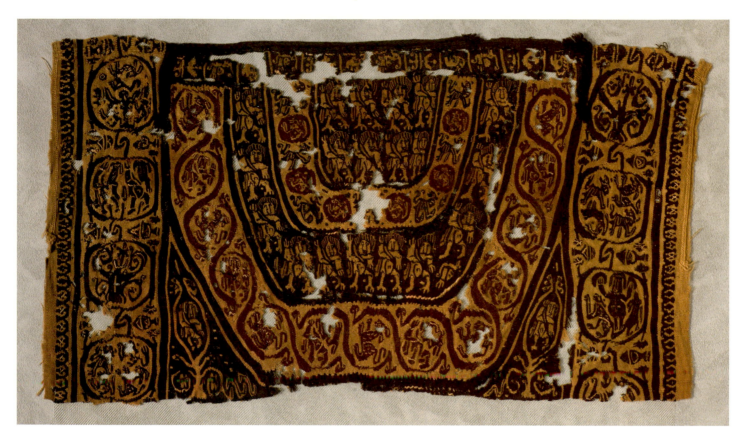

Fig 4.22, Neck panel from a wool tunic, 12/32 threads per cm, *T.1968.381*. Width of neck opening: 320mm.

Fig 4.23(a), Detail of a *clavus* and fringe at the lower edge of a wool overtunic, 8/23 threads per cm, *T.1982.178*.

Fig 4.23(b), Detail of shoulder section of *clavus*.

Fig 4.24, Part of a short *clavus* with a cross on the shoulder from wool tunic, 11/42 threads per cm, *T.1968.296*.

lower edges, which were made by adding extra threads to the selvedges, suggest that many were worn as overtunics. They are patterned with a profusion of small figures, birds, plants and animals with a contrasting border filled with geometric motifs. At each end maenads hold special musical instruments, called *crotala*, consisting of small cymbals attached to a long forked handle (Fig 4.23).[53]

A shorter *clavus*, which is probably from a tunic rather than an overtunic, is more overtly Christian in its symbolism with a cross on the shoulder, a sequence of eight crosses worked in bleached linen thread in the centre of ornate octagons and a three-leaf terminal (Fig 4.24). To weave such intricate patterns into the dense wool fabric shows considerable skill on the part of the weavers.

A shift away from Dionysian iconography towards a more clearly defined range of Christian motifs is apparent too on linen tunics. An example of such a tunic made from fine linen is decorated with very small tapestry ornaments enclosing a cross in the centre using Z-spun purple wool (Fig 4.25). Wide seam allowances are stitched at the sides and under the arms and, unusually for a tunic made from linen, instead of having short cut ends secured from unravelling by a wrapped, interlocking thread, a finishing border can be seen along the sides and at the end of the sleeve. Another feature of this tunic is a short thread of red wool below the neckline in the centre of the tunic presumably woven in by the weavers as a guide for repeating the other half.

53 Musée Dobrée, op. cit. in note 26, p.158, no. 117.

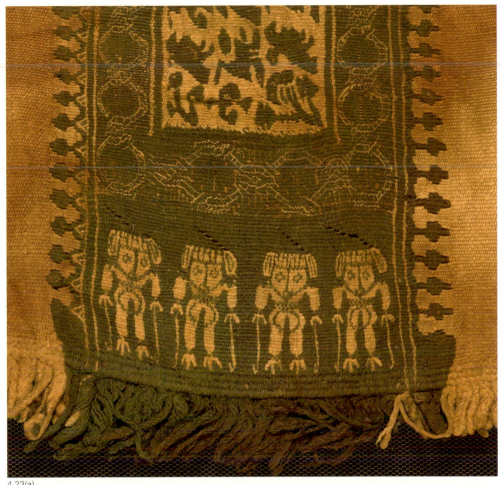

4.23(a),

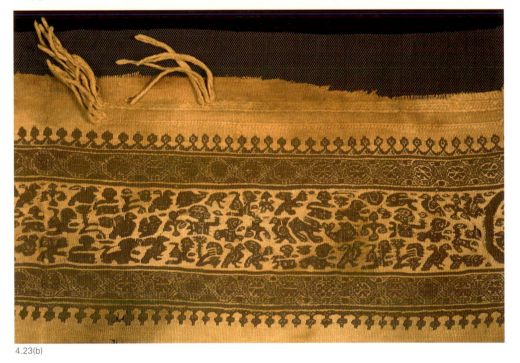

4.23(b)

4.24

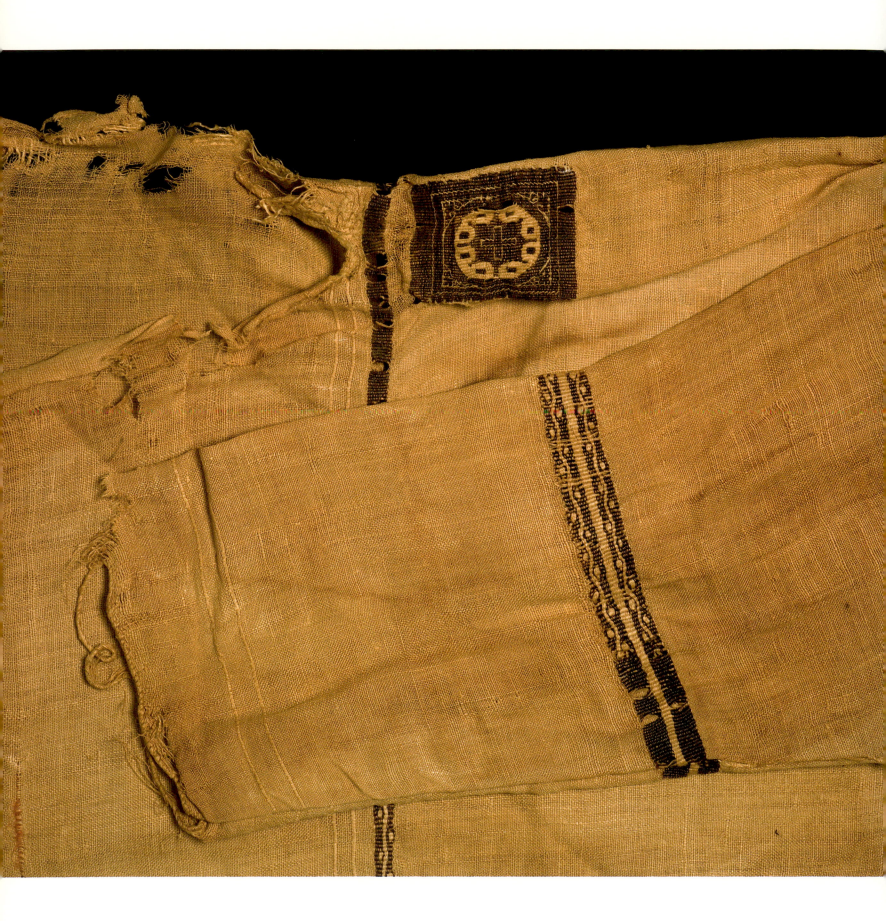

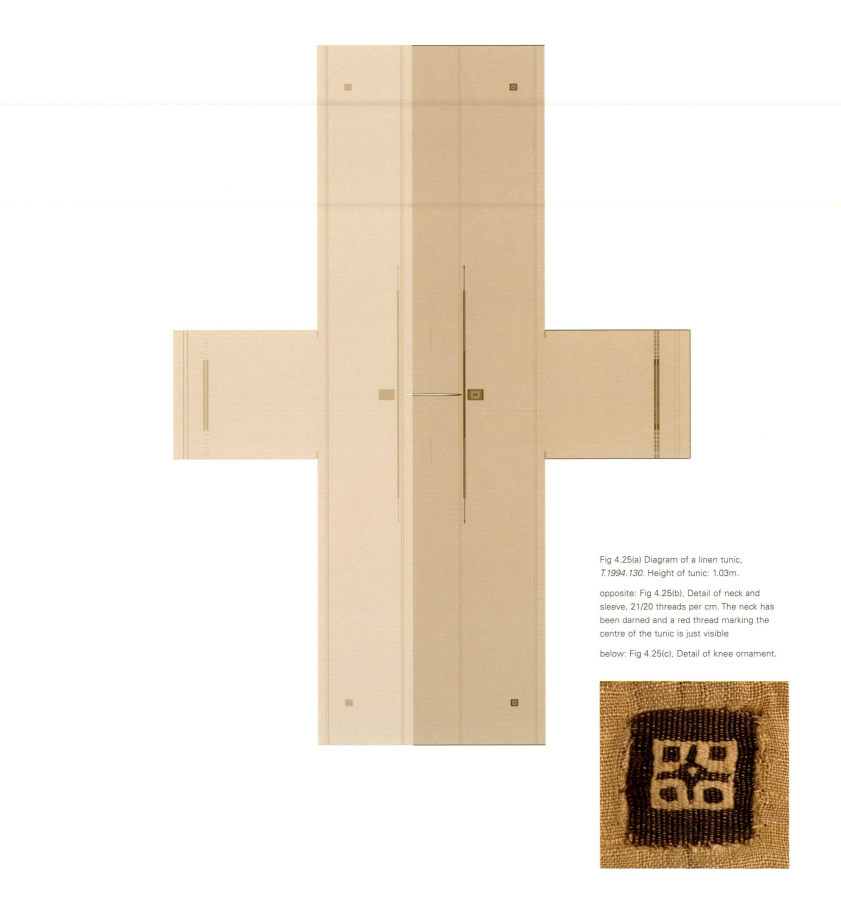

Fig 4.25(a) Diagram of a linen tunic, *T.1994.130*. Height of tunic: 1.03m.

opposite: Fig 4.25(b), Detail of neck and sleeve, 21/20 threads per cm. The neck has been darned and a red thread marking the centre of the tunic is just visible

below: Fig 4.25(c), Detail of knee ornament.

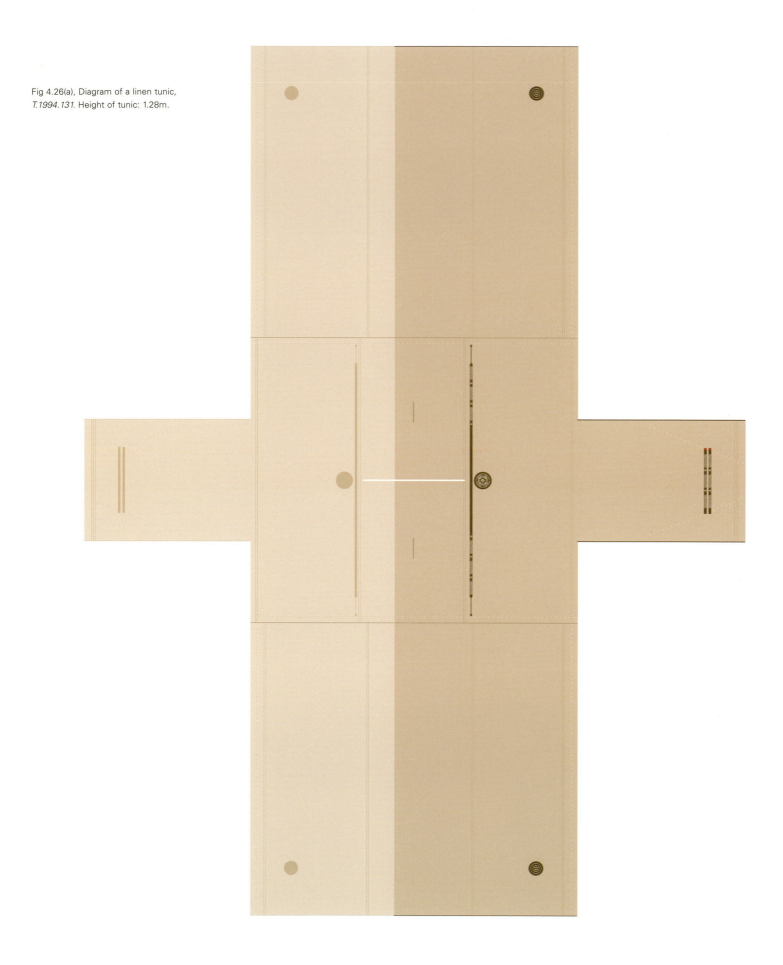

Fig 4.26(a), Diagram of a linen tunic, *T.1994.131*. Height of tunic: 1.28m.

A linen tunic of similar weight but with a waist seam also has a very small amount of intricate tapestry-woven decoration in fine linen on a background of Z-spun purple wool (Fig. 4.26). However, on this tunic the patterning is purely geometric. This tunic too has short red threads in the centre of the tunic below the neck and there are areas of darning in a thicker linen thread.

A child's linen tunic probably also dates to the late sixth century and similarly uses red threads as guidelines for some of the layout. Unusually the ground has been woven as an entirely plain tunic, although the guidelines must have assisted in aligning the sewn-on ornaments, which appear to have been cut from another tunic and recycled rather than being separately woven (Fig 4.27). In addition to twining where the sleeves join the body section and on both sides of the neck opening, short red threads have been added by the weavers next to the neck opening and at the same position on the skirt, as well as on the top of the sleeve. The waist tuck is stitched so firmly that it is impossible to be certain whether it conceals a seam but, in view of the small size of the tunic, this seems unlikely. The tapestry decoration is exclusively of small roundels enclosing four-armed crosses in alternating colours of green and red wool.

The weight of linen tunics varied considerably but those with a light, airy open texture are less often preserved, although they had a long history of use dating back to the Pharaonic period.[54] Part of a *clavus* and matching sleeveband from Akhmim are rare examples from a three-piece tunic of this type (Fig 1.7). The tapestry-woven decoration worked in red wool between selfbands of eight picks is very slight, as more would have tended to distort the cloth, and this small amount of patterning may be another reason why so few pieces are preserved. Part of a sleeve with narrow tapestry-woven bands in red wool also derives from a relatively lightweight tunic and demonstrates a return to weaving patterns on a solid coloured background (Fig 4.28).

Stylistically distinct is a *clavus* patterned with pairs of fish separated at intervals by a leaf palmette with a face peering outwards on a red ground (Fig 4.29). Five different shades of wool are Z-spun and only the dark blue is S-spun. The subtle colour scheme, in addition to the spin of the yarn, points to a centre in Syria as a more likely place of production. However, more tunics with this style of decoration need to be identified to help clarify the matter. This is particularly necessary as two strips patterned with a

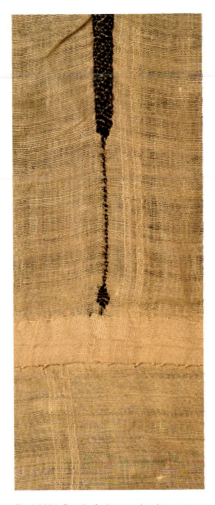

Fig 4.26(b), Detail of *clavus* and waist seam. The linen ground has 22/25 threads per cm.

Fig 4.27(a), Diagram of a child's linen tunic with applied decoration, *T.1992.5*. Height of tunic: 590mm.

54 R. Hall, *Egyptian Textiles* (Princes Risborough, 1986), p.9.

55 D. and M. King, *Textiles in the Keir Collection 400 BC to 1800 AD* (London, 1990), pp.15–16.

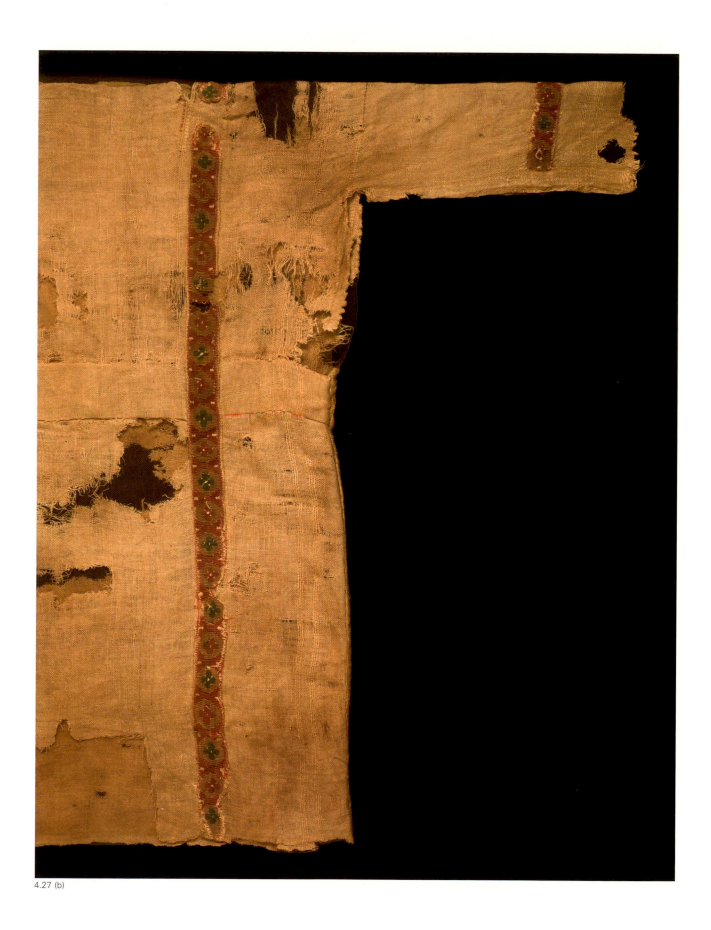

4.27 (b)

variety of ducks and fish and a similar leaf palmette also woven in five shades of wool, with only the red yarn being Z-spun, and including highlights in yellow silk, is considered to have been probably made in Egypt.[55]

Indeed, by the late sixth and seventh century there was much greater variation in the use of coloured wools on linen and separately woven applied bands start to become more prevalent as a result of influence from the dress styles of the Persians, who occupied Egypt in the early seventh century. Probably dating to this period is a sleeve from a linen tunic with pile on the inside recovered at Hawara by Petrie (see Fig 1.6). The weft-looped pile, 35mm in length, is inserted in widely-spaced rows on the inside face. It has sleevebands patterned in dark pink Z-spun wool, which analysis indicates was dyed with a type of purpurin-rich madder,[56] and stitched in blue linen thread to the lower edge of the sleeve is a narrow band of blue wool and bleached linen with a small geometric pattern. Although only part of one sleeve is preserved, this style of tunic shows signs of influence from the tailored linen shirts worn by the ruling Sassanian elite. Some of these silk trimmed shirts have pile on the inside, including examples in Toronto and New York.[57] The latter also uses blue linen thread for an inscription stitched in the bottom corner of a side gore.

The taste for more colourful tapestry-woven decoration is apparent in a wide variety of tunics that are characterised by *clavi* patterned with rows of small 'scattered' buds and which frequently have added trimmings at the neck, hem and cuffs (Figs 4.30 and 4.31). Made from wool as well as linen, linen examples survive in greater number suggesting they were more extensively produced. This style of patterning appears to have been introduced into Egypt from further east as it is associated with early seventh-century textiles from Halabiyah in Syria and 'En-Boqeq by the Dead Sea.[58] It may have arrived during the period of Persian occupation of Egypt at the beginning of the seventh century. However, many of the tunics from Egypt with this style of patterning appear to be rather later in date and the style possibly persisted for several generations. In

left: Fig 4.27 (b), Detail of linen tunic, 16/11 threads per cm, *T.1992.5*.

below: Fig 4.28, Part of sleeve from linen tunic, 18/13 threads per cm, *T.1968.75*. Width of sleeve: 295mm.

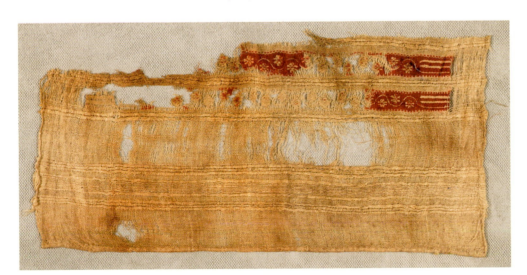

56 Walton Rogers, op. cit. in note 48. The warp ends are grouped in pairs for the area of tapestry.

57 V. Gervers, 'Medieval garments in the Mediterranean world', in N. B. Harte and K. G. Ponting (eds.), *Cloth and Clothing in Medieval Europe* (London, 1983), p.313; Metropolitan Museum of Art, New York, accession number 90.5.901. This shirt was given to the museum in 1890 and therefore, predates the excavations at Antinoë, where most of the shirts were recovered.

58 R. Pfister. *Textiles de Halabiyeh* (Paris, 1951), nos. 12–35; A. Sheffer and A. Tidhar, 'The textiles from the 'En-Boqeq excavation in Israel', *Textile History* 22/1 (1991), pp.3 and 13.

Fig 4.29, Part of a *clavus* from a linen tunic, 20/17 threads per cm, *T.11141*. All the wool yarn is Z-spun, except that dyed dark blue which is S-spun.

Fig 4.30, Part of a sleeve from a linen tunic, 26/20 threads per cm, with applied wristband, width 20mm, *T.1968.92*. Width of sleeve 300mm.

Fig 4.31, Lower edge of a wool tunic, 15/15 threads per cm, with applied tapestry-woven hemband, width 35mm, *T.1968.159*.

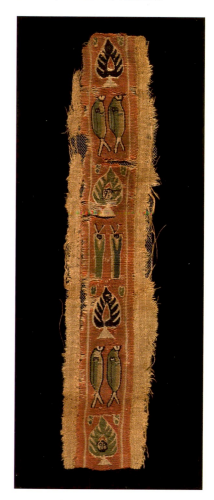

some tunics too the patterning takes on a new orientation and is restricted to a band at the hem, showing a new approach to the layout of decoration for these tunics are made from a narrow width of cloth folded double. A key example in this respect is a sleeveless linen burial tunic, or shirt, worn by Thaïs at Antinoë, although this grave itself remains difficult to date due to the variety of textiles it contained (see p.104).[59]

Fragments of tunics patterned with rows of 'scattered buds' include examples from Petrie's excavations at Hawara and el-Lahun.[60] Some made from wool are woven in a more balanced weave than had previously been usual for wool tunics and areas of darning show that they were worn over a long period of time. Among complete examples in other collections, a linen tunic in a private collection in Belgium has been carbon-14 dated from the second half of the eighth century to late tenth century indicating that it would not have been worn before the Islamic period.[61]

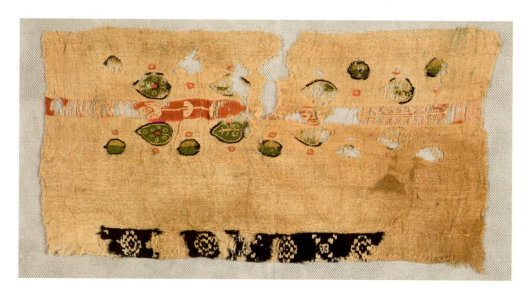

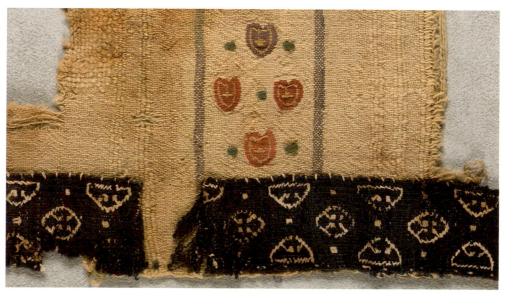

59 Calament, op. cit. in note 50, pp.30–31, figs. 11 and 12; D. Bénazeth, 'Les tissus 'sassanides' d'Antinoé au musée du Louvre', in C. Fluck and G. Vogelsang-Eastwood, *Riding Costume in Egypt, Origin and Appearance* (Leiden, 2004), p.122.

60 There are examples with a Lahun provenance among the textiles acquired from Petrie at Bolton Museum and Art Gallery and the Petrie Museum, University College London.

61 De Moor, op. cit. in note 32, pp.217–8.

The Arab Period

Just as there was no break in weaving traditions with the transfer to Roman rule so there was no sudden change with the arrival of the Arabs in Egypt in AD 641. Nevertheless, there was a gradual decline in the production of woven-to-shape tunics with integral tapestry-woven ornaments. Wool tunics were increasingly patterned all over with stripes of various colours and check-patterned fabrics also began to be used again for clothing after a long period of being out of favour. Many tapestry-woven ornaments were woven separately from the actual tunic and applied afterwards on to the ground fabric whether it was wool or linen. Tailored tunics made from narrow cloth became more prevalent and they too usually had woven bands applied at the neck and sleeve openings, which were generally similar to those stitched to tunics woven-to-shape. As time passed the use of trimmings diminished and stitched decoration became more common leading eventually to a greater use of embroidery on clothing.[62]

Many of the best-preserved tunics in Manchester from this later period appear to have come from the cemetery at el-Lahun in the Fayum and most are woven from wool. They form a good comparative group to some tunics recovered by Petrie's German rival, Georg Schweinfurth, in 1886 from the nearby sites of Crocodilopolis and Heracleopolis Magna, which are preserved in Berlin.[63] Similarities between the garments suggest that a regional style may have developed in this part of Egypt when it was under Arab rule and it is known from written sources that specialist weaving workshops in the Fayum were highly regarded.[64]

A number of distinctive woven-to-shape wool tunics may be considered representative of this localised production. The earliest is probably an orange overtunic intended for a woman as it is patterned with a large, tapestry-woven neck panel, which simulates the outline of a jewelled necklace (Fig 4.32). Constructional details of the weaving, including areas of twining at the arm angles and next to the neck opening, have, in part, been emphasised by the use of different coloured wools: red (which is the colour of the warp) for the twining at the underarm angles and next to the *clavi*, and turquoise blue beside the neck opening. The sewing of the garment also employs two colours of wool thread, white wool for the deep waist tuck and the sideseams that are stitched through the white bands, and blue for the arm seams and for additional oversewing along the sides (Fig 4.32d). This use of sewing thread in a contrasting colour marks a trend towards more decorative stitching, which was used on adults', as well as children's, clothing.

A green wool tunic (carbon-14 dated to AD 650–770) continues the tradition of having full-length *clavi* woven into the tunic and matching sleevebands, which are worked in white linen thread on a purple background, but there are no longer any shoulder or knee ornaments (Fig 1.5). Instead purpose-made bands with geometric patterning have been applied at the hem and the neck (although the latter are now missing) and

62 J. Scarce, *Women's Costume of the Near and Middle East* (London, 1987), pp.118–20; J. Lafontaine-Dosogne op. cit. in note 47, p.12, fig. 27.

63 C. Fluck and P. Linscheid, *Textilien aus Ägypten, Teil 2: Textilien aus Krokodilopolis und Herakleopolis Magna* (Weisbaden, forthcoming): P. Linscheid, 'Late Antique to Early Islamic Textiles from Egypt', *Textile History* 32/1 (2001), p.75.

64 R. B. Sarjeant, *Islamic Textiles. Material for a History up to the Mongol Conquest* (Beirut, 1972), pp.154–5.

Fig 4.32(b), Diagram of overtunic.

Fig 4.32(a), Wool overtunic, 8/44 threads per cm, *T.8358*. Height of tunic: 1.84m.

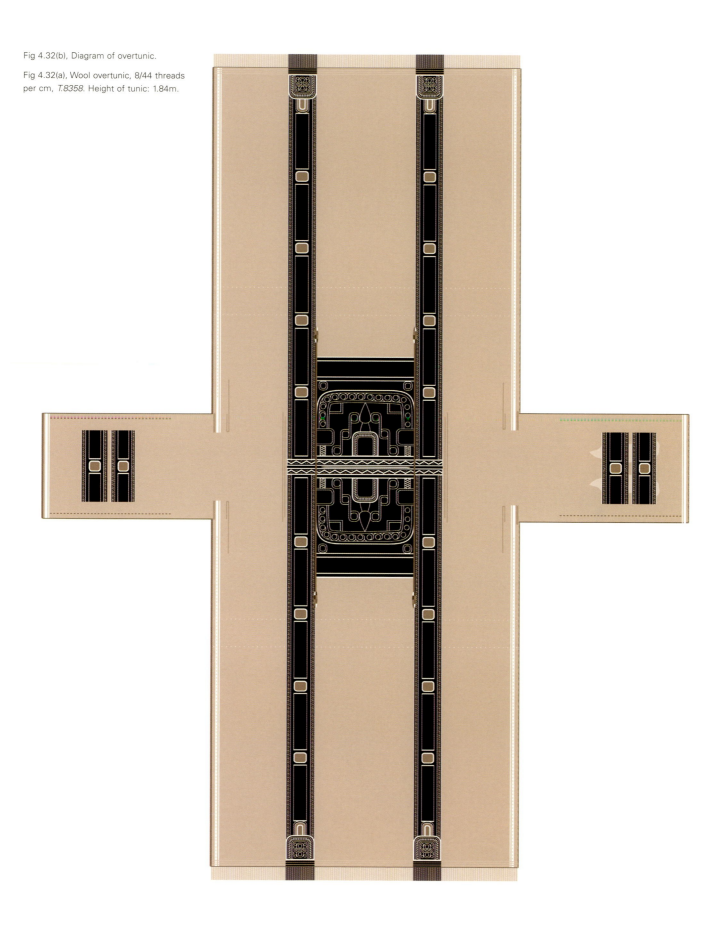

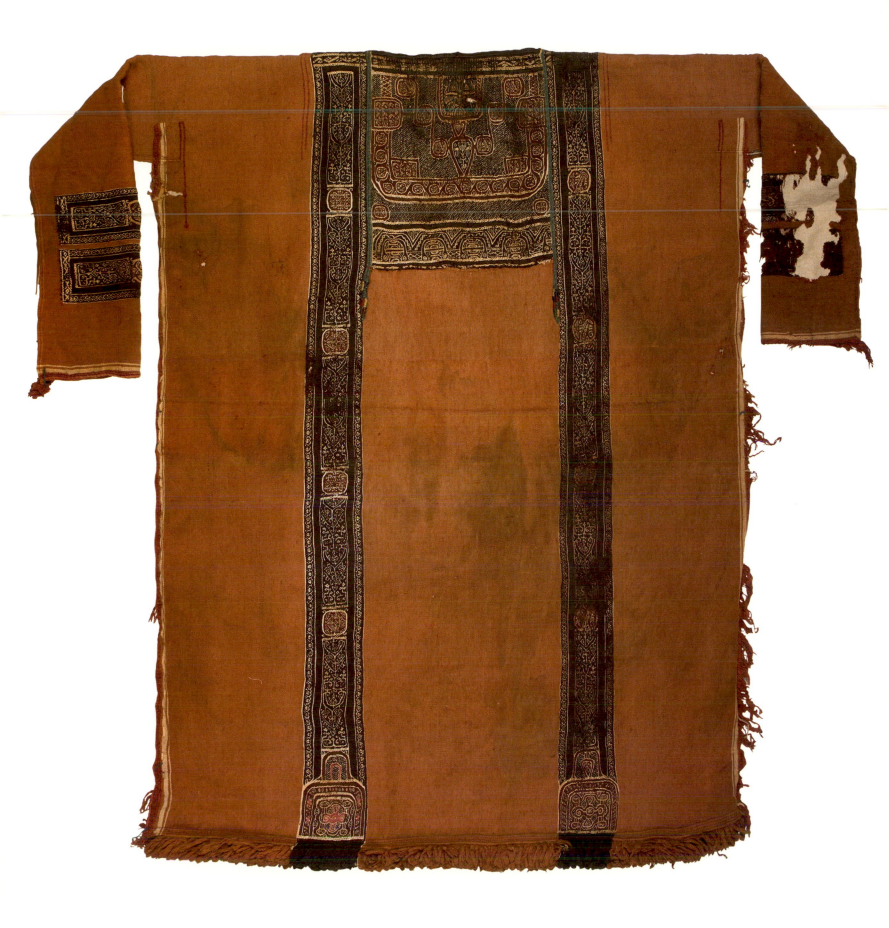

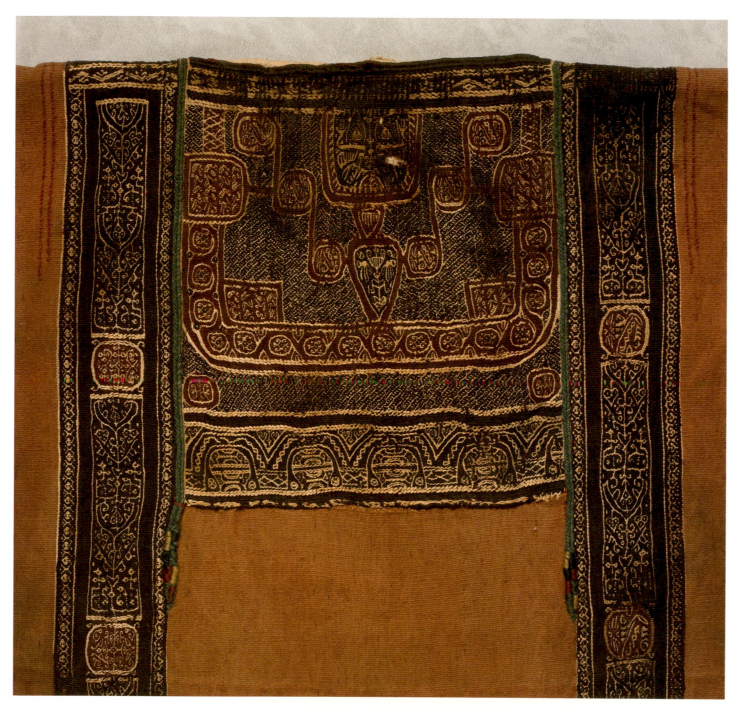

Fig 4.32(c), Detail of neck panel, height: 325mm.

it is probable that the tunic was woven without any neck opening as the neckline has been deliberately cut and shaped. Therefore, there are no longer any rows of internal twining ending in tassels next to the neckline and instead strengthening in the form of blanket stitching has been added after weaving on each side of the neck opening. However, the internal twining where the sleeves meet the full width of the cloth has been emphasised by the use of contrasting purple wool, which matches the colour of the *clavi*. The dimensions of this tunic are 1.945 x 2.56 metres. It was, therefore, a very heavy garment especially as the density of the weave meant that it used a considerable quantity of wool.

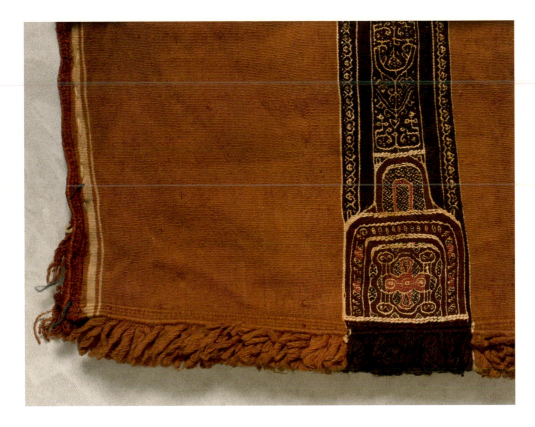

Fig 4.32(d), Detail of sideseam with stitching in blue and white wool thread and lower edge with reinforced selvedge and fringe.

An almost identical green wool tunic from Lahun is in the collection of the Victoria and Albert Museum.[65] The main difference is that, as the tunic in London is smaller in size (the loomwidth is 2.37 metres), the *clavi* and sleevebands are slightly narrower, with fewer rows of decoration, and the applied bands remain in place at the neck and wrists. However, as no waist tuck was added, the finished garment was longer than the tunic in Manchester and it is considered to have been made for a woman.[66]

A dark blue wool tunic of similar style has broad white bands between the *clavi* and sideseams accentuating the width of the centre section of the tunic (930mm wide on this tunic) (Fig 4.33). Therefore, when worn it would have probably draped over the shoulders in folds. Polychrome, tapestry-woven bands have been applied at the neck and wrists and, in order to fit the shape of the neckline, the neckband was stitched with a series of tucks. A cheaper red and white patterned band has been stitched to the lower edge of the tunic with an extra strip at each side, which is typical of this group of adults' tunics. The *clavi* and sleevebands, which are 185mm wide, are patterned in linen thread with stylised plant forms bordered on each side with a row of small chevrons incorporating trefoil terminals. This style of patterning is similar to that on the *clavi* and sleevebands of the orange tunic described above and a child's tunic of blue wool with white stripes in a private collection.[67]

It is instructive to compare this dark blue wool tunic with fragments from a tunic with more skilful and sophisticated patterning, as it offers an insight into how styles were

65 A. F. Kendrick, *Catalogue of Textiles from Burying-Grounds in Egypt, Vol. II* (London, 1921), p.23, no. 337.

66 King, op. cit. in note 27, p.11.

67 H. Granger-Taylor, 'The construction of tunics', in C. Rogers (ed.), *Early Islamic Textiles* (Brighton, 1983), p.11.

Fig 4.33, Wool tunic, 10/41 threads per cm,
with matching tapestry-woven bands applied
at the neck and wrists and a contrasting
hemband, *T.8360*. Height of tunic: 950mm.

imitated. The largest fragment shows part of a wide *clavus* patterned with pairs of snakes, millipedes, birds, and buds worked in white linen on a coloured ground bordered by an angular scroll with stylised animal heads woven with touches of red and green wool (Fig 4.34). A tapestry-woven 'hemband' of contrasting colour, 120mm wide, is woven into the tunic on the same warp using dovetailing to separate the purple and dark pink weft yarns. Just like the applied hembands, this integral band extends a short distance up the side of the tunic. The pattern on the 'hemband' with a row of lozenges enclosing a horse, a roundel and an eight-pointed star is itself a copy of a woven silk. Dye analysis revealed that Armenian cochineal (*Porphyrophora hamelii* Brandt) was used for the dark pink ground of the hemband.[68] This dye is obtained from the adult females of an insect species that lives mostly on two plants, *Aeluropus littoralis* (= *A. laevis*) and *Phragmites communis*, that grow in the valleys in the inland region around Mount Ararat.[69] The dyestuff has been identified only on a few textiles found in Egypt, although they include a red and white silk trimming patterned with a lattice framework enclosing palmettes, which is therefore somewhat similar in design to the 'hemband'.[70] However, the dye has also been detected on a number of textiles of earlier date at Palmyra in Syria, which lay much closer to its centre of production in Armenia.[71] Consequently, although the dyestuff could have been traded, its rarity among textiles in Egypt combined with the unusual design of the tunic suggests the garment had an origin elsewhere in the Near East.

Fig 4.34, Part of blue wool tunic, 11/56 threads per cm, with integral tapestry-woven hemband, *T.8461*. Width of *clavus*: 166mm.

Two pieces of another wool tunic in the collection have similar speckled insects, birds and serpents woven in linen thread into the wide *clavi* (220mm) and deep neck panel.[72] However, the dark blue ground colour of the tunic is unexceptional and the lower edge is no longer preserved so that no hemband remains for comparison. Darning in purple wool yarn on the tapestry-woven decoration indicates, however, that, like many wool tunics from the period following the Arab conquest of Egypt, the garment was not immediately discarded once it showed signs of wear.

Another adult-size, woven-to-shape wool tunic with a cut, rounded neckline and applied bands at the neck, hem and wrists has different type of *clavi*. They are very narrow, plain white *clavi*, which finish just above the waist tuck and which are spaced close together (Fig 4.35, see p.44 & overleaf). An additional detail not observed on earlier tunics, and possibly restricted to a few workshops, is the presence of plain tapes applied as facings to the underarm openings. They are held in place with running stitches and the sideseams are tightly bound at the point where the opening ends and the seam begins, showing that many practical considerations went into the details of the garment construction. This amount of reinforcement may have been needed as the wearer's arms were perhaps inserted through the underarm openings rather than the actual sleeves.

68 Walton Rogers, op. cit. in note 48.

69 Verhecken and Wouters, op. cit in note 45, p.227.

70 Schrenk, op. cit. in note 10, pp.205–6, no. 71, and table 2, no. 24, p.480.

71 A. Stauffer, 'The textiles from Palmyra: technical analyses and their evidence for archaeological research', in Cardon and Feugère, op. cit. in note 3, p.251.

72 Accession number *T.1994.113*. 1 and 2. A fragment of a further wool tunic of this type is preserved in the Benaki Museum, Athens, accession number 6906. I am grateful to Roberta Cortopassi for this information.

Fig 4.36(b), Diagram of tunic, *T.8361*.

Fig 4.36(c), Detail of underarm seam with facing.

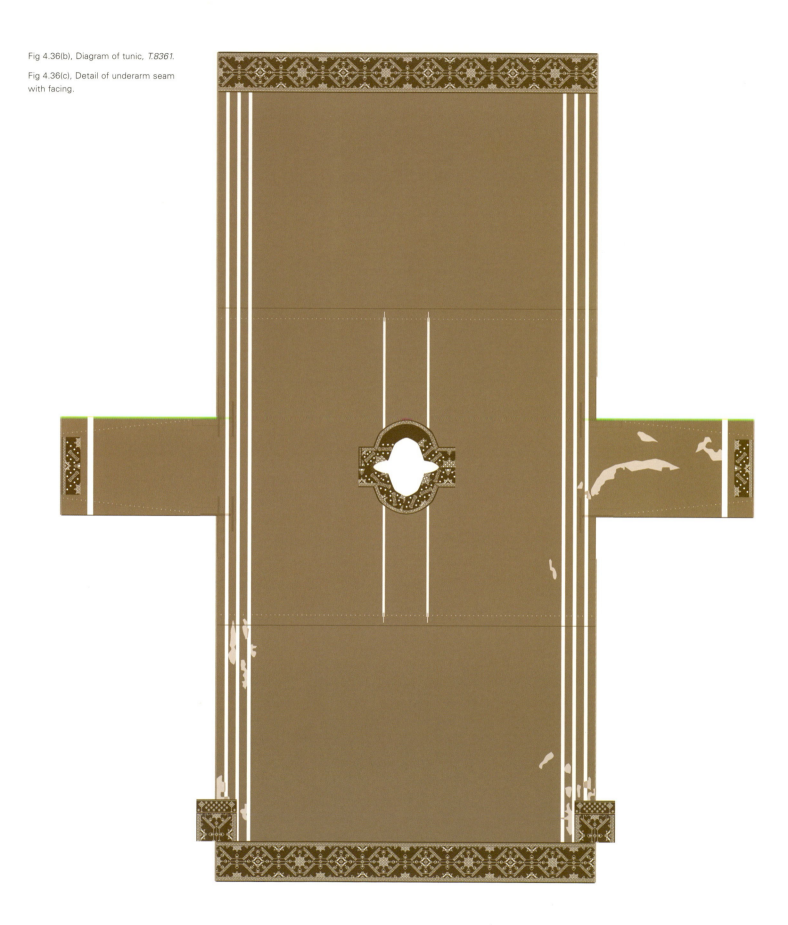

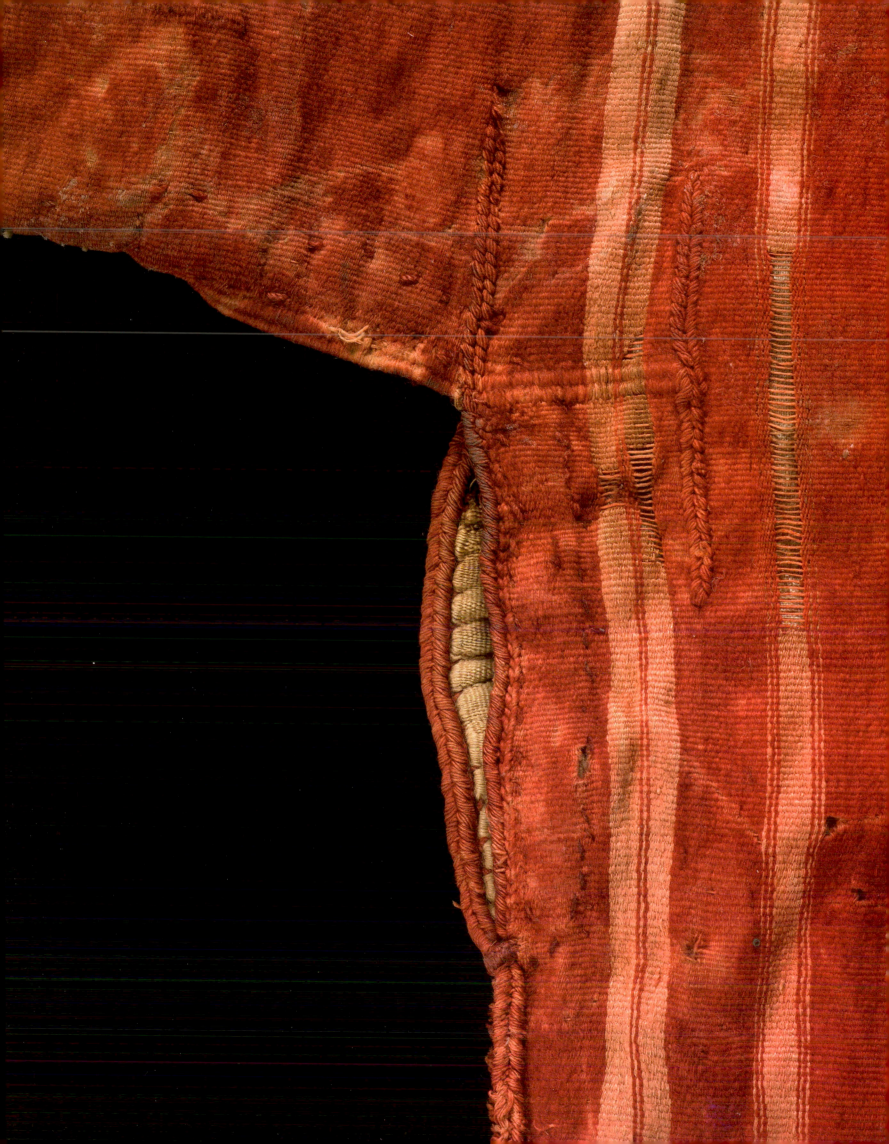

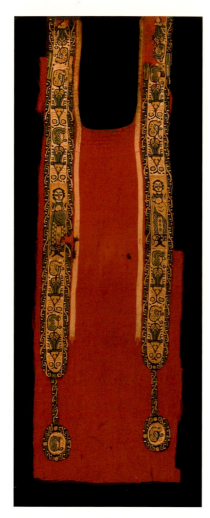

Fig 4.36(a), Part of a red wool tunic, 13/36 threads per cm, with sewn-on tapestry-woven *clavi* stitched next to narrow white *clavi*, T.15073. Width of neck opening: 95mm.

Fig 4.36(b), Detail of linen neck facing.

73 J. D. Cooney, *Late Egyptian and Coptic Art. An Introduction to the Collections in the Brooklyn Museum* (Brooklyn, 1943), pl. 53; Schrenk op. cit. in note 10, pp.236–8, no. 88. There is also a loose *clavus* with a similar design layout in the Whitworth Art Gallery T.11981.

74 A. F. Kendrick, *Catalogue of Textiles from Burying-Grounds in Egypt, Vol. III* (London, 1922), p.7, no. 620; King, op. cit. in note 27, pp.11–15.

Often wool tunics with plain, vestigial *clavi* have more ornate ornaments applied alongside them. Part of a red tunic of this type in Manchester has applied tapestry-woven *clavi*, which are shaped to terminate in small roundels. The *clavi* are patterned with a single pair of haloed figures with their hands held aloft in prayer and a sequence of stylised vases above and below using five colours of wool yarn, as well as bleached linen (Fig 4.36a). Similar sewn-on *clavi* patterned with a haloed figure on each shoulder occur, for example, on a green wool tunic in Brooklyn and as loose fragments at the Abegg-Stiftung, Riggisberg.[73] However both examples show animals, as well as plant ornament, on each side of the saint, plant scroll borders and also technical differences in the use of weft wrapping, which reveal the Manchester *clavi* to be the product of a less accomplished workshop.

When no bands were applied at the neck, as on this red wool tunic fragment, facings of either undyed wool or linen were sewn to the cut openings to prevent the raw edges from fraying at the neck. On this particular tunic, a margin of 10mm of cloth has been folded inwards and a linen facing, 40–44mm wide, held in place with hem stitches along each edge and seven rows of running stitch, worked in three-ply wool thread (Fig 4.36b). The facing itself is made from a minimum of three strips of linen seamed together on the bias so that it could curve to fit the neckline. The *clavi* too have been carefully stitched in position using linen thread, with a row of running stitches down the centre worked so that they are barely visible on the front and hem stitches along the edges. This shows a considerable change of approach to the traditional method of weaving tunics to shape and reveals the increasing amount of sewing that went into the finishing of many tunics by the end of the seventh century.

There are many wool tunics, and fragments of tunics, preserved of this general type with plain narrow clavi, scooped narrow necklines and sewn-on ornaments. A particularly interesting example in the Victoria and Albert Museum highlights the diverse cultural and religious mix of the people who wore these clothes. The red wool tunic features a set of ostentatious applied ornaments with figurative decoration in eight or nine colours and, remarkably, woven into the shoulder bands in Arabic script is the name of God, *Allah*.[74]

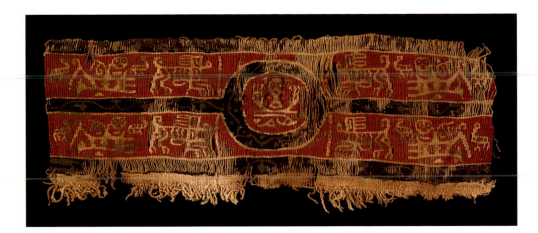

Fig 4.37, Tapestry-woven sleeveband (width 235mm) patterned with the head of *Ge*, the personification of earth in the central roundel, T.8403.

Wide woven-to-shape tunics with applied ornaments were made in linen as well as wool at this period but they lack even the short narrow *clavi*, which continued to be woven into some wool tunics. Such *clavi* were anyway no longer essential and they became less common too on wool, as more emphasis was placed on the elaborate sewn-on ornaments, which were made in specialist workshops.

These separately woven tapestry-woven ornaments became extremely common at some point after the Arab conquest, to judge by the numbers of them preserved, and they would have formed a very visible aspect of dress. In this respect, the wearer continued to flaunt his or her personal taste. Usually characterised by a warp of plied linen yarn and edges of stout, plain linen for folding under before applying to the ground fabric, the dress ornaments are often very colourful and include detailed figurative scenes with borders patterned with floral scrolls and imitation gemstones. An example in the collection of the Abegg-Stiftung, Riggisberg, which shows a fishing scene, has been carbon-14 dated to AD 605 to 717,[75] but others appear to date no earlier than the late eighth and ninth centuries and thus a long workshop tradition must have been established for their production.

The ornaments belong to various iconographic groups, although they are often edged with very similar border patterns. The groups include biblical scenes, such as episodes from the story of the patriarch Joseph referred to above (see Figs 2.7 & 3.8), which are considered to mark the first application of Old Testament iconography to items of dress in Egypt.[76] Carbon-14 dating indicates that this group of ornaments is unlikely to date earlier than the late eighth century.[77] The Sacrifice of Isaac was another Old Testament subject chosen for tapestry-woven dress ornaments, while the Adoration of the Three Magi and the Flight of Mary, Joseph and the baby Christ to Egypt were selected from the New Testament.[78] Many religious scenes are difficult to identify and may represent apochryphal stories of local significance. Other ornaments show a preference for the earth goddess, *Ge*, who symbolised fertility and was often surrounded by creatures from the land and the sea (Fig 4.37).[79] Patterns, both figurative and geometric, copied from silk textiles were also very popular (Fig. 4.38 and Figs

75 Schrenk, op. cit. in note 10, p.338, no. 155.

76 Granger-Taylor, op. cit. in note 32, p.18.

77 Schrenk, op. cit. in note 10, p.335, no. 154.

78 M-H. Rutschowskaya, *Coptic Fabrics* (Paris, 1990), pp.118–34; L. de Chaves, '"La fuite en Egypte et le retour des mages" medallion copte de la collection du Musée Benaki', *Bulletin de la Société d'Archeologie Copte* 23 (1994), pp.57–62.

79 Abdel-Malek, op. cit. in note 15, p.88.

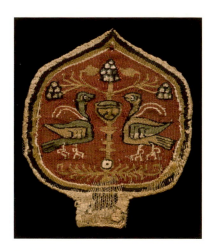

Fig 4.38, Tapestry-woven ornament,
T.1968.249. Height: 118mm.

below: Fig 4.39, Part of a tapestry-woven
hemband, *T.8566*. Height of band: 250mm.

80 For example see Kendrick, op. cit. in note
 74, pls. 3–6.

81 A similar hemband still stitched to a linen
 tunic is preserved in the Abegg-Stiftung,
 Riggisberg: Schrenk, op. cit. in note 10,
 pp.169–73, no. 155.

2.8, 2.9 & 3.12). Indeed, initially some of these tapestry ornaments may have used samples of the actual silks for models rather than relying on a cartoon.

Although frequently made in sets, not all tunics have matching ornaments. Contrasting *clavi* and hembands are fairly common, whereas tunics with large shoulder and knee medallions usually have matching *clavi* and sleevebands.[80] Tapestry-woven hembands were often at least twice the width of weft-patterned bands, such as those stitched to many of the tunics from the Fayum, and, thus, these wider bands would have formed a very prominent feature of the tunics (Fig. 4.39).[81] Indeed, sometimes the underlying fabric of the sleeves was almost concealed by the applied ornaments for often two bands were applied to each sleeve, one at the wrist and another higher up the arm.[82]

Tunic ornaments were also woven from silk showing the increasing availability of this costly material (see Fig 3.11).[83] Woven in weft-faced compound twill with a single main warp, many of these silks were produced in only two colours with the pattern in white on a coloured ground of red or purple, or less frequently, yellow, blue or black. A silk *clavus* strip of this type has been carbon-14 dated to AD 679–884[84] but like the tapestry-woven ornaments they appear to have been in production for several generations.[85] The tunics to which they were stitched tended to be linen although more colourful, figurative silk ornaments were sometimes applied to silk garments.[86]

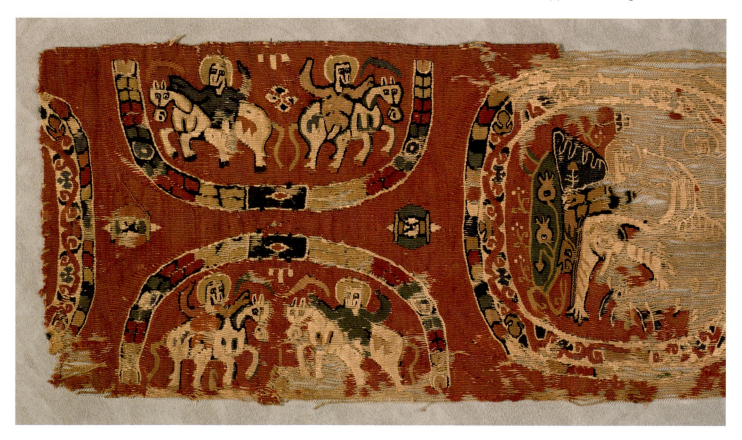

Previously precious pieces of silk had generally been cut into strips for recycling as trimmings on a limited range of special garments, which were as likely to be made from a fine wool cloth as linen. They included the long-sleeved riding coats, leggings and tailored tunics of the elite Sassanian officer class, who governed Egypt in the early seventh century, which were discovered at Antinoë.[87] Some fine quality polychrome silk bands woven in weft-faced compound twill were used in a similar way as garment trimmings and perhaps also as headbands and belts.[88] In Manchester there are fragments of one of these silk borders stitched to part of a wool garment woven from Z-spun yarn that was recovered from a burial at Qau el-Kebir (Fig 1.8).[89] Patterned with opposing triangles enclosing plant and geometric motifs using wefts of four colours, the long sides have cut edges, which have been folded back to form a trimming 23mm wide. It has been suggested that a number of bands were woven on the same warp, which was why the warp ends were cut.[90]

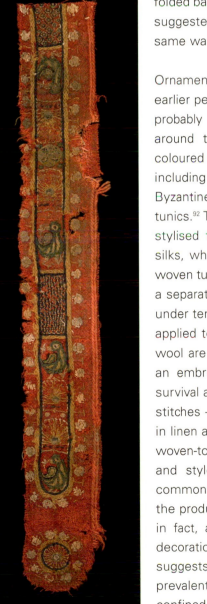

Ornaments were also embroidered on to tunics. In earlier periods they were extremely rare and most were probably worked abroad, perhaps in Syria.[91] However, around the eighth century embroideries worked in coloured silks with scenes from the New Testament, including the Annunciation and the Nativity, based on Byzantine prototypes, were being applied to some tunics.[92] The embroideries were edged with borders of stylised flowers and buds similar to those on woven silks, which were copied also by weavers of tapestry-woven tunic ornaments. The stitching was worked on to a separate piece of linen, which may have been placed under tension by means of a small frame, before being applied to a linen tunic.[93] Examples of embroideries in wool are preserved much less often. However, part of an embroidered *clavus* in Manchester is a fortunate survival and shows a high level of skill with a variety of stitches – chain, stem, running and couching – worked in linen and four colours of wool thread directly on to a woven-to-shape, red wool tunic (Fig 4.40). The technique and style of this wool embroidery has nothing in common with the figurative silk embroideries and was the product of entirely different workshop practices. It, in fact, appears to look forward to the embroidered decoration associated with later Islamic dress[94] and suggests that embroidery skills were becoming more prevalent in Egypt under Abbasid rule and were not confined only to *tiraz* pieces produced for the court.

Fig 4.40(a), Part of an embroidered *clavus* (width 43mm) from a red wool tunic, 14/13 threads per cm, *T.1968.283.* (see detail on page 153).

82 Kendrick, op. cit. in note 74, pls. 3–4.

83 M. Martiniani–Reber, *Lyon, musée historique des tissus. Soieries sassanides, coptes et Byzantines Ve-XIe siècles* (Paris, 1986), pp.80–97; Kendrick, op. cit. in note 74, pp.73–83.

84 Schrenk, op. cit. in note 10, pp.273–5, no. 114.

85 A. Stauffer, 'Une soierie "aux amazones" au Musée Gustav Lübcke a Hamm', *Bulletin du CIETA* 70 (1992), pp.45–9.

86 Kendrick, op.cit. in note 74, p.74.

87 Martiniani-Reber, op. cit. in note 83, pp.36–60; M. Martiniani-Reber, *Textiles et mode sassanides. Les tissus orientaux conservés au départment des Antiquités égyptiennes* (Paris, 1997), pp.41–118.

88 Schrenk, op. cit. in note 10, pp.421–5, nos. 204–206.

89 The silk border was recorded as being the 'rarest textile found' on the site, G. Brunton, *Qau and Bandari, Vol. III* (London, 1930), p.26.

90 Schrenk, op. cit. in note 10, p.472.

91 King, op. cit. in note 27, p.4; Musée Dobrée, op. cit. in note 26, p.51, no. 24.

92 Rutschowskaya, op. cit. in note 78, pp.128–9; Musée Dobrée, op. cit. in note 26, p.137, no. 101.

93 Kendrick, op. cit. in note 74, p.56. No constructional details of the linen tunics to which the silk embroideries were applied appear to have been recorded.

94 See, for example, M. Ellis, *Embroideries and Samplers from Islamic Egypt* (Oxford, 2001), pp.20–21, nos. 8 and 9.

Fig 4.41, Part of a sleeve (width 452mm) from a woven-to-shape wool tunic, 8/29 threads per cm, *T.8426*. The wool warp is dyed red with madder and the pink weft with lac.

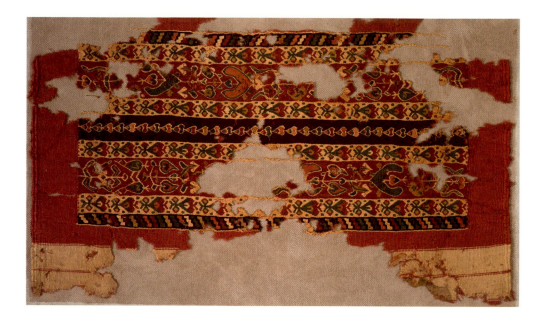

Some woven-to-shape tunics continued to have ornate tapestry decoration woven into the cloth as it was made. They sometimes had very colourful patterns with multiple borders closely comparable to those woven on applied ornaments. Part of a sleeve from a dark pink wool tunic shows a band of such patterning worked in seven shades of wool, in addition to bleached linen (Fig 4.41). The dark pink hue of the ground of this tunic was obtained by dyeing the pink weft with lac, probably *Kerria lacca* (L.) Kerr, an expensive imported dyestuff derived from a scale insect found in the Indian sub-continent, while the concealed wool warp was dyed red with cheaper, locally grown, dyers' madder, *Rubia tinctorum* L.[95]

The upper panel of a linen three-piece tunic similarly shows the extent that some weavers went into copying complex patterns (Fig 4.42). The neck panel, *clavi* and shoulder *tabulae* feature roundels and a lozenge enclosing a small bird derived from Central Asian woven silks of the seventh to ninth centuries.[96] A second register on each side of the neck has a repeating sequence of figures including a man on an equine animal, which may possibly represent Christ riding in triumph on a donkey into Jerusalem,[97] and the ornaments are edged with imitation gems. The sleevebands have a row of 'scattered' bud patterning and at the wrists a contrasting pattern of chevrons imitates an applied band. The sleeve ends were folded back and hemmed in linen thread, whereas two-ply thread of orange wool has been used to stitch the underarm seams instead of the usual linen thread. It is possible that the wool sewing thread was a later addition as areas of patterning on the shoulders were mended and darned in a similar reddish-orange thread. In addition, blanket stitches in three-ply thread of red wool were used to hold together the long slits between the areas of tapestry and ground weave on the neck and shoulders. This tunic still marked out the position of the sleeves in the traditional way using short red threads as guidelines and, thus, it shows the use of old techniques combined with more recent iconography.

95 Walton Rogers, op. cit. in note 48.

96 D. G. Shepherd, 'Zandaniji revisited', in M. Flury-Lemberg and K. Stolleis (eds.), *Documenta Textilia: Festschrift für Sigrid Muller-Christensen* (Munich, 1981), pp.119–21.

97 I owe this suggestion to Christina Unwin.

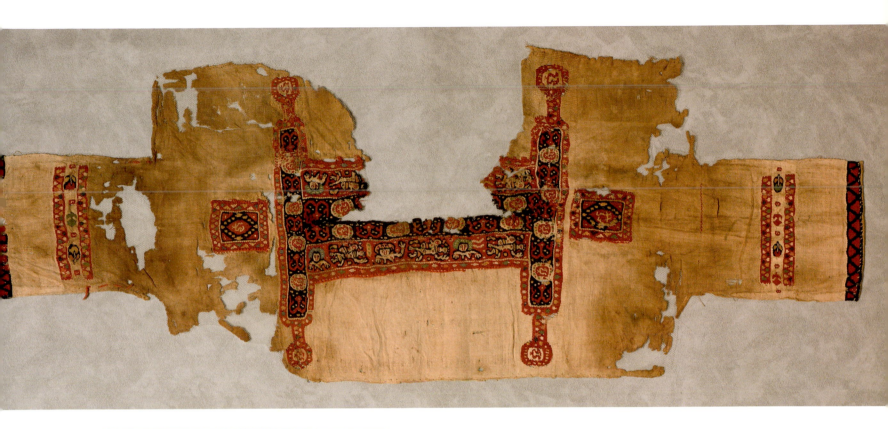

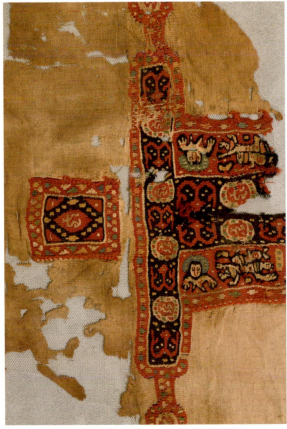

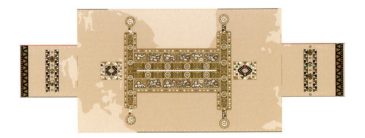

Fig 4.42(a), Upper section of a three-piece linen tunic, 14/20 threads per cm, *T. 8569*. Finished height of tunic panel: 180mm.

Fig 4.42(b), Detail of shoulder area.

Fig 4.42(c), Diagram of tunic.

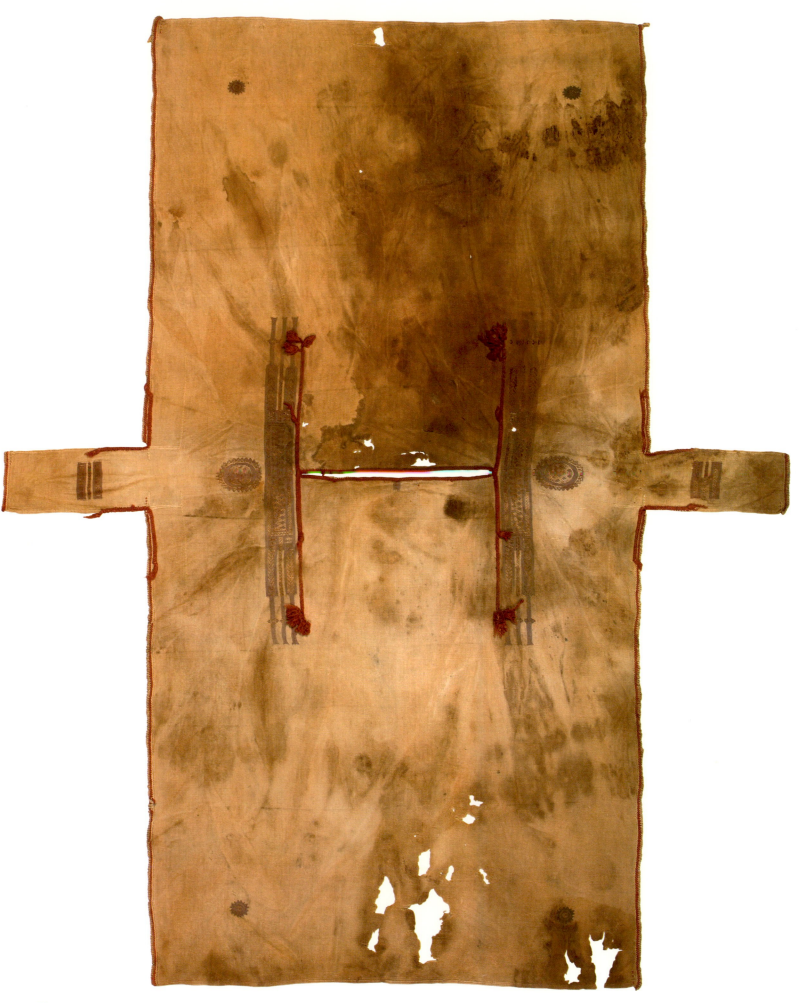

opposite: Fig 4.43(a), Child's wool overtunic, 10/32 threads per cm, *T.8374*.

left: Fig 4.43(b), Diagram of tunic.

Woven-to-shape wool tunics and overtunics featuring geometric tapestry-woven patterning were also still produced as late as the eighth and ninth centuries. Frequently woven from undyed wool, these tunics were probably worn by men rather than women, and a child's overtunic of this type in Manchester may have been intended for a boy. This meticulously woven child's tunic shows the *clavi* divided into three pendent terminals, which is characteristic of the group (Fig 4.43). Red wool has been used as twining to outline the edge of the neck, *clavi* and corners of the narrow sleeves. In addition, the sides and sleeve ends have been finished with very short fringes of twisted loops. Therefore, this decorative use of red thread would have made it a more appealing garment for a child.

The intricate geometric patterning is more apparent on an adult's overtunic of this type, which also has extremely narrow sleeves that lay on the shoulders without being seamed under the arms (Fig 4.44). It, too, was finished with twisted loops along the sides and the ends of the sleeves. The division of the sleeve decoration into three bands rather than the usual pair is also distinctive. Other tunics with similar patterning include an example recovered by Petrie at Memphis, where he spent a season excavating in 1910.[98] Carbon-14 dating of another similar tunic in a private collection in Belgium gave a wide date range for it from the second half of the seventh century to the first half of the tenth century.[99]

98 This textile is in the Ashmolean Museum, University of Oxford, accession number 1968.592.

99 De Moor, op. cit. in note 32, pp.190–1, no. 90.

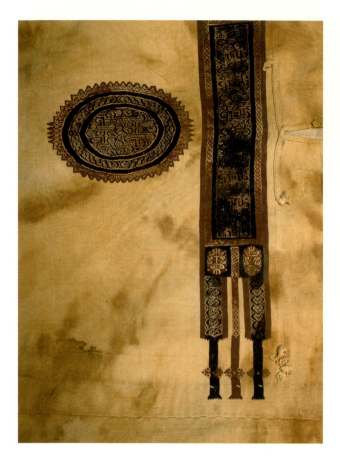

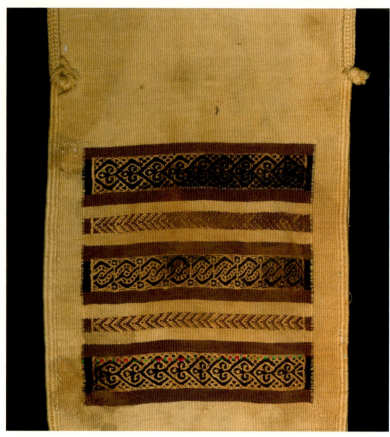

Fig 4.44(a), Detail of shoulder ornament and *clavus* on an adult wool overtunic, 10/44 threads per cm, *T.8362*.

Fig 4.44(b), Detail of sleeve (width 165mm).

A final example of a woven-to-shape wool tunic selected here to illustrate the variety of decorative styles worn in the centuries immediately after the Arab conquest of Egypt has very wide *clavi* of dark blue wool edged with purple borders patterned with hooks in white linen and sleevebands with geometric, interlace patterning (Fig 4.45).[100] By now the original function of the *clavi* as signifiers of status and class was disappearing and they were becoming merged into a general decorative scheme of coloured stripes. Unlike complex tapestry-woven *clavi*, coloured stripes were a simple form of patterning that continues to be a popular feature of Arab dress to the present day.

Alongside the traditional woven-to-shape tunics of the mid-seventh and eighth centuries, new styles made from narrower widths of cloth folded double in a vertical direction were being produced, although the basic method of construction looked back to the 'bag' tunics of Pharaonic Egypt. Most of the tunics that are preserved in this style were made for children, but this probably reflects the greater ease of recovering nearly intact garments of smaller dimensions from burials, as well as the high mortality rate of children in antiquity when disease and malnutrition were commonplace.

The simplest style of tunic was sleeveless and carbon-14 dating of two tunics of this type in Manchester gave very similar date ranges of AD 670 to 775 and 660 to 780, indicating that they were made after the Arab conquest and were contemporary with

[100] Part of a tunic with a similar *clavus* is preserved in Moscow: Shurinova op. cit. in note 36, no. 200.

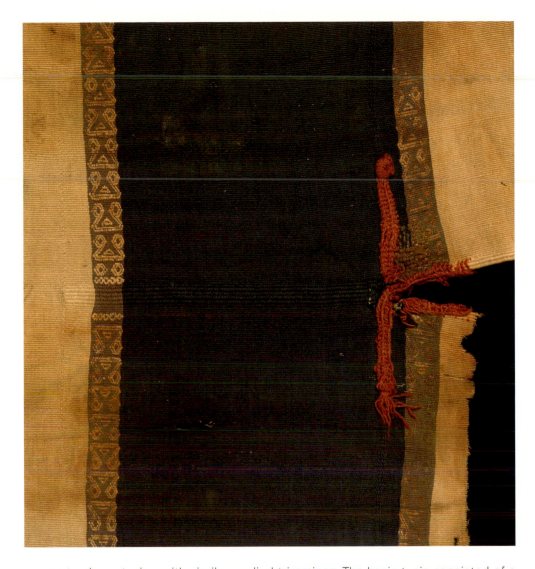

Fig 4.45 Detail of neck and *clavus* of wool tunic, 8/56 threads per cm, *T.2001.243*. Width of clavus: 235mm.

woven-to-shape tunics with similar applied trimmings. The basic tunic consisted of a single loomwidth of narrow cloth folded double and seamed along the selvedges at the sides with run-and-fell seams (Fig 4.46 a, b & c). The loomwidth was not standardised but for children's tunics ranged between 430 to 550mm. The cloth was no longer always weft-faced tabby. Some is woven in a more balanced tabby weave and occasionally the slightly uneven tight twist of the yarn, which is S-spun, resulted in a texture that has been likened to the imprint of a bird's foot, as on the red wool tunic illustrated.[101] However, as the fabric was quite thin and only very lightly finished it was less durable. The material was usually slightly cut away under the arms to create a better fit and a short vent was left at the bottom of each sideseam to enable greater freedom of movement. The lower edges of the tunic were folded double to a depth of 8mm and hemmed usually with two rows of stitches, one in hem stitch and a second row, which was positioned closer to the fold to ensure that the edge lay flat, in back stitch. A few children's tunics have wider hems which include a band of undyed wool concealed on the inside of the tunic, and this may have been used as a

[101] A recent study of wool tabbies calls this a 'crowsfoot tabby', Lena Hammarlund, 'Handicraft knowledge applied to archaeological textiles – visual groups and the pentagon', *Archaeological Textiles Newsletter* 41 (2005), p.14.

Fig 4.46(a), Child's wool tunic, 14/17 threads per cm, *T.8577*. Height of tunic: 765mm.

Fig 4.46(b), Diagram of tunic.

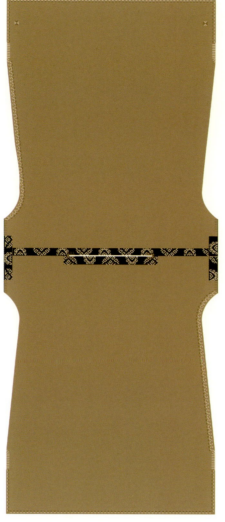

guide when the cloth was on the loom, to mark off the length of cloth required for a tunic.[102] A dark green wool tunic of this type in the Victoria and Albert Museum has a hem 43mm wide held down with nine rows of stitches, which also continue round the side vents, and the vents in this instance are reinforced with a facing cut from a piece of recycled cloth.[103] The use of facings can, therefore, be seen as a new development employed on several different types of tunics in Egypt in the late seventh century.

The neck opening on sleeveless tunics was cut in a variety of styles. Often the neckline was little more than a slit trimmed with patterned bands of wool and linen but it could also be rounded at the front, or both back and front, with a fastening on the left-hand side of the neck, or occasionally on both sides. Asymmetrical openings were also cut.[104] If the neck opening was just a narrow slit, the band at the back of the neck was usually stitched to extend across both shoulders to the armholes. By contrast, at the front a band cut to a shorter length, which was a little longer than the width of the neck, was applied. At each end of the neck opening blanket stitches were worked in coloured thread, which generally matched the colour of the applied band. Therefore, this reinforcement stitching was similar to that used on the woven-to-shape tunics with cut necklines and applied bands. If the neck opening was more rounded at the back and front both bands were more often the same length, and the opening was often fastened with cords plied from threads of different colours.[105]

The selvedges of the cloth formed the edges of the armholes on these sleeveless tunics. Decorating them were bands, which usually matched those applied at the neck, and very sensibly they did not extend under the arms to be damaged by perspiration. Blanket stitching was also often added as strengthening to the armholes (Fig 4.46c).

The decorative elements of these tunics were, therefore, comprised of applied bands and a range of stitches worked in colourful threads of mainly three-ply wool. Tapestry-decoration was no longer imperative, although a few tunics of this style woven from linen as well as wool are patterned with a band of tapestry buds above the hem.[106] A significant example of a tunic of this style made from linen rather than wool was one

102 There is one tunic of this type in Manchester, T.2000.242.

103 Accession number T.232–1923.

104 Kendrick, op. cit. in note 65, p.82, no. 568, pl. xxviii.

105 A brown wool tunic type in Manchester has one cord plied from green and red threads and the other from blue and yellow threads, T.1968.167.

106 For example P. du Bourguet, *Catalogue des étoffes coptes du musée du Louvre* (Paris, 1964), p.318, no. F191; Kendrick, op. cit in note 65, p.24, no. 340, pl. xiv; Nauerth, op. cit in note 46 pp.96–7, no. 95, taf. 46.

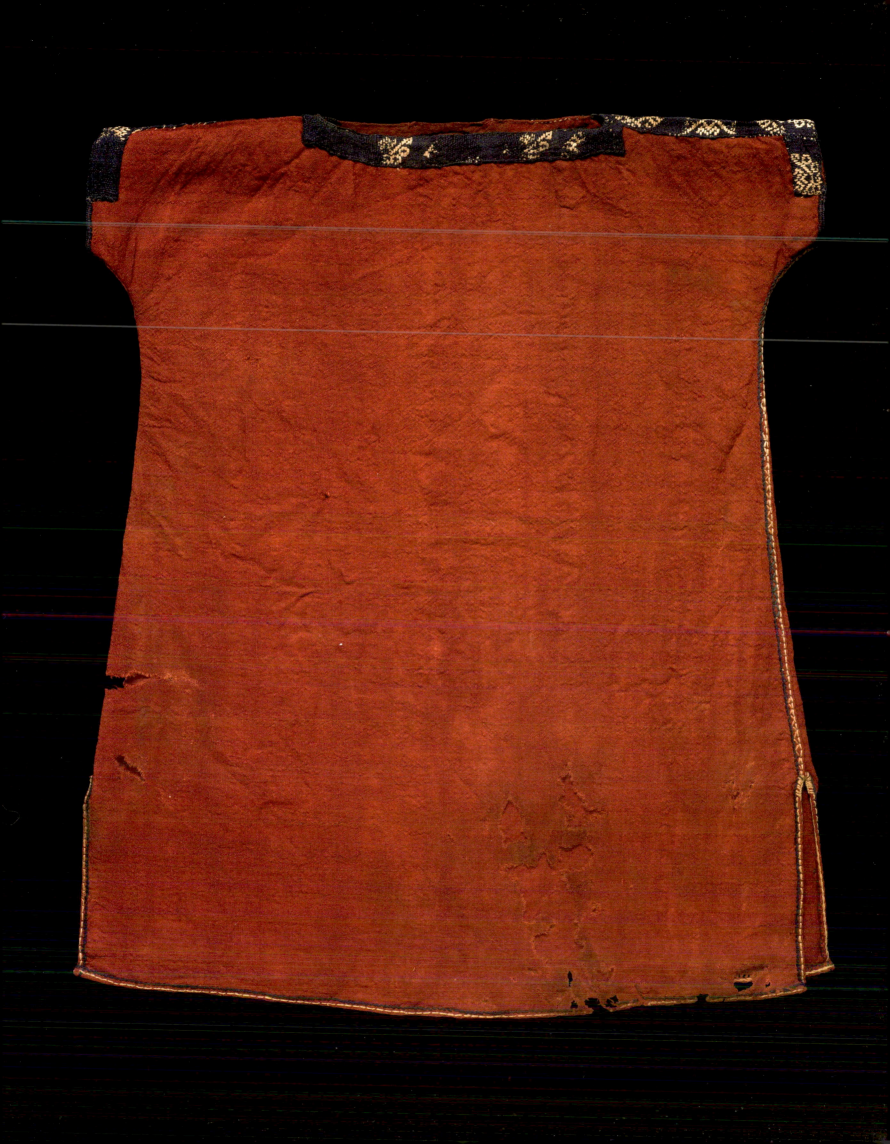

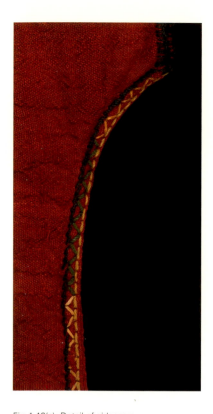

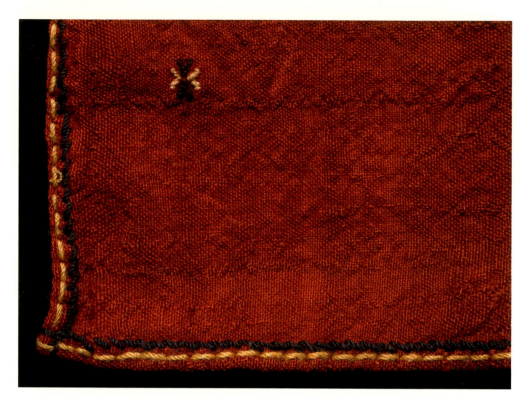

Fig 4.46(c), Detail of sideseam.

Fig 4.46(d), Detail of stitching including a small cross near the bottom corner at the back of the tunic.

107 Calament, op. cit. in note 50, p.31, figs. 11 and 12.

108 D. Bénazeth, 'Trying to date the Antinoë silks with the radiocarbon method', in Fluck and Schrenk, op. cit. in note 44.

109 V. Lochhead, 'The conservation of four Egyptian tunics', in S. A. O'Connor and M. M. Brooks (eds.), *Archaeological Textiles*, *UKIC Occasional Papers* 10 (1990), pp.44–6.

110 Hall, op. cit. in note 54, p.27.

of the five burial tunics worn by Thaïs at Antinoë. In addition to a row of tapestry-woven buds, the lower edge of the garment is fringed.[107] Carbon-14 dating evidence for this burial indicates a date shortly after the Arab conquest (AD 640–720).[108] A wool tunic of this type, which was recovered from the grave of a child aged about twelve at Mostegedda, is patterned more simply with bands of slubbed (unevenly spun) wool in orange and red on an undyed ground and, like the linen tunic worn by Thaïs, is finished at the lower edge with a simple fringe.[109]

The variety of stitches is especially noteworthy, as well as the skilful manipulation of the cloth to form seams and hems. On the wool tunics the stitching was emphasised by the use of threads of different colours used side by side on the hems and seams, or for short sections where an extra type of stitch might be added, such as double-running stitches arranged to form chevrons on the seams of some tunics (Fig 4.46c). Another feature of some tunics of this type in Manchester is the presence of a small cross, or crosses, brocaded or stitched in one or two colours in a corner close to the hem (Fig 4.46d). It is possible that these crosses identified the wearer as a Christian.

Another sleeveless wool tunic of this style in Manchester is exceptional in having loops of weft wool pile woven on the inside (Fig 4.47). The tunic is now inside out as this appears to be how it was worn during burial, which accords with a burial custom that had a long history in Egypt dating back to around 2800 BC.[110] It also appears, from the position of the applied bands at the neck and from the areas where the cloth has disintegrated from the effects of the body fluids, that the tunic was worn back to

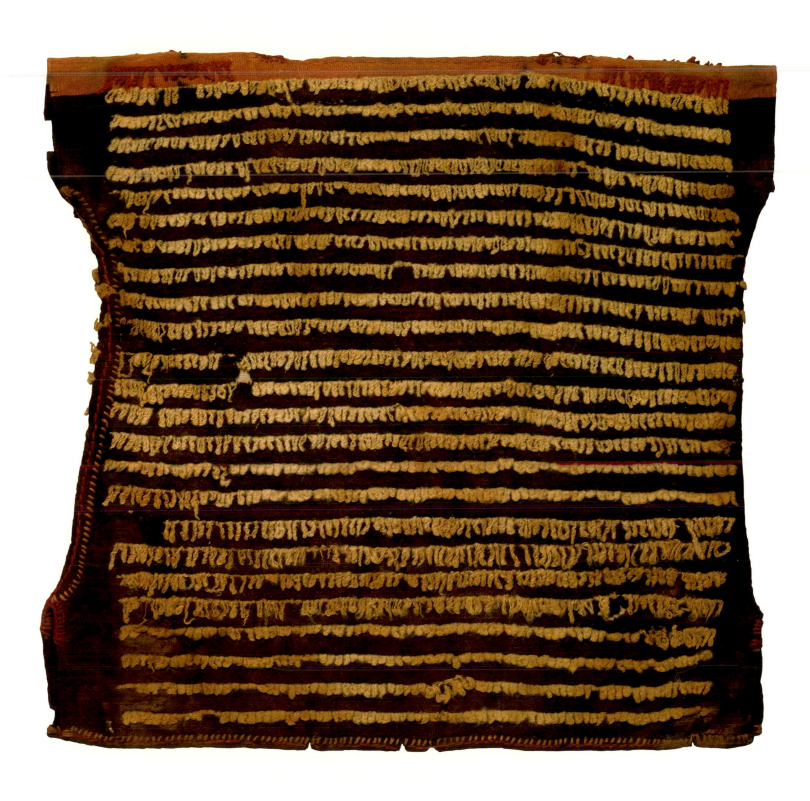

Fig 4.47(a), Child's wool tunic, 11/27 threads
per cm, *T.8380*. Height of tunic: 450mm.

Fig 4.47(b), Diagrams of tunic, inside and outside.

Fig 4.47(c), Detail of wool pile.

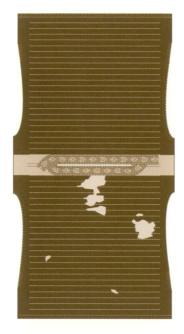
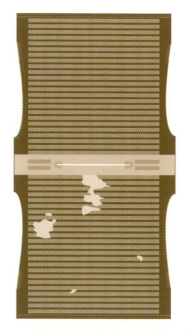

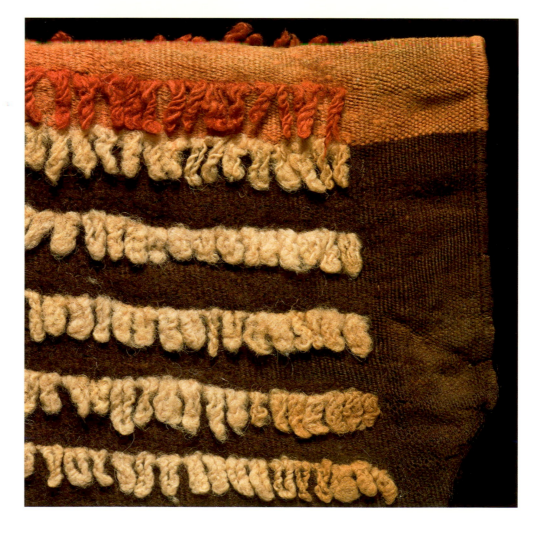

front for burial. It was made from wool dyed brown, except for an orange band 46mm wide which runs across the centre, and therefore was positioned at the top of the tunic when the cloth was folded double. Undyed wool was used for the rows of pile spaced 16 to 18mm apart, which stand out against the brown ground, except for the orange section where two short rows of red pile were substituted for the off-white. Red and orange wool threads were also chosen as sewing threads for the sideseams and hem, and for the strengthening in blanket stitch at the vents and neck edge. This is the smallest tunic in the collection and would have been worn by a child no more than three years old. Therefore the pile would have made it into a very warm garment for a young infant. Other tunics with wool pile are very rare. However, the woven-to-shape wool burial tunic of Leukyônê at Antinoë had yellow pile on the inside showing that this feature was not confined to the clothing of very young children.[111]

No sleeveless wool tunics for adults are preserved among the clothing from Egypt in Manchester. Nevertheless, a superb tunic of this type from Lahun was given by Petrie to an American supporter a few years before his donation to the Whitworth Art Gallery.[112] Made from navy blue wool woven in weft-faced 1.2 twill with a brushed nap, its finished dimensions are 1.41 x 1.095 metres. It is seamed and hemmed in matching blue wool and also contrasting dark pink wool, which is used to decorative effect especially around the armholes where herringbone stitching has been used as well as back stitch. The absence of any woven patterning or applied bands may explain why no other tunics of this type appear to have been preserved, as fragments would be difficult to identify.

Tunics with short sewn-on sleeves were also made from similar narrow widths of cloth folded in half in a vertical direction with the selvedges at the sides concealed within the run-and-fell sideseams. The shaping of the neckline and stitching of patterned bands at the neck and sleeve openings of these tunics is also very similar. One tunic in Manchester has open seams for a short section under the arms (Fig 4.48), but usually the seam was closed for the whole length except for the vents next to the bottom edge.

A short-sleeved tunic of this style in Manchester has been carbon-14 dated to AD 650 to 780, thereby indicating that it was produced at the same period as the sleeveless tunics described above (see Figs 2.4 and 2.6). A sleeve from a brown wool tunic of a similar type with a trimming of red wool patterned in linen thread was recovered from Petrie's excavations of the cemetery at Hawara.[113] Although, Petrie considered this cemetery to have gone out of use before the time of the Arab invasion, since the latest coin buried in a jar as a funeral offering dated to the middle of the sixth century,[114] it is possible that a re-evaluation of the later graves might result in a slight readjustment of the cemetery's chronology.

Tunics with sewn-on sleeves for children were also frequently made from recycled cloth. Usually no trimmings were applied to these tunics but, sometimes, the stitching

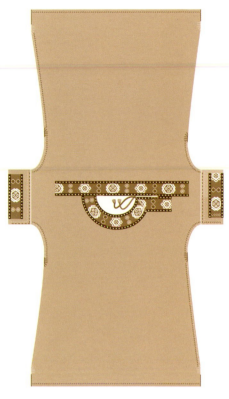

Fig 4.48(b), Diagram of tunic.

[111] Calament, op. cit. in note 50, pp.28–9.

[112] University of Pennsylvannia Museum, accession number E 16804.

[113] Accession number T.1988.75. The sleeve was given to Manchester Museum by Jesse Haworth.

[114] W. M. Flinders Petrie, *Hawara, Biamhu, and Arsinoe* (London, 1889), p.13.

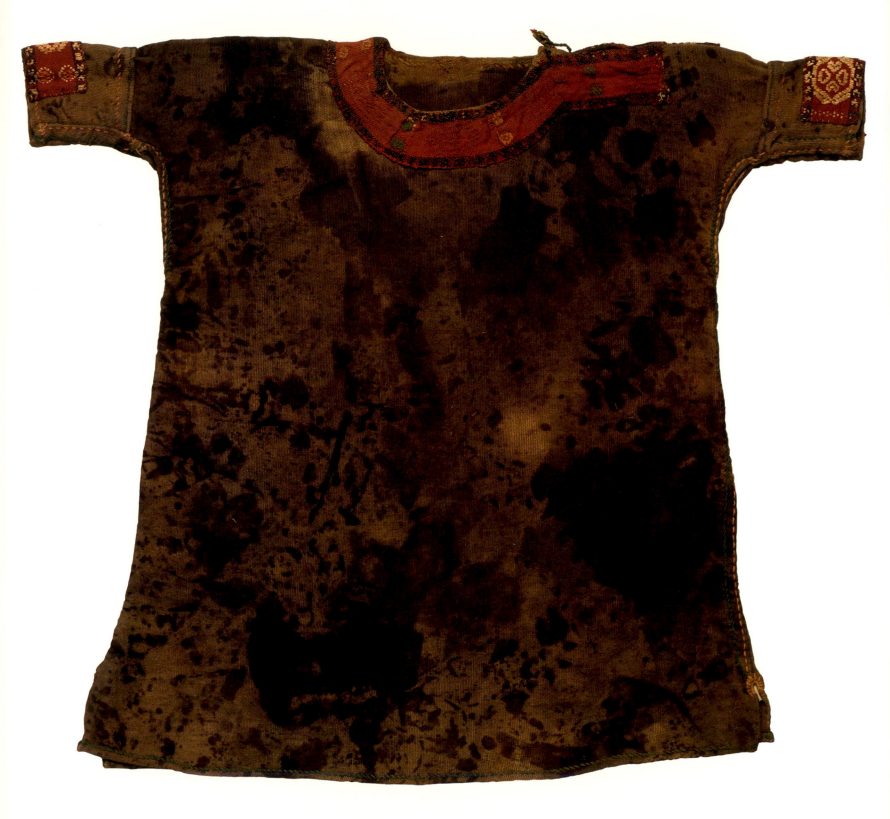

Fig 4.48(a), Child's wool tunic, 8/40. threads
per cm, *T.8378*. Height of tunic: 555mm

of the seams and hems in wool of contrasting colours enables them to be identified (Fig. 3.13). Among the examples in Manchester is a tunic made in 1.2 twill, which has been extensively darned and is nearly threadbare.[115] A sleeve made from a blue and white linen fabric is probably another example of recycled cloth, as similar fabrics were often used for hangings or coverlets. It does, however, have two small tapestry-woven ornaments applied to the sleeve and shoulder in addition to a band applied to the end of the sleeve (Fig 4.49).

A further stage of development in the styling of tailored tunics is apparent in tunics made to fit children of a larger size. As the width of the cloth produced in many weaving workshops after the mid-seventh century was often too narrow to be made into one-piece tunics, inserts were added at the sides in the form of triangular gores. Some children's sleeveless tunics even had small gores of this type added at the sides (see Fig 3.14).[116] The larger tunics, however, also often required extra inserts at the sleeves in the form of underarm gussets. This method of shaping tunics can

Fig 4.49, Sleeve of child's blue and white check-patterned linen tunic. 18/12 threads per cm, with applied decoration *T.1993.26*.

[115] Accession number T.1989.23. The wool fabric has 10/26 threads per cm.

[116] An example in the Louvre is exceptional in having tapestry-woven decoration on the shoulders, P. du Bourguet and P. Grémont, *Tissus Coptes* (Angers, 1977), pp.68–9, no. 82.

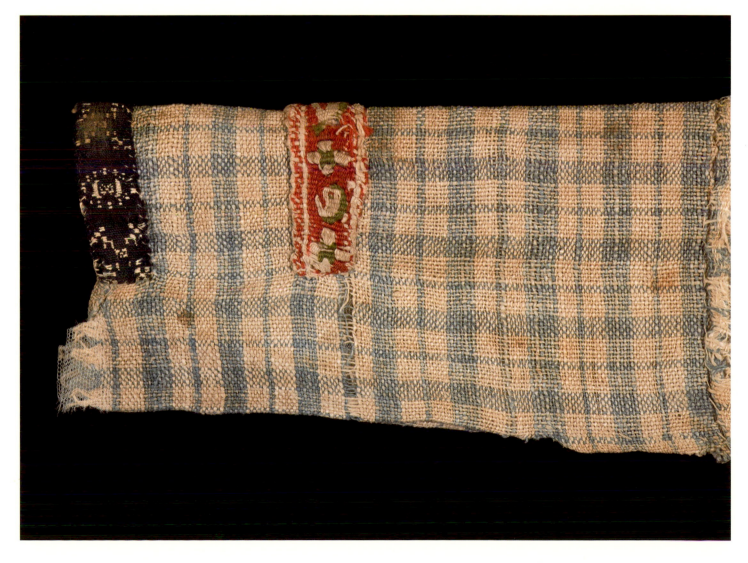

Fig 4.50(a), Child's linen tunic, 20/20 threads per cm, *T.1993.27*. Height of tunic: 585mm.

Fig 4.50(b), Diagram of tunic.

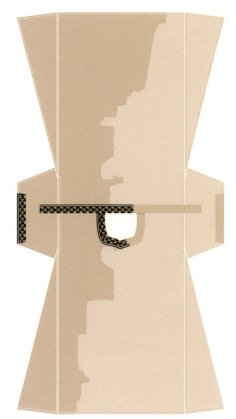

already be seen in the linen shirts worn by the Persian officials, who governed Egypt in the early seventh century, and also among the clothing from graves at Halabiyah, in north east Syria, dating no later than AD 610 when the town was destroyed by the Sassanian ruler, Khusrau II.[117]

Linen tunics styled in this manner may have begun to be made in Egypt earlier than those made from wool, as linen was the fabric generally used for the tailored shirts. Several of these linen tunics were recovered from Crocodilopolis, including an example that has been carbon-14 dated AD 618 to 682.[118] A child's tunic of this type in Manchester has side gores that extend to the armpits and applied bands at the sleeves and neck, which is cut to a point at the centre front, (Fig 4.50). A remarkable child's tunic of this style was recovered from a grave at Akhmim. It is made from cotton, which was resist dyed to form a pattern in white on blue of small flower heads within a lattice framework.[119] The combination of cotton and resist dyeing suggests that the cloth, at least, may have had a foreign origin.[120]

117 Pfister, op. cit. in note 58.

118 Linscheid, op. cit. in note 63, pp.76–7; C. Fluck 'Carbon-14 analysed textiles in the Museum für Byzantinische Kunst, Berlin', in Fluck and Schrenk, op. cit in note 44.

119 The tunic is in the Victoria and Albert Museum, accession number 1522–1899; G. Vogelsang-Eastwood, *Fra Faraos Klædeskab: Mode I Oldtidens Ægypten* (Amsterdam/Copenhagen, 1995), p.89, fig. 151. I am grateful to Helen Persson for this reference.

120 For resist-dyed cotton in Egypt see J. P. Wild, 'Cotton in Roman Egypt: some problems of origin', *Al-Rafidan* 18 (1997), pp.292–3.

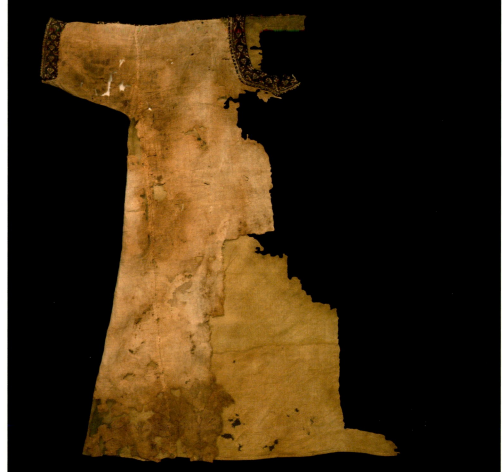

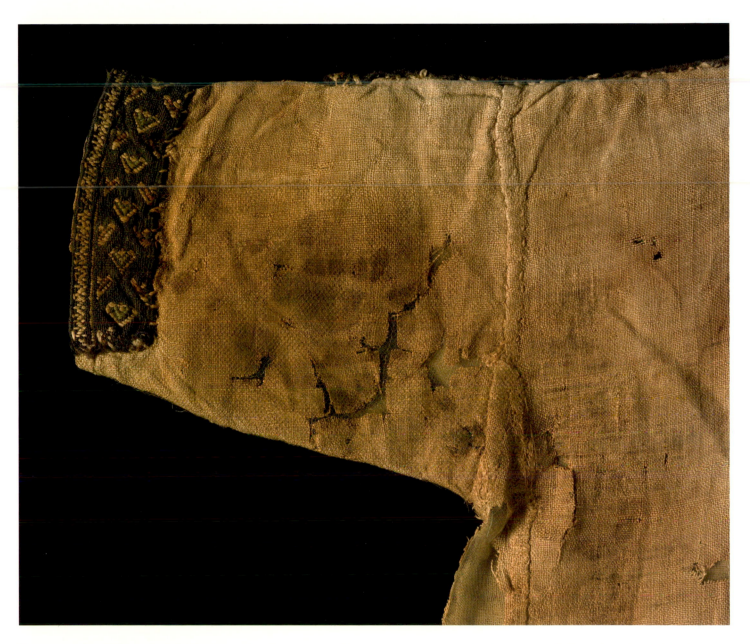

There are four children's wool tunics with side gores in Manchester and some further fragments, which may have come from larger tunics. Two have been carbon-14 dated and gave dates of AD 770 to 970 and 880 to 990, indicating that they may have been made as much as two centuries after the other tunics made from vertical-folded narrow cloths. These two later wool tunics, however, have other features that mark them out as being different. Both are constructed from nine or ten pieces of matching cloth: a centre panel, four triangular panels for the side gores, two sleeve pieces, one or two underarm gussets and a neck panel (Figs 2.5 and 4.51). It is the addition of a neck panel and the manner in which these two tunics were fastened at the neck that distinguishes them. The neck panel consists of a small rectangular piece of cloth, which was stitched on the left side of the neck next to the sideseam so that it

Fig 4.50(c), Detail of sleeve and top of side gore.

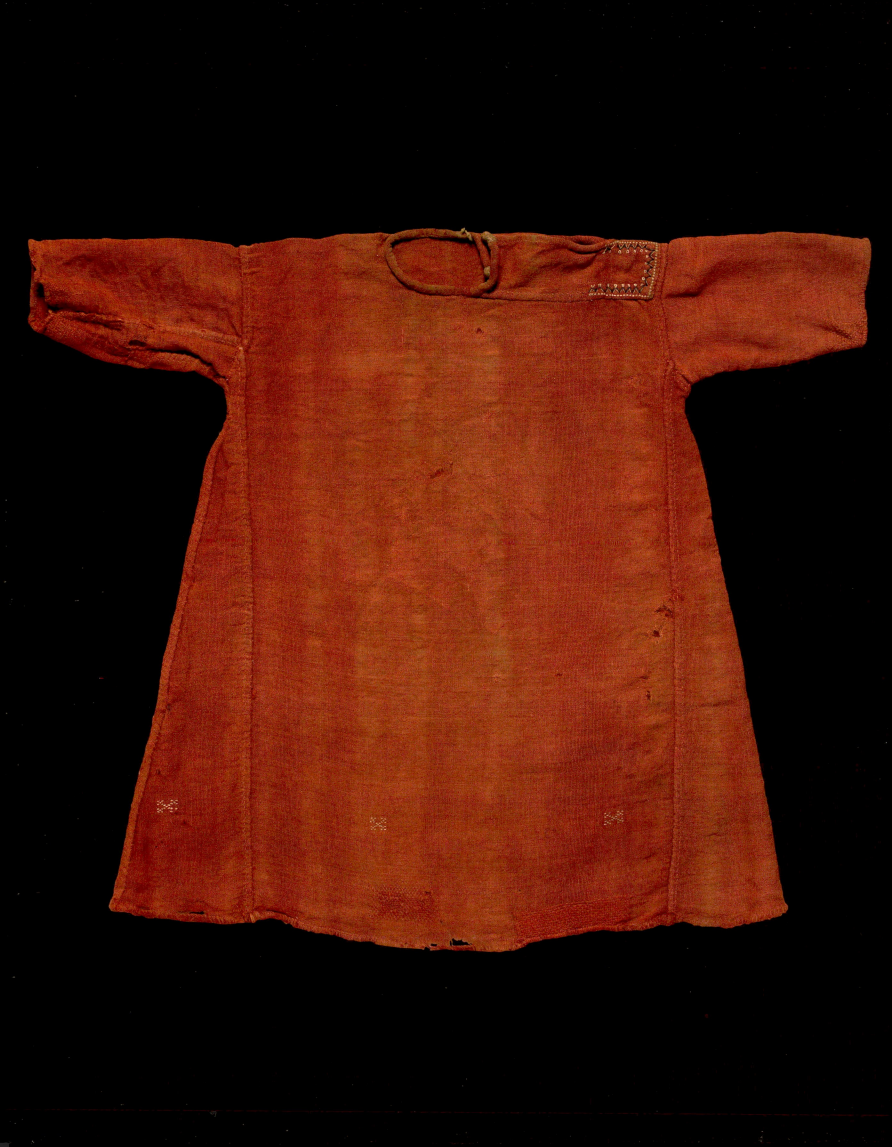

extended from the shoulder to the neck. The centre panel lying underneath it was partly cut away to enlarge the neck opening. A binding was sewn round the neck using a strip of similar cloth or a contrasting fabric and, at each end, a cloth button was formed, either by winding a thread tightly round the protruding end of the binding (Fig 2.5d), or by wrapping round an extra piece of cloth (which appears to be linen) and stitching it in place (Fig 4.51c). A cord with looped ends was threaded through the neck binding and pulled through the stitching so that one loop was on the inside and the other, at the back, on the outside. Each loop, therefore, fastened over a button. On the plain red wool tunic, which is the earlier tunic, the neck panel was embellished next to the shoulder with decorative stitching in blue and white threads (Fig 4.51d). The seams, however, were stitched in red thread to match the cloth. This tunic also has a series of three small crosses brocaded above the hemline in white linen thread, which are present on several other wool tunics as well, and has darning at the hem and on both sleeves.

The check-patterned cloth used for the second tunic of this type is very distinctive and marks a trend towards the greater use of patterned fabrics for clothing in the succeeding centuries. The pattern is formed from threads of red, yellow, orange and blue wool and white linen arranged in a repeating sequence of 2 red, 2 yellow, 2 red, 8 blue threads in the warp direction and 2 red, 2 orange, 2 red, 10 blue in the weft with paired linen threads after 3 blue, 2 blue and 2 blue so that they form a white block in the centre of each blue square (Fig 2.5c). The weave is a balanced tabby, which ensured that the small checks were even in size. Another tailored tunic, with side gores made from a wool checked-patterned cloth, was recovered from a burial at Antinoë and is preserved in Lyons.[121] However, only red and blue wool was used for the pattern with four threads of red alternating with four of blue in both the warp and weft. The neckline of the tunic was finished in the earlier manner with an applied band of red and blue wool patterned in linen rather than having a neck panel and buttons.

Two other children's tunics with side gores show signs of extensive wear. One is sleeveless and so heavily darned that scarcely any of the original wool fabric remains untouched (Fig 3.14). Narrow bands of red wool patterned with chevrons in white linen were applied at the neck and armholes, although one of the latter is missing and probably had become detached before burial. The other is made from eleven pieces of recycled blue cloth (Fig 3.15). Not all the cloth is identical in weight and three different fabrics appear to have been used. A study of the wear patterns suggested the tunic was made in part from an adult's garment, which had been cut up and reused.[122] It has applied bands round the neckline and sleeve ends and fastened with tasselled ties on the left side of the neck. Three double crosses in linen and red wool have been stitched above the hem, in a similar position to those on the red tunic with side gores, and further crosses in white linen are stitched on the sleeves, although it is possible that these may have been in a different position on the garment before it was remade. However, it is the pattern darning, which is the most significant feature of

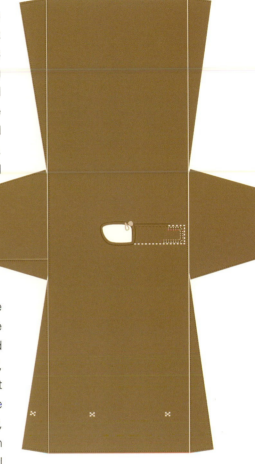

Fig 4.51(a), Child's wool tunic, 10/28 threads per cm, *T. 8375*. Height of tunic: 640mm.

Fig 4.51(b), Diagram of tunic.

121 Musée Historique des Tissus, Lyon, inventory number 28.520/135

122 B. Cooke, 'Fibre damage in archaeological textiles', in O'Connor and Brooks, op. cit. in note 109, p.9, figs. 30–32.

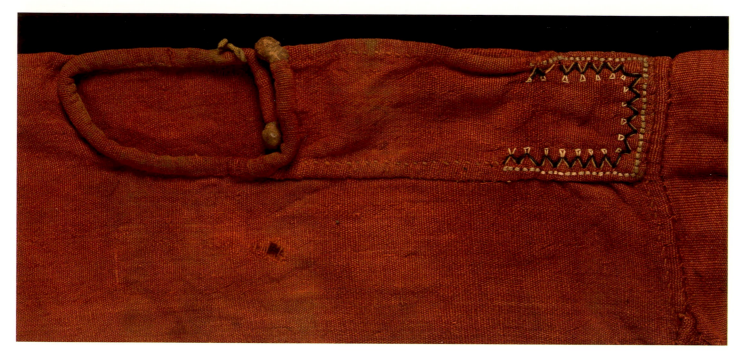

Fig 4.51(c), Detail of neck opening.

this tunic (Fig 7. 6). This has been carried out in brown wool thread on the front and back of the tunic creating a variety of geometric patterns. The manual dexterity required for this stitching indicates that needlework was becoming a domestic skill as well as a professional craft in Egypt by the ninth or tenth century. By the late twelfth century pattern darning is known to have been carried out in workshops in Egypt from samplers stitched in silk on linen recovered from Fustat in Old Cairo and the technique continued to be popular for the rest of the medieval period,[123] but this tunic appears to be the earliest example worked in wool.

The tunics from Egypt described and discussed here, therefore, enable their development to be traced from the late third to the tenth centuries albeit in a very general manner, especially when it is appreciated that a single burial can yield as many as five tunics (Fig 4.52). The evidence, supported by carbon-14 dating, indicates that the greatest change in the styling of tunics occurred during the seventh century influenced by Eastern styles transmitted through the Persians. Some archaeologists have suggested that cut and tailored tunics were already prevalent in Egypt some two centuries earlier but the evidence for this has yet to be published and, at present, it remains an uncertain fact.[124] In any event, the constant recycling of textiles and garments, as well as the production of tunics in three pieces with a waist seam, meant that stitching items of clothing was already a common practice; it was the shaping that was the important difference.

Woven-to-shape tunics with integral tapestry-woven ornaments continued in production throughout the entire period but already by the mid-seventh century their popularity was on the wane. This was hardly surprising since the need to conform to

123 Ellis, op. cit. in note 94, pp.24–43.

124 K. H. South, M. C. Kuchar and C. W. Griggs, 'A preliminary report of the textile finds, 1998 season, at Fag el-Gamus', *Archaeological Textiles Newsletter* 27 (1998), p.10.

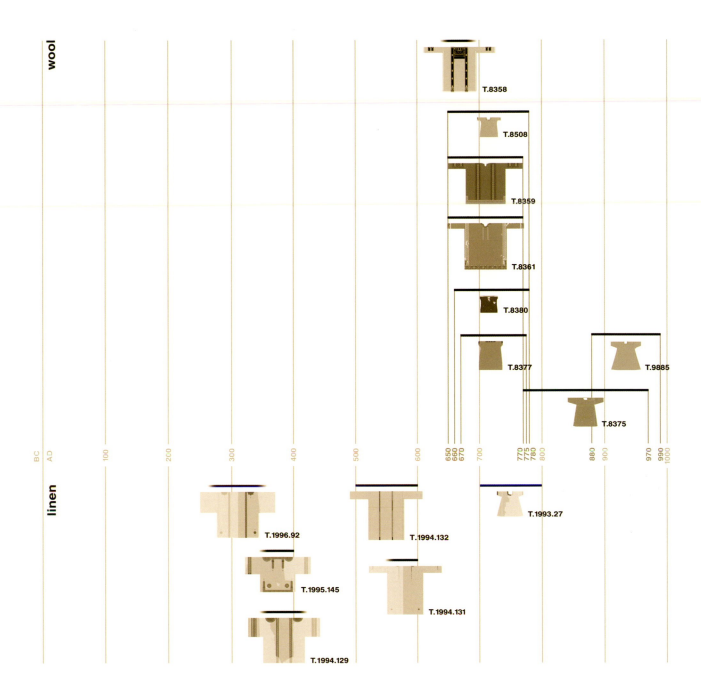

wool

T.8358

T.8508

T.8359

T.8361

T.8380

T.8377

T.9885

T.8375

BC AD · 100 · 200 · 300 · 400 · 500 · 600 · 650 660 670 · 700 · 770 775 780 800 · 880 900 · 970 990 1000

linen

T.1996.92

T.1994.132

T.1993.27

T.1995.145

T.1994.131

T.1994.129

a Roman dress code no longer applied. The use of looms adapted to weaving narrower widths of cloth also meant that tapestry weaving was no longer so appropriate and different methods were employed to create similar effects, including weaving separate bands and sets of ornaments. There was a growing tendency to cut cloth to a standard formula for clothing and, in tandem with this new approach, there was an increasing emphasis on sewing skills, which were exploited for decorative purposes. Weaving-to-shape was not wholly abandoned in subsequent periods and still persists for some garments in the Near East[125] but, under Arab rule, classical traditions gradually declined and new influences became more dominant, which ultimately led to a change of wardrobe.

Fig.4.52 Table showing styles of wool and linen tunics from the late 3rd to 10th centuries.

125 Gervers, op. cit. in note 57, p.302.

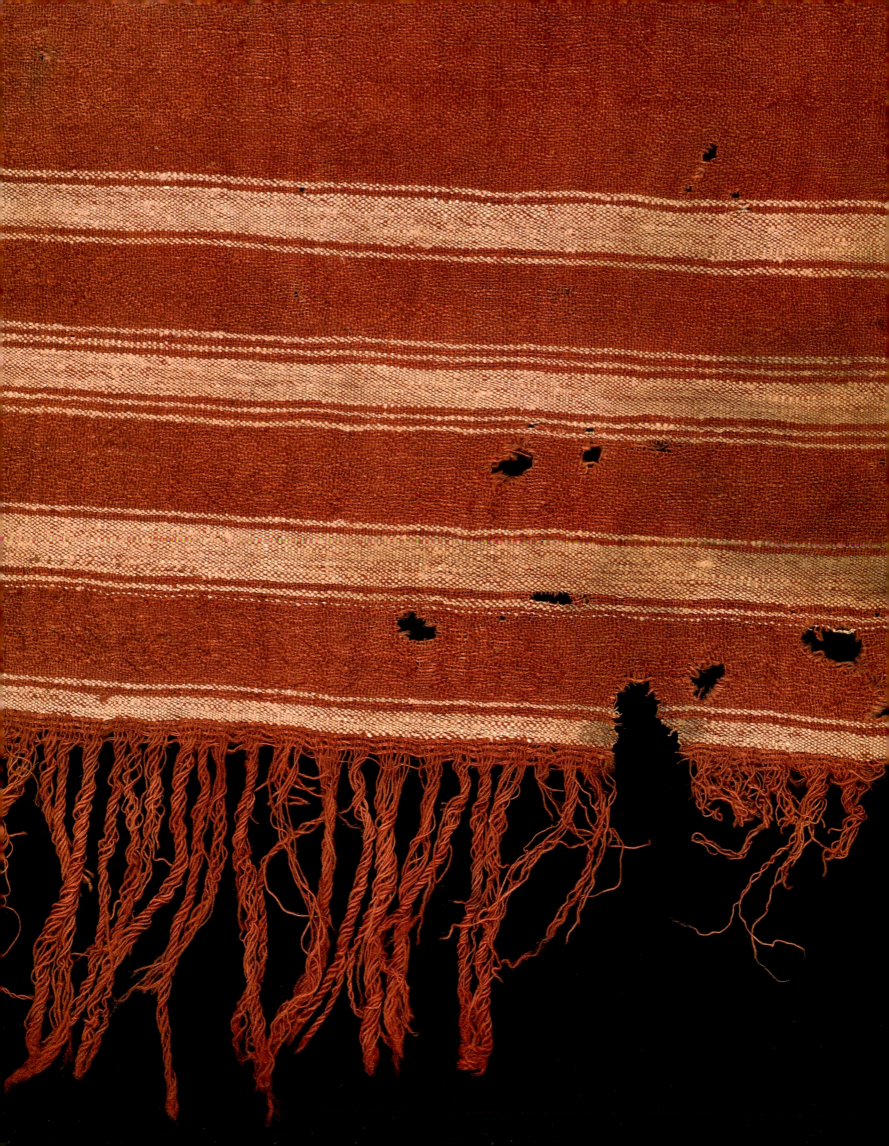

Chapter 5

Cloaks, mantles and shawls

CLOAKS, CAPES AND MANTLES were the chief types of outer garments worn by men in late antiquity.[1] The differences between them depended on the way they draped, fastened and were shaped. Cloaks are mentioned in written sources under a variety names. Latin terms included *birrus, caracallus, cucullus, lacerna, sagum, paenula* and *paludamentum*. Some distinctions can be made between them but many of the subtle nuances are difficult to determine now – the *sagum* was mainly a rectangular military cloak held in place on the right shoulder by a brooch, a *paludamentum* was a large cloak that was reserved for men of high status, such as generals or the emperor, whereas a *lacerna* was a thinner, civilian cloak. The *paenula, caracallus, cucullus* and *birrus*, by contrast, were semi-circular hooded capes of varying length. The *birrus* was distinguished by its manner of fastening at the front, which meant that it was drawn on over the head.[2] The *caracallus* was initially worn in Gaul and became popularised by the army in the third century when it was even adopted as the nickname for an emperor, Marcus Aurelius Antoninus (211–17), from his liking for wearing it.[3] The *cucullus* was a shorter, shoulder-length cape as the name suggests. The price list in the Edict of Diocletian indicates that some styles of cloak were made from linen as well as wool,[4] rainproof leather capes are referred to by Roman authors such as Martial[5] and writing tablets from Roman Britain mention cloaks made from bark (*sagum corticum*).[6]

Despite the fact that cloaks were such important garments and were produced in large quantities, they are preserved in far fewer numbers from burials in Egypt than tunics, except as fragments. One reason for their poor survival is their comparatively scant decoration, which made them less desirable to many collectors. Fortunately Petrie did not share this view and he kept as much material as possible relating to everyday life. Consequently, he gave portions of at least four wool cloaks to the Whitworth in 1897, pieces to the Bankfield Museum, Halifax, and probably indirectly to the British Museum, and several others to American supporters, who in turn gave them to the University of Pennsylvannia Museum of Archaeology and Anthropology, Philadelphia, where they could be examined and studied.[7] All of these appear to have been recovered by Petrie at el-Lahun in the Fayum in 1888 and 1889 and, in the light of the

opposite: Fig 5.8, Part of a wool shawl with fringe, 15/16 threads per cm, *T.9869*.

1 A. T. Croom, *Roman Clothing and Fashion* (Stroud, 2000), pp.49–55.

2 J. P. Wild, 'The *Byrrus Britannicus*', *Antiquity* 37 (1963), p.195.

3 G. Sumner, *Roman Military Clothing (2) AD 200–400* (Oxford, 2003), pp.10–11.

4 The relevant section of the list is tabulated in V. Gervers, 'Medieval garments in the Mediterranean world' in N. B. Harte & K. G. Ponting (eds.), *Cloth and Clothing in Medieval Europe* (London, 1983), pp.286–7.

5 *Epigrams* 14.130, quoted in Wild, op. cit. in note 2, p.194.

6 J. P. Wild, 'The textile industries of Roman Britain', *Britannia* 33 (2002), p.26.

7 Bankfield Museum EG 329, L. E. Start, *Coptic Cloths* (Halifax, 1914), pp.12–13; British Museum E.A. 68977, illustrated in H. Granger-Taylor 'Weaving clothes to shape in the ancient world: the tunic and toga of the Arringatore', *Textile History* 13/1 (1982), pp.15–16; University of Pennsylvannia Museum E 15235, E 16840 and E 16803, (the latter is described in H. Granger-Taylor, op. cit., pp.12–13 and 21).

Fig 5.1, Diagram of woven-to-shape hooded wool cloak. The fragment superimposed is *T.8500*.

other textiles, especially tunics, from the same cemetery, probably date close to the time of the Arab conquest in the seventh century.[8] Another reason for the lack of preservation of cloaks is that they may have been placed less frequently in burials than tunics and certainly not in the same quantity. Nevertheless, they were often considered to be a necessary grave garment and reference is made in a papyrus to the acquisition of a very cheap old cloak specially for burial.[9]

Like other garments in the ancient Mediterranean world, cloaks were woven to shape in a relatively standardised manner over many centuries. For rectangular cloaks this was a straightforward process, although examples of rectangular wool cloaks preserved in the northern provinces of the Roman empire and *Germania Libera* show that there was considerable variation in the finishing of edges.[10] A semi-circular cloak with an integral hood was much more of a challenge and required considerable expertise to produce. The method was identified and described by Hero Granger-Taylor, who studied one of Petrie's cloaks in Philadelphia, and her analysis has informed all subsequent work on the subject.[11] She showed that the web of the cloak changed in width during the weaving of it in a rather similar manner to a sleeved tunic. Starting with the hood, the fabric was then extended on each side creating a stepped outline with a series of borders and selvedges (Fig 5.1). The semi-circular lower edge was formed by reducing the width of the cloth uniformly on each side and twining the loose ends into a closing cord. A further feature was a short, discontinuous white band woven above the lower edge. Therefore, the weaving process resulted in various diagnostic features being incorporated into the woven web, which assist in the identification of cloak fragments. Astonishingly the same method of weaving hooded cloaks is still pursued in a few remote Berber villages in the Atlas mountains of Morocco, although nowadays the cloaks are made chiefly from goathair rather than wool.[12]

The hooded cloak described above has other significant characteristics. It is woven in a dense weft-faced 1.2 twill, which would have enabled it to be warm, weatherproof and hardwearing thereby allowing the wearer to withstand the rigours of winter and cold nights. Furthermore, in order to wear the cloak comfortably it was expertly sewn so that it could just be pulled over the head without slipping from the shoulders. No cutting of the fabric took place, so the corner flaps were folded inwards and firmly hemstitched and, similarly, the top section of the hood was folded under to form a double thickness. After the seams were stitched, three rows of double-running stitch were neatly sewn round the opening for the head and next to the seam on top of the head, while a single row of stitches was inserted on either side of the front seam to help keep the fabric flat. Among the other woven-to-shape hooded cloaks at Philadelphia is a child's size cloak woven in weft-faced tabby from red wool[13] and a larger, yellow cloak, which was extensively repaired in antiquity, woven in 1.2 weft-faced twill with pile on the inside to provide extra warmth.[14] Both cloaks also have short bands woven in white wool close to the lower edge with two, tapestry-woven inverted triangles in purple wool embellishing the band on the yellow cloak.

8 Hawara is referred to as the source of one cloak in Philadelphia in A. Sheffer and H. Granger-Taylor, 'Textiles from Masada. A preliminary selection' in *Masada IV. The Yigael Yadin Excavations 1963–1965 Final Reports* (Jerusalem, 1994), p.205 but the museum records give the provenance as el-Lahun.

9 T. Frank (ed.), *An Economic Survey of Rome, II* (Baltimore, 1936), pp.318–20.

10 J. P. Wild and L. Bender Jørgensen, 'Clothes from the Roman empire. Barbarians and Romans', in L. Bender Jørgensen, B. Magnus and E. Munksgaard (eds.), *Archaeological Textiles, Report from the 2nd NESAT Symposium* 1984 (Copenhagen, 1988), pp.82–85.

11 Granger-Taylor, op. cit. in note 7, pp.12–16.

12 Granger-Taylor, op. cit. in note 7, pp. 21–22.

13 Accession number E 16840.

14 Accession number E 15235.

These cloaks enable four others to be identified from among the gift of textiles that Petrie made to the Whitworth Art Gallery in 1897. All were made from brightly coloured wool. Two are orange, which analyses indicate were dyed with both madder and weld, another is pale pink resulting from using alum-mordanted wool in a madder dyebath, and the fourth is yellow.[15] They are densely woven with a high proportion of weft to warp threads – two in weft-faced 1.2 twill and two in weft-faced tabby, although as one would expect the twill-woven fabrics have a higher density of weft threads. For instance, one example, which has been cut from the corner of a hooded cloak and preserves traces of a seamline, has 60 picks to 10 warp ends per cm (Fig 5.2). It may be noted too that the spacing of the warp on these cloaks is very similar to that of many wool tunics, showing a standardisation of weaving practice in workshops at the time.[16] No examples of 2.2 twill are represented, although this was a type of cloth associated with cloaks in the Roman period and identified in some quantity

Fig 5.2, Detail of hooded wool cloak woven in 1.2 twill, 10/60 threads per cm, *T.9889*, showing a selvedge and starting border. The stitching indicates where the fabric was folded to form one side of a seam, which would have been positioned below the throat at the front.

15 The dyes were analysed by Dr George Taylor and Penelope Walton Rogers, Textile Research Associates, York.

Fig 5.3, Detail of reverse of wool cloak woven in 1.2 twill with pile, 12/50 threads per cm, *T.9891*.

Fig 5.4(a), Detail of lower edge of wool cloak woven in weft-faced tabby, 11/25 threads per cm, *T.8500*.

Fig 5.4(b), Detail of reverse.

16 The thread count in the warp of seven examples of these cloaks is either 10 or 11–12 threads per cm.

17 L. Bender Jørgensen, 'A matter of material: changes in textiles from Roman sites in Egypt's Eastern desert', *Tissus et Vetements dans l'Antiquité Tardive, Antiquité Tardive* 11 (2004), pp.94–97; and L. Bender Jørgensen, 'Teamwork on Roman textiles: the Mons Claudianus Textile Project', in C. Alfaro, J. P. Wild and B. Costa (eds.), *Purpurae Vestes. Textiles y tintes del Mediterraneo en época romana* (Valencia, 2005), pp.71–72.

18 Wild, op.cit. in note 2, p.198.

19 A similar method of combining a cord and a plaited border was used for the child's hooded cloak at Philadelphia.

among the large assemblages of cloth fragments from sites such as Mons Claudianus and 'Abu Sha'ar in the Eastern desert.[17] This negative evidence lends further support to the suggestion that the weave was not typical of Egypt.

An additional feature of some twill-woven cloaks was for long, weft-looped wool pile to be incorporated into the cloth on the inside providing extra warmth. The density and length of pile varied from cloak to cloak and would have added significantly to the cost of the garment and this may be the explanation for the term *'leoninus'* (lion-like) applied to the most expensive *byrrus* in the Edict of Diocletian.[18] The example from the Whitworth illustrated here has pile inserted in rows up to 20mm apart and it is as long as 110mm so that each row overlaps five lower rows resulting in a warm, but heavy, garment (Fig 5.3).

Two of the cloaks preserve sections of their curved lower edge, both being characterised by discontinuous bands, 32mm and 24mm deep, in contrasting white wool. On the larger cloak fragment the full extent of the band is present, a width of 840mm. It is also embellished in the centre with a small brocaded and tapestry-woven ornament in Z-spun purple wool and, like many other garments, it has been repaired by darning the cloth in two-ply wool (Fig 5.4). This cloak has a plaited edge with a very highly twisted cord next to it, which was made by dropping some ends just above the plaiting and twisting them into a cord. The cord thus sat just behind the finished edge.[19] By contrast the edge of the pink cloak has been folded double, neatly hemmed and trimmed with a short fringe showing that various methods of finishing cloaks were followed at the time (Fig 5.5).

Hooded garments had much to recommend them as clothing in Egypt and the Near East, where the dust, heat and cold meant they were worn for protective as well as practical reasons. Woollen, hooded overtunics were in some respects similar to hooded cloaks but as they were usually woven in a T-shape with straight sides, narrow sleeves, tapestry-woven decoration and sewn-on hoods they would have been produced in different workshops and possibly aimed at a different clientele. Well-preserved examples in the Louvre and the Metropolitan Museum of Art, New York are child-sized garments,[20] but this is doubtless partly an accident of survival and reflects high infant mortality at the period as well as the bias of collectors for small intact garments. As with hooded cloaks the continuation of the tradition can be seen in the clothing of the Berbers of Morocco, who wear hooded jackets (*jallaba*) constructed in a similar manner, although they usually have sewn-on sleeves and a centre front opening.[21]

Fig 5.5, Detail of lower edge of wool cloak woven in weft-faced tabby with applied fringe, 13/18 threads per cm, *T.9886*.

20 P. du Bourguet, *Catalogue des étoffes coptes du musée du Louvre* (Paris, 1964), pp.572–73 and M.H. Rutschowscaya, *Coptic Fabrics* (Paris, 1990), p.55; A. Stauffer, *Textiles of Late Antiquity* (New York, 1995), p. 27. The proposed eleventh century date for the garment in the Louvre is now considered to be incorrect.

21 C. Spring and J. Hudson, *North African Textiles* (London, 1995), p.86.

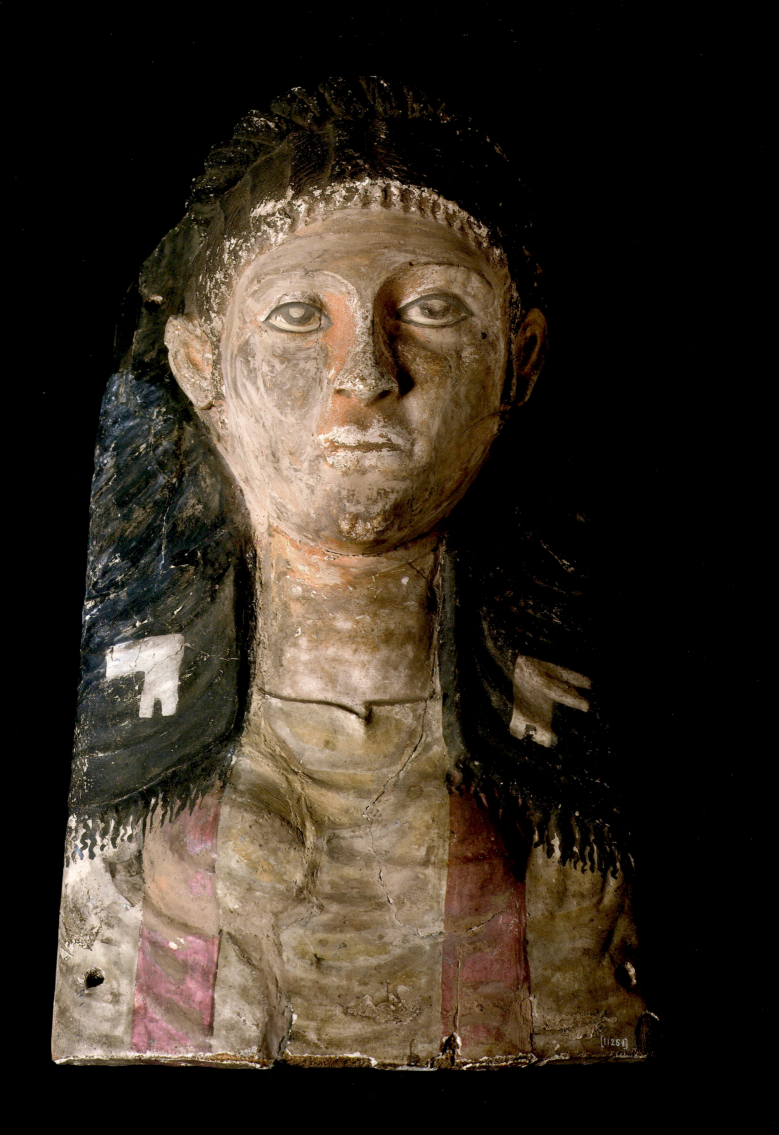

Hooded clothing made from linen is less common. Two hooded tunics, of which one is reputed to have been found at Akhmim and is now in the Gemeentemuseum, The Hague, The Netherlands, and the other in the Ashmolean Museum, Oxford, are both made from recycled cloth with applied tapestry-woven decoration.[22] Consequently, their construction is more makeshift than if they had been purpose woven.

Mantles were long, rectangular purpose-woven garments worn by men and women that required no sewing at all. Depictions show them placed over the left shoulder, wound round the body and draped over the left arm leaving the right arm free for greater movement (see frontispiece). They were, therefore, of considerable overall length. An almost complete woman's mantle from the Cave of Letters in Israel, which dates to no later than AD 132, is 2.7 metres in length and 1.4 metres wide.[23] During the first and second centuries AD it was common for mantles to be decorated in the corners with tapestry-woven motifs such as notched bands, gammas and swastikas worked in a contrasting colour (Fig 5.6), but these marks appear to have lost their significance after the third century, although they often continued to be represented on wall paintings and mosaics.[24] More elaborate tapestry-woven corner motifs appear on some textiles identified as mantles, although they have also been interpreted as hangings or curtains.[25]

It is, indeed, often difficult to distinguish wool mantles from furnishing fabrics such as mattress covers. Fortunately some mantles and shawls have been recorded in association with specific burials, thereby aiding the identification of more fragmentary pieces. Examples from Egypt include a shawl recovered from the grave of Leukyôné at Antinoë, which is patterned with a group of yellow bands on a red ground and a fringe of twisted threads and was worn over a yellow wool tunic with beige stripes at the sides and pile woven on the inside.[26] Mantles could also be woven from more luxurious silk fabrics and a particularly lovely example is represented on the mid-sixth century mosaic at San Vitale, Ravenna of Empress Theodora and her court. This mantle enveloping the woman standing beside the empress, has an all-over pattern of small hexagons and a large, presumably tapestry-woven, eight-pointed star in one corner.

A diagnostic feature of many wool mantles appears to be the slightly open texture of the weave, which would have helped to trap the air and keep the body warm. They were also woven in a relatively balanced tabby weave, in contrast to the many weft-faced fabrics used for other types of wool clothing, and sometimes the yarn was highly twisted in both the warp and weft resulting in a crêpe-like fabric. Textiles of a similar character were recovered from looted burials at Khirbet Qazone, which is situated close to the Dead Sea in Jordan. They probably date to the late first or second century and have been interpreted as summer mantles or scarves.[27] Petrie gave to the Whitworth Art Gallery an almost complete mantle or shawl of this type made from predominantly blue wool (Fig 5.7). It has a loomwidth of 775mm and

opposite: Fig 5.6, Plaster mask for a female mummy, probably from near Hermopolis Magna, Middle Egypt, 2nd century (© *The Manchester Museum*). The mantle has a gamma motif at each corner.

22 M. Flury-Lemberg, *Textile Conservation and Research* (Bern, 1988), pp.238–39; Ashmolean Museum, accession number 1888.1109.

23 Y. Yadin, *The Finds from the Bar-Kokhba Period in the Cave of Letters* (Jerusalem, 1963), p.238.

24 N. K. Adams and E. Crowfoot, 'Varia Romana: textiles from a Roman army dump', in P. Walton Rogers, L. Bender Jørgensen and A. Rast-Eicher, *The Roman Textile Industry and its Influence* (Oxford, 2001), pp.33–36.

25 Rutschowscaya, op. cit. in note 20, pp.60 and 151.

26 F. Calament, 'Une découverte récente: les costumes authentiques de Thaïs, Leukyôné & Cie', *La revue du Louvre et des Musées de France* 2 (1996), pp.28–29.

27 H. Granger-Taylor, 'The textiles from Khirbet Qazone (Jordan)', in D. Cardon and M. Feugère (eds.), *Archéologie des textiles des origines au Ve siècle de notre ere. Actes du colloque de Lattes, octobre 1999* (Montagnac, 2000), p.154.

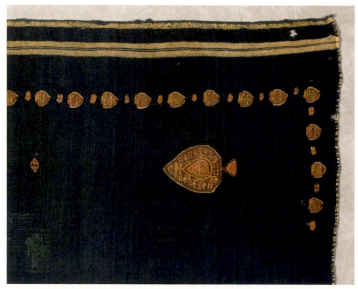

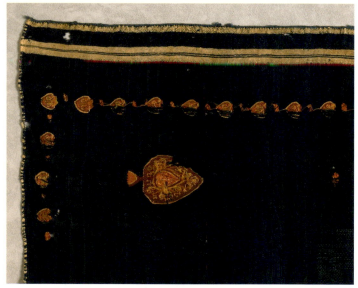

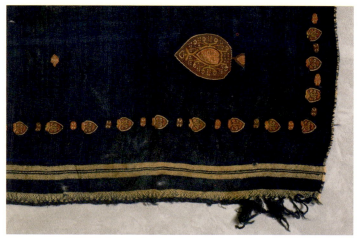

measures 1.89 metres in length so that it is smaller and lighter than the mantle from the Cave of Letters mentioned above but very similar to an example from Kirbet Qazone, which is over 1.8 metres in length and 750mm wide. The sides are reinforced with a pair of white selvedge cords and each end is patterned with bands of white wool and a series of tapestry-woven buds, eighteen at one end and sixteen at the other indicating that the tension on the loom decreased nearer to the finish of the piece. It is not reversible as there are strands of floating wefts on the back obscuring some of the tapestry patterning and neither of the narrow edges is finished with a fringe. A comparable maroon-coloured shawl in the Louvre is 1.4 metres in length and 800mm wide.[28] The arrangement of the patterning is very similar, with yellow bands at each end and four tapestry-woven ornaments in the corners in the shape of large buds. However, a fringe of green wool adds a further touch of colour to the garment.

Fragments of wool cloth of very similar weight and appearance probably also derive from mantles or lightweight shawls. They are woven in a wide range of colours – red, green, yellow, blue and violet – and often have a series of bands in a contrasting colour close to the edges (Fig 5.8, see page 116). In addition, the selvedge cords are frequently in a contrasting colour, usually white, and many have fringes formed from groups of plied or plaited ends.

More transparent wool veiling of even lighter weight may have been intended to drape over the head rather than the neck and shoulders. A fragment woven from S-spun white wool has a sequence of selfbands in thicker yarn and a group of small tapestry-woven crosses in violet-coloured wool (Fig 5.9). Another piece of the same cloth has been extensively darned. These fragments given by Petrie probably come from el-Lahun in the Fayum and are likely to date to the seventh or eighth century. They may be considered forerunners of the specialist output in shawls, veils and turbans produced in the Fayum after the Arab conquest, which is known both from written sources and from *tiraz* pieces (the latter referring to textiles with an inscription embroidered or woven across them in a band). An example of a white wool shawl of this type, 720mm wide, which is preserved in the Benaki Museum, Athens, is inscribed in coptic Greek with a prayer and the name l'Apa Thôter.[29] This unusual name and the style of lettering enables it to be linked to the Fayum and dated to the tenth century.

Similarly other lightweight tabby-woven textiles made from dark purplish-black wool patterned with narrow bands in softer spun yarn and further bands in linen thread (Figs 5.10 and 5.11) bear a striking resemblance to the *tiraz* shawls produced at private workshops in the Fayum and other centres, including Bahnasâ (Oxyrhynchus), from the eighth century.[30] Dye analysis of the dark-coloured yarn on one of Petrie's textiles reveals a sophisticated understanding of colour. First it was dyed a deep blue using woad or indigo, then darkened with a tannin-based dye – probably a tree bark or oak galls- and finally boosted with a madder-type dye.[31] Therefore, the dyeing evidence also illustrates the highly skilled workshop practices that produced such textiles.

opposite:

Fig 5.7(a), Diagram of wool shawl, 14/9 threads per cm, *T.8564*.

Fig 5.7(b), Detail of wool shawl, *T.8564*, showing starting border, tapestry-woven decoration and darning.

Fig 5.7(c), Detail of reverse.

Fig 5.7(d), Detail of finishing border.

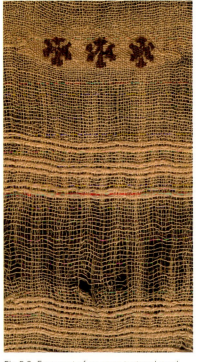

Fig 5.9, Fragment of an open-textured wool shawl, 13/10 threads per cm, *T.9876*.

28 Bourguet, op. cit in note 20, pp.574–5.

29 M. Durand and F. Saragoza (eds.), *Égypte, la trame de l'Histoire. Textiles pharaoniques, coptes et islamiques* (Paris, 2002), p.199.

30 M. Durand and S. Rettig, 'Un atelier sous contrôle califal identifié dans le Fayoum: le tiraz privé de Tutun' in Durand and Saragoza, op. cit. in note 29, pp.167–70.

31 P. Walton Rogers, 'Dyes in miscellaneous samples from the Whitworth Art Gallery', 4 September 2004.

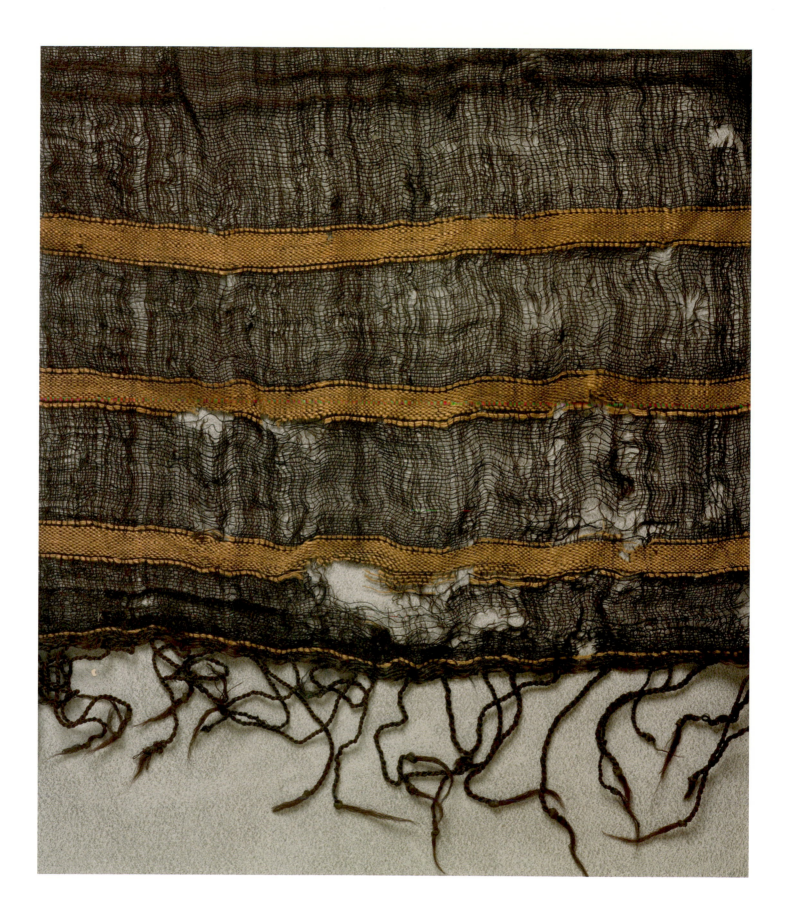

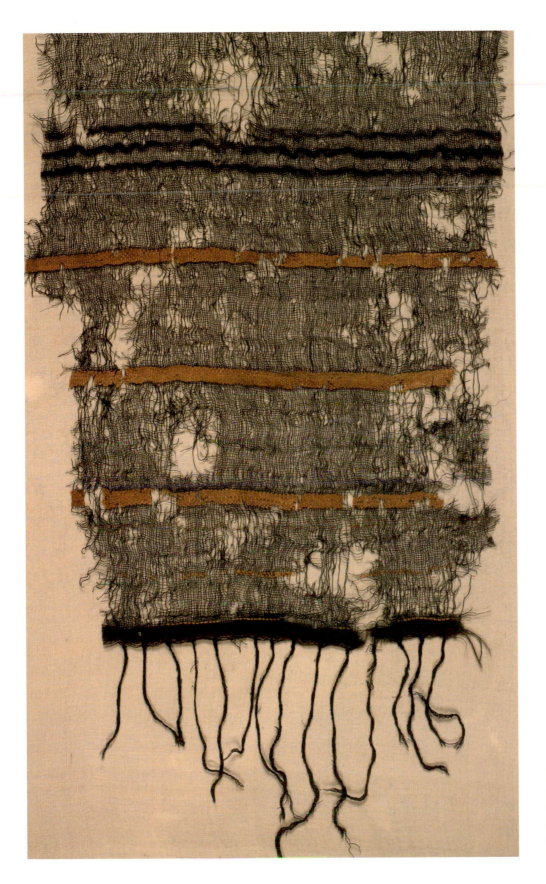

opposite: Fig 5.10, Detail of one end of a fine wool shawl, 9/10 threads per cm, with three linen bands and a plied fringe, *T.9193*. It has a complete loomwidth of 1.29 metres.

Fig 5.11, Detail of one end of a fine wool shawl, 12/10 threads per cm, with four linen bands and a plaited fringe, *T.9863*.

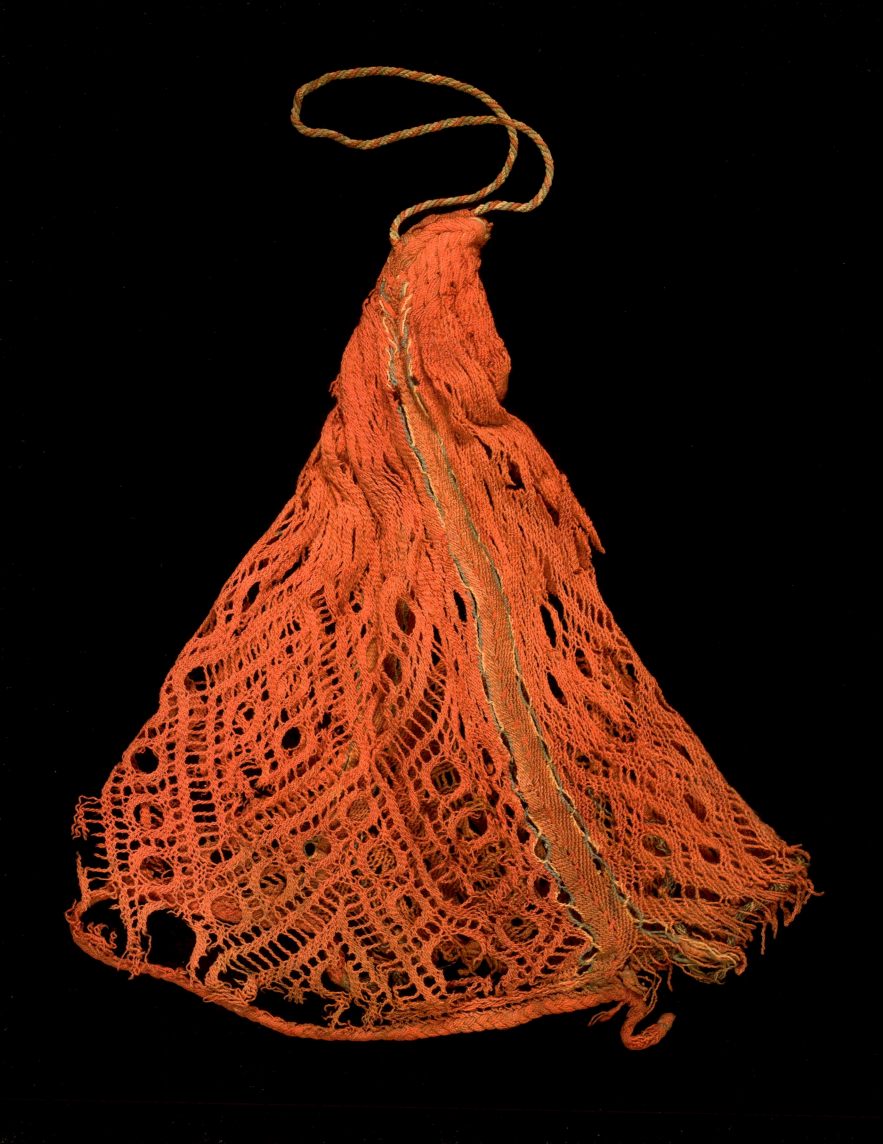

Chapter 6

Headwear

HEADDRESS PLAYS A SIGNIFICANT ROLE in most societies in denoting status, gender and age, as well as serving more practical purposes, and in this respect Egypt in the first millennium was no exception. Consequently, it is easier to distinguish male from female headwear than for many other items of clothing. The different types of headcoverings described here range from sprang caps, hairnets and headbands, chiefly for women, to hoods and protective hats for men.

A married woman in the Roman and Byzantine periods was expected to cover her head when out of doors and generally this was achieved by pulling her large, draped mantle over her head. This did not flatten her hairstyle to the same extent that would have been the case had she placed a fitted headdress on top of her head. It was an important consideration since great emphasis was placed on elaborate coiffures with complex arrangements of curls and plaits that gave rise to much ridicule in contemporary literature.[1] Mummy portraits and masks provide an idealised impression of how hair was dressed among the wealthier sections of society in Egypt in the early centuries of Roman rule (Figs 1.4 and 5.6). Criticism of the length of time women spent on their hair was also a theme of some Christian evangelists in Egypt and North Africa at the beginning of the third century. Tertullian chastised women on their vanity: *'All this wasted pain on arranging your hair – what contribution can this make to your salvation? Why can you not give your hair a rest? One minute you are building it up, the next you are letting it down – raising it one moment, stretching it the next. Some women devote all their energy to forcing their hair to curl, others to making it hang loose and wavy, in a style, which may seem natural, but is not natural at all. You perpetrate unbelievable extravagances to make a kind of tapestry of your hair, sometimes forming a sort of sheath to your head and a lid on top like a helmet, sometimes an elevated platform, built on the back of your neck'.*[2]

Burials from many sites in Egypt offer a different perspective on the subject of head-dress for it is apparent that it was relatively common for women to wear their hair protected by semi-transparent hairnets and elaborately patterned snoods made in a technique known as sprang. This is the name given to 'a method of making a fabric by manipulating the parallel threads of a warp that is fixed at both ends. The manipulation can take the form of interlinking, interlacing or intertwining adjacent threads or groups of threads. The work is carried out row by row at one end of the warp [and] as an

opposite: Fig 6.14(a), Wool openwork sprang cap, *T.9864*. Height: 290mm.

1 J. P. V. D. Balsdon, *Roman Women. Their History and Habits* (London, 1962), pp.255–6.

2 Tertullian, *De cultu feminarum*. 2, 7 quoted in Balsdon, op. cit. in note 1, p.258.

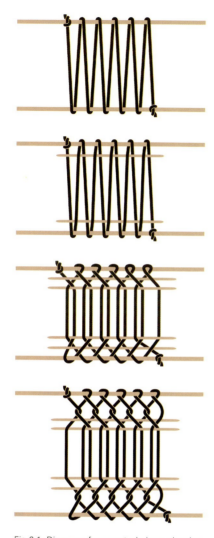

inevitable result of the warp being fixed at both ends, corresponding but contrary movements of the threads appear simultaneously at its other end' (Fig 6.1).[3] Caps made in sprang were probably a Hellenistic introduction into Egypt since headwear of this kind was worn in Greece at least as early as the fifth century BC, when depictions of the caps, and the small frames on which they were made, appear in Greek art.[4] They were also worn in other parts of the Near East, including Syria and Israel,[5] and a mosaic in Tunis shows a woman spinning with her hair restrained by a patterned snood, which closely resembles a polychrome sprang cap (Fig 6.2).

In Egypt, sprang caps have chiefly been recovered from burials, although a few in a more fragmentary state have been recorded from settlement sites such as Karanis.[6] Many were found placed on the head and strands of hair are sometimes still preserved

Fig 6.1, Diagram of sprang technique, showing mesh formed simultaneously at both ends, worked on a frame with rods.

Fig 6.2, Detail from a mosaic showing a woman spinning with her hair concealed by a patterned snood (*Bardo National Museum, Tunis*).

3 P. Collingwood, *The Techniques of Sprang* (London, 1974), p.31.

4 I. Jenkins and D. Williams, 'Sprang hair nets: their manufacture and use in ancient Greece', *American Journal of Archaeology* 89 (1985), pp.416–17, figs.2–6, 12–16.

5 A. Sheffer and H. Granger-Taylor. 'Textiles from Masada. A Preliminary Selection', in *Masada IV* (Jerusalem, 1994), pp.216–20.

6 L. M. Wilson, *Ancient Textiles from Egypt in the University of Michigan Collection* (Michigan, 1933), pp.43–5.

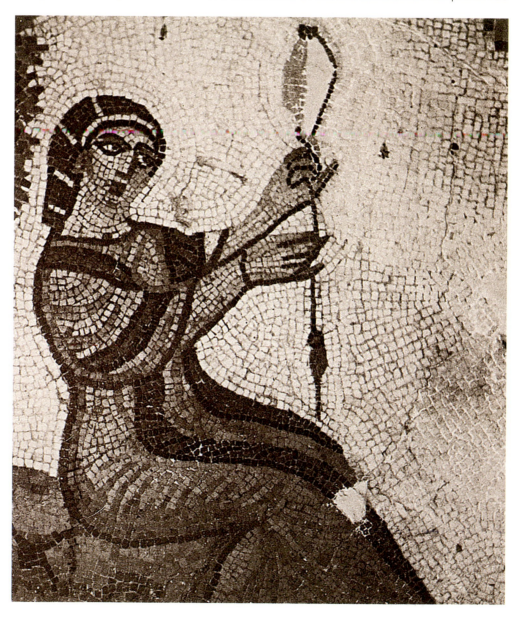

Fig 6.3, Woman's head with a sprang cap from a burial at Hawara (© *Petrie Museum of Egyptian Archaeology, University College London, UC28073*).

caught between threads.[7] However, the caps were not always worn in the manner that they would have been in life. An example of this is preserved in the Petrie Museum, University College London, for in its collection from Hawara is the head of a woman, who was aged around forty at death, with a cap in place on the head covering the eyes and much of the face, thereby suggesting that a special burial ritual was being followed (Fig 6.3).[8] Another middle-aged woman buried at Deir-el-Bahri, near Thebes, in the fourth century had three wool sprang caps over her hair that had first been bound in linen cloth.[9] Extra caps were also often placed in a pile beside the corpse for use in an afterlife. For example, Petrie recovered a small lidded basket containing three hairnets from a burial at Hawara[10] and during the 1901–2 season at Antinoë, Albert Gayet recorded five unworn caps from the grave of Leukyônè, in addition to a 'lacelike' wool bonnet on her head that was held in position by a band of bound plant fibres.[11] It is this distinctive type of arched headband that is depicted on the *clavi* of a three-piece tunic

7 W. D. Cooke and A. Tullo, 'The conservation of a collection of Coptic sprang hats in the Whitworth Gallery, Manchester', *Bulletin du CIETA* 66 (1988), p.7.

8 A. Javér, D. Eastop and R. Janssen, 'A sprang cap preserved on a naturally dried head', *Textile History* 30/2 (1999), pp.135–9.

9 A. Stauffer, *Textiles of Late Antiquity* (New York, 1995), p.29 and p.46, no. 41; Javér et al, op. cit. in note 8, p.139.

10 W. M. F. Petrie, *Hawara, Biahmu, and Arsinoe* (London, 1889), p.12, pl.xix, no.21; S. Walker and M. Bierbrier, *Ancient Faces. Mummy Portraits from Roman Egypt* (London, 1997), p.212, no.321.

11 A. Gayet, *Notice relative aux objets recueillis à Antinoë pendant les fouilles exécutées en 1901–1902 et exposés au musée Guimet du 5 juin au 5 juillet 1902* (Paris, 1902) p.123; F. Calament, 'Une découverte récente: les costumes authentiques de Thaïs, Leukyôné & Cie', *La revue du Louvre* 2 (1996), pp.28–9, fig.4.

Fig 6.4 Detail of clavus showing styles of male and female headdress, *T.1994.132*.

12 See A. Lorquin, *Les Tissus Coptes au musée national du Moyen age – Thermes de Cluny* (Paris, 1992), p.19; Collingwood, op. cit. in note 3, p.128.

13 Jenkins and Williams, op. cit. in note 4, pl.43, fig.13.

14 See A. F. Kendrick, *Catalogue of Textiles from Burying-Grounds in Egypt. Vol. II* (London, 1921), p.90, no.605.

15 Accession nos. 63.11.17 to 26.

16 Javer *et al.* op. cit. in note 8, p.135; Wilson, op. cit. in note 5, pp. 43–5; K. H. South, M. C. Kuchar and C. W. Griggs, 'A preliminary report of the textile finds, 1998 season, at Fag el-Gamus', *Archaeological Textiles Newsletter* 27 (1998), p. 10; P. Linscheid, 'Late Antique to Early Islamic Textiles from Egypt', *Textile History* 32/1 (2001), p.78; Kendrick, op. cit. in note 14, pp. 89–91; M. Erikson, *Textiles in Egypt 200–1500 A.D. in Swedish Museum Collections* (Gothenburg, 1997), pp.167–8.

17 Wilson, op. cit. in note 6, p.44.

18 Petrie, op. cit. in note 10, p. 12, pl.xviii.

19 A. De Moor, C. Verhecken-Lammens and M. Van Strydonck, 'Radiocarbon dating of Coptic woollen caps in sprang technique', *Bulletin du CIETA* 79 (2002), pp.26–32.

described above, where it is shown as the feminine equivalent of a Phrygian cap (see p.70, Fig 6.4).

Sprang caps worn in Egypt were made in a variety of styles using either two-ply wool or linen yarn or a combination of threads of the two fibres. The choice of two-ply yarn not only enabled it to withstand the tension on the frame but it also made a cap more durable. Caps made only from wool were more naturally elastic but by creating open-work patterns greater elasticity was imparted to linen as well as to wool caps. Overall, they reveal a considerable mastery of the technique and its rich patternmaking potential. In shape the caps are either rectangular or tapered, the latter resulting from narrowing the width of the cap by combining groups of threads as the centre-point was reached on the frame, when it was more difficult to manipulate the warp threads and to keep the tension even.[12] However, most caps are at least slightly reduced in width at the centre. Another difference was the manner in which the caps were finished. Usually a cord was passed through the centre of the web to prevent the fabric from unravelling and the cord was also used to pull the cap into the shape of the head when worn (Fig 6.5). Alternatively, when folded in half, the top of the cap was very firmly stitched to form a tail or tassel, which probably hung downwards at the back of the head as shown in earlier depictions on ceramic vessels from Greece (Fig 6. 6).[13] Some caps show a combination of these two methods of finishing, both a centre cord and stitched tassel. The trimmings attached to the lower edge of the cap at the front, which would have been worn on the forehead or brow, were also made in a variety of ways. They include narrow three-strand plaits that frequently match the colour of the cap, thicker plaits of up to nine strands often in a contrasting colour, bands of sprang, or bands in tabby weave requiring very little equipment to produce. At the back of the cap the loops were left when it was removed from the frame. Two cords, often made by plying long strands left from the browband, were threaded through the loops and tied at the nape of the neck, or on top of the head at the front.

The wool caps are usually very colourful, revealing a considerable range and combination of patterns from stripes, chevrons and diamonds, possibly imitating hair jewels,[14] to subtle effects mimicking the interlinking of threads, but monochrome wool caps were also produced characterised either by textured patterning or openwork. All ten sprang caps donated to the Whitworth Art Gallery by Petrie are made from wool, as are the caps that he gave to Bolton Museums and Art Gallery, all of which came from the cemetery at el-Lahun.[15] Similar caps have been recovered from other sites in the Fayum, including Hawara, Karanis, Fag el-Gamus, Heracleopolis Magna and Crocodilopolis, as well as from Akhmim and Matmar further south.[16] Two wool caps recovered from rubbish deposits at Karanis had coins dating from the late fourth to mid fifth century associated with them,[17] and at Hawara a cap of crimson wool in an openwork style was recovered from a tomb of around the fourth century.[18] Further dating evidence for a variety of sprang caps made from wool thread has recently been obtained from carbon-14 dating ten examples in a private Belgian collection.[19] This provided an overall

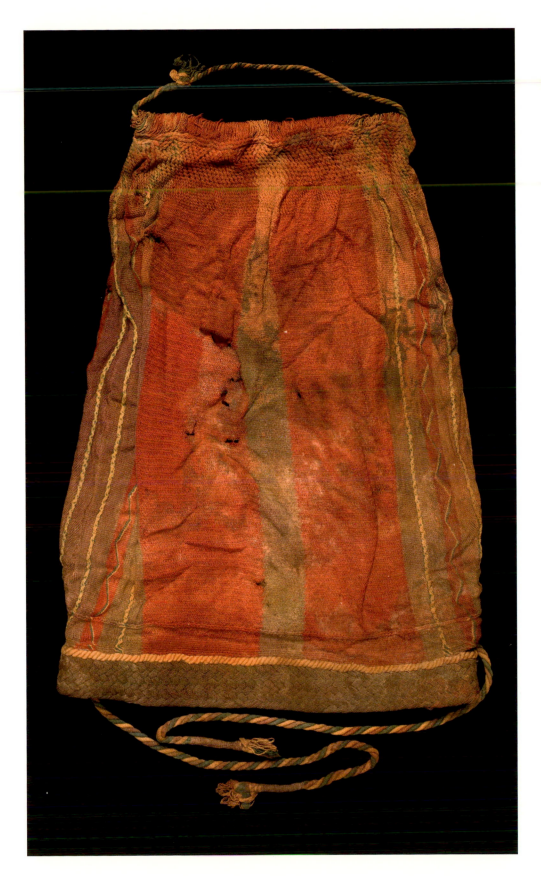

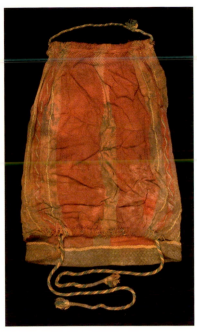

Fig 6.5(a), Front and back of rectangular wool sprang cap, *T.8364*. Height: 410mm.

Fig 6.5(b), Diagram of rectangular sprang cap.

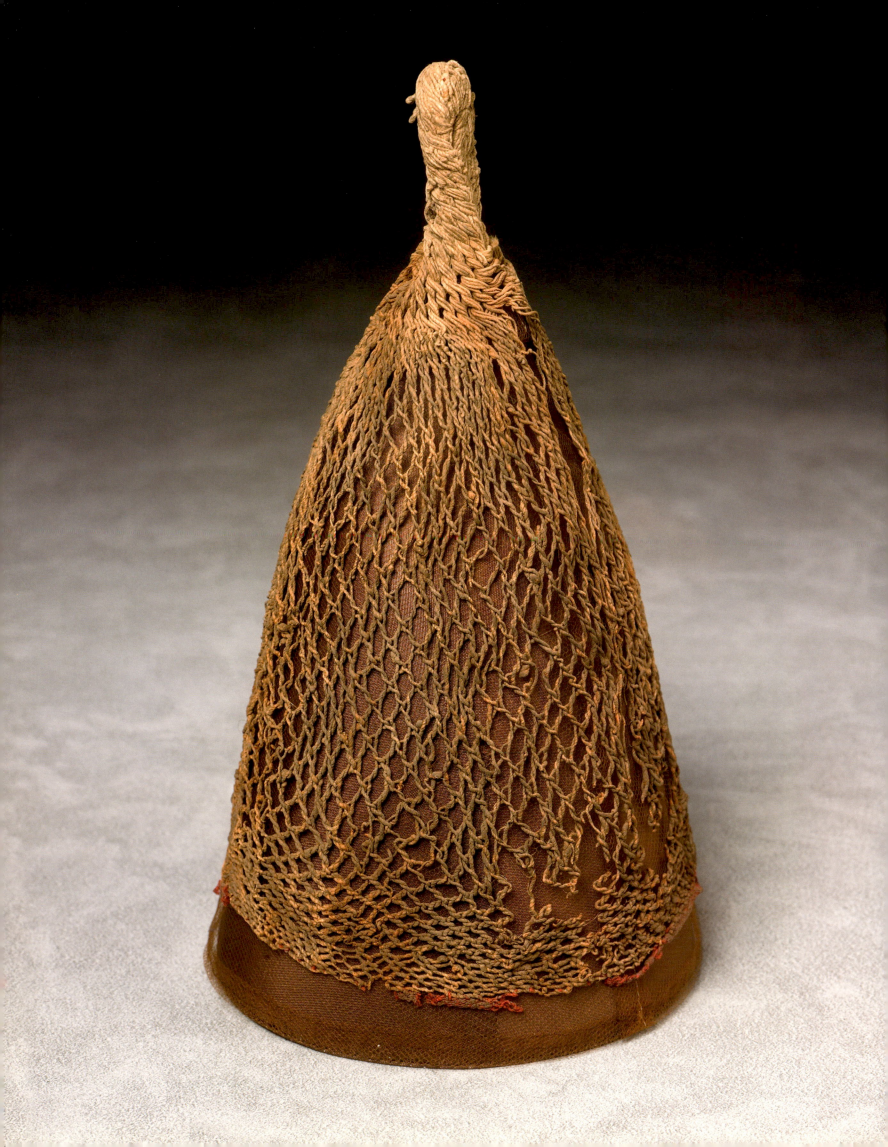

date range of AD 430 to 675. It seems, therefore, that such caps were worn infrequently, if at all, after the Arab conquest. An exception is a linen cap from the Fayum, now in Berlin, that has been carbon-14 dated AD 651–706.[20]

There was some standardisation of patterns, as well as a preference for particular colour schemes. Red caps with patterning in green, yellow and purple were popular at el-Lahun and some are almost identical. Four wool caps now in Manchester and another two in Bolton are also finished with similar red and yellow patterned bands of intertwined sprang that perhaps represent a localised workshop practice (Figs 6.7, 6.8 & 6.9).

Often extra threads were twined through the interlinked ground structure, either diagonally or vertically, to provide further patterning frequently in the form of lines, spots and diamonds. For example, one cap in Manchester has yellow threads worked in this manner (Fig 6. 10), and in another pairs of yellow threads regularly switch from twining

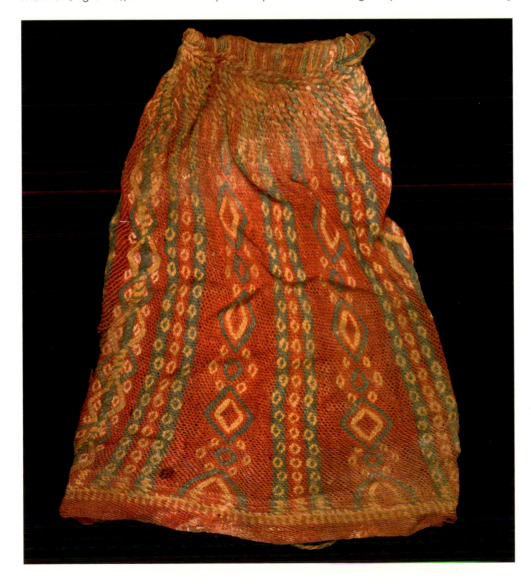

opposite: Fig 6.6(a), Linen sprang hairnet of tapering shape excavated at Antinoë 1913–14, *T.1995.5*. Height: 260mm.

above: Fig 6.6(b), Diagram of tapering sprang cap.

left: Fig 6.7, Polychrome wool sprang cap with red and yellow sprang browband, *T.8370*. Height: 350mm.

20 C. Fluck,'Carbon-14 analysed textiles in the Museum für Byzantinische Kunst, Berlin', in C. Fluck and S. Schrenk (eds.), *Textiles and Methods of Dating* (forthcoming).

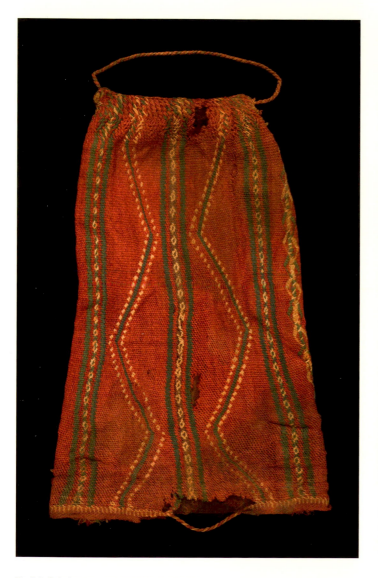 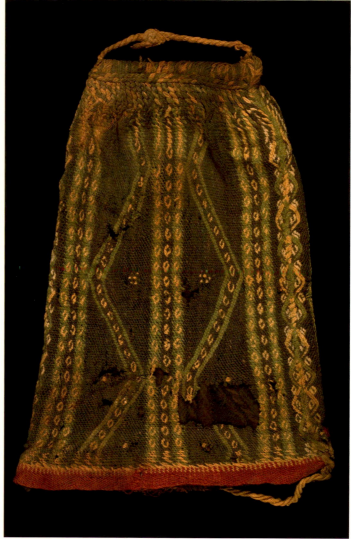

Fig 6.8, Polychrome wool sprang cap with red and yellow sprang browband, *T.8373*. Height: 420mm.

Fig 6.9, Polychrome wool sprang cap with red and yellow sprang browband, *T.8369*. Height: 375mm.

opposite: Fig 6.10, Polychrome wool sprang cap with plaited browband, *T.8371*. Height: 340mm.

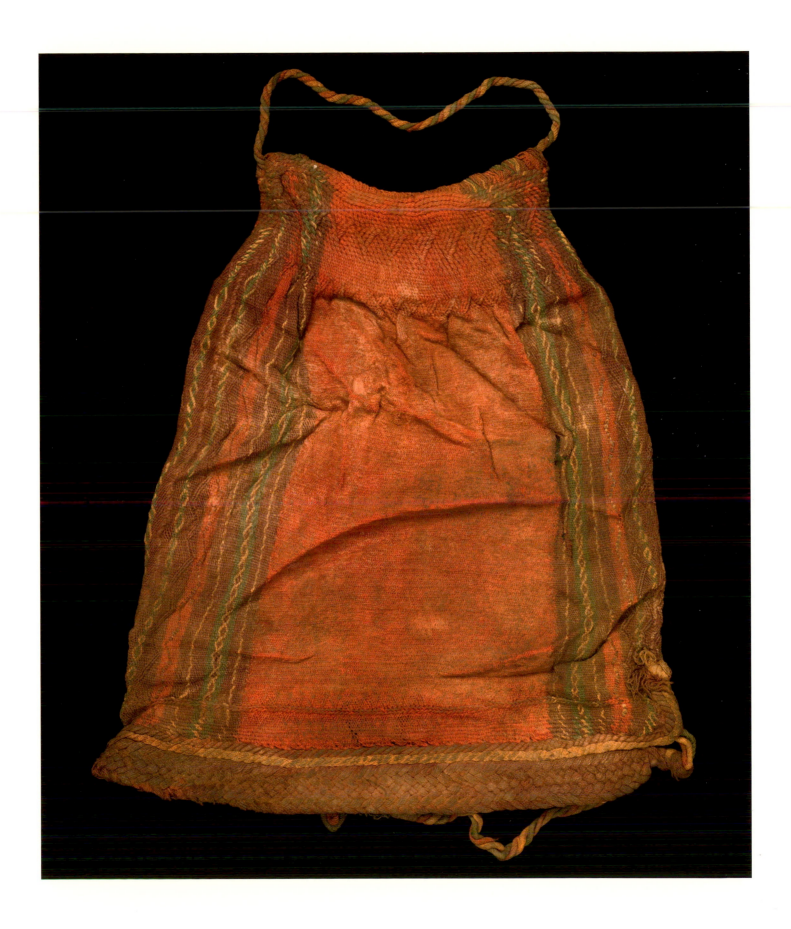

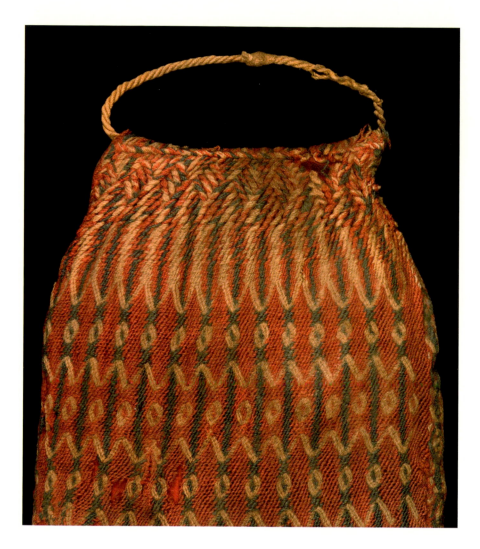

Fig 6.11, Part of a polychrome wool sprang cap with yellow chevrons and dots worked in interlinking and twining, *T.8363*.

Fig 6.12, Diagram of interlinked sprang showing method of decreasing, triangles formed by changing the direction of twist and chain at centre of cap.

opposite: Fig 6.13, Polychrome wool sprang cap with plaited browband, *T.8368*. Height: 350mm.

21 The method is described in Collingwood, op. cit. in note 3, pp.153–64.

22 Collingwood, op. cit. in note 3, pp.166–7. The ridge is not duplicated at the opposite end of the warp.

23 Collingwood, op. cit. in note 3, pp.103–5.

to interlinking to produce chevrons and dots (Fig. 6.11).[21] The former cap, like many, has a row of chaining just on the front,[22] a short distance above the starting edge; this would have helped to strengthen the cap and keep it in shape at a vulnerable point when it was on the head. Above and below the chained ridge on this cap is a row of chevrons formed by changing the direction of the interlinked twists in a set sequence, a feature that was regularly repeated near the top of the cap (Fig 6.12). It also has self-patterned bands worked across the broad centre section that were created by altering the direction of twist of the interlinking every four rows, which was another characteristic of many wool caps.[23] Caps combining various types of patterning had to be carefully planned before the work began and the ingenuity of the designs is impressive (Fig 6.13).

Caps with elaborate openwork patterns made wholly from wool thread tend to be very close in style to caps made from linen thread and they have a similar distribution. Generally, a single colour was used for the web, although touches of colour were sometimes added by including threads of contrasting colour at the sides or for the drawstrings at

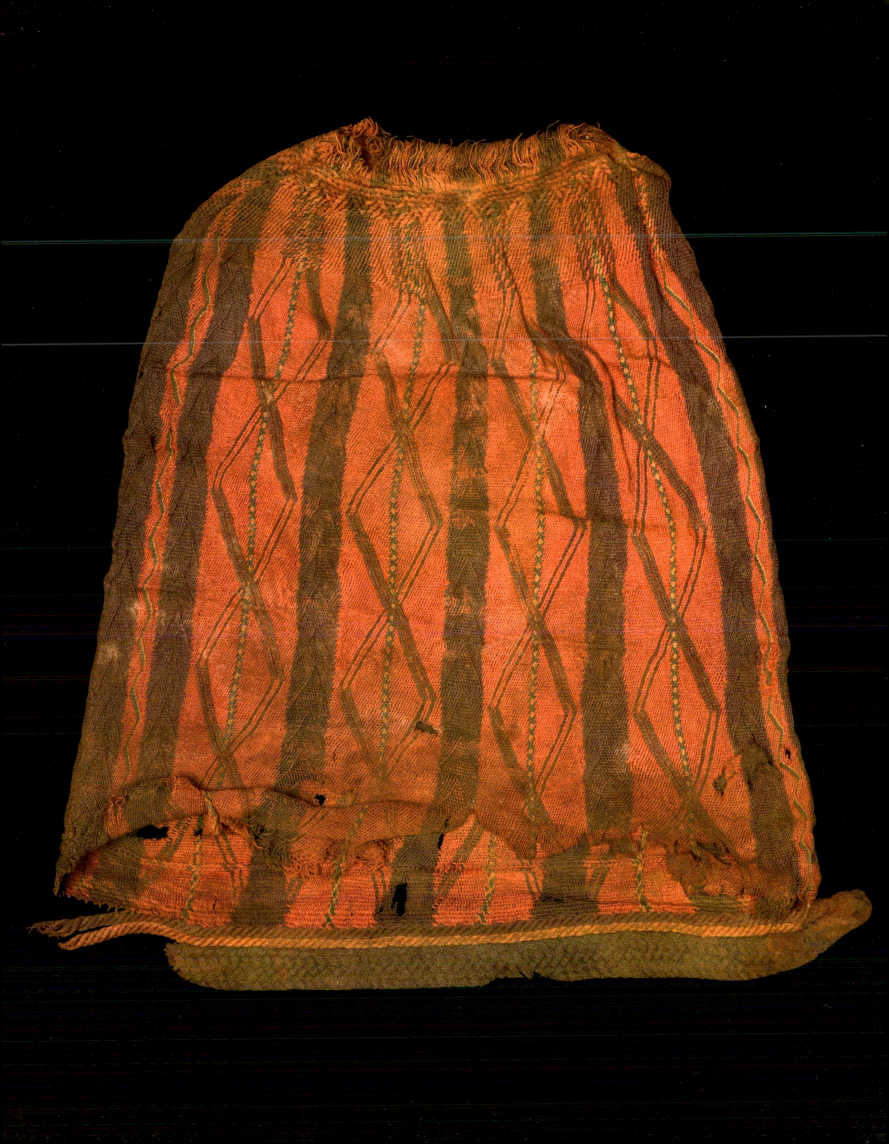

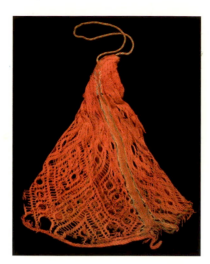

Fig 6.14(a), Wool openwork sprang cap, *T.9864*. Height: 290mm.

Fig 6.14(b), Detail.

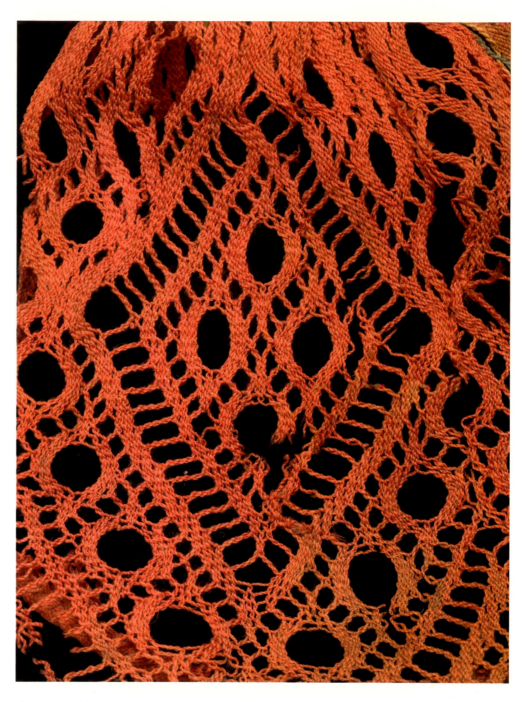

the top and lower back edge. An example, in Manchester, made from red wool has a pair of yellow and blue threads close to the sides, and the drawstrings at the neck and centrefold are plied from threads of the same colours (Fig 6.14). The openwork is formed by interlinking groups of threads together, as well as imparting multiple twists in order to elongate the holes and add stability to the structure.

Linen sprang caps, by contrast, were exclusively produced with openwork patterns, although in varying degrees of sophistication. These are the type of hairnets that appear

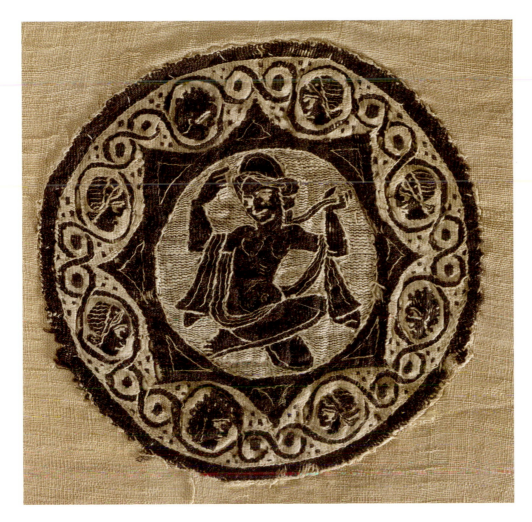

Fig 6.15, Tapestry-woven medallion showing Aphrodite encircled by five female heads wearing stylised hairnets, 6th century (© *Musée de Cluny, Paris*).

Fig.6.16 Diagram of openwork sprang mesh formed from alternate rows of 1/1 and 2/2 interlinking.

to be represented on the female heads encircling Aphrodite on a tapestry-woven orna-ment (Fig 6.15). Many of these hairnets were retrieved from burials in Antinoë, including a small hairnet, now in Manchester, which was excavated during the 1913–14 season (see Fig 6.6). This cap has a simple mesh formed for the most part from rows of 1/1 interlinking alternating with 2/2 interlinking (Fig 6. 16). It is seamed up the sides in linen thread and along the bottom edge is a narrow band of red wool. A single thread of red wool is also added to the tassel at the top.

There are also sprang hairnets that combine threads of linen and wool. Again many have been recorded from Antinoë, but this reflects the vast size of the cemetery and quantity of burials and other caps of this type from Heracleopolis Magna, Saqqara and Akhmim show that they enjoyed widespread popularity.[24] It is likely that they are less frequently preserved due to the combination of the fibres rather than that they were less common in antiquity. A cap recovered from the 1913–14 season at Antinoë is worked with panels of dark blue wool alternating with panels of undyed linen and by interlinking the threads in different sequences the size and pattern of the mesh changes in the contrasting panels (Fig 6.17). A similar hairnet was among three recovered in 1901

24 Kendrick, op. cit. in note 14, pp.90–1, nos.608 and 610; Stauffer, op. cit. in note 9, p.29, no.40

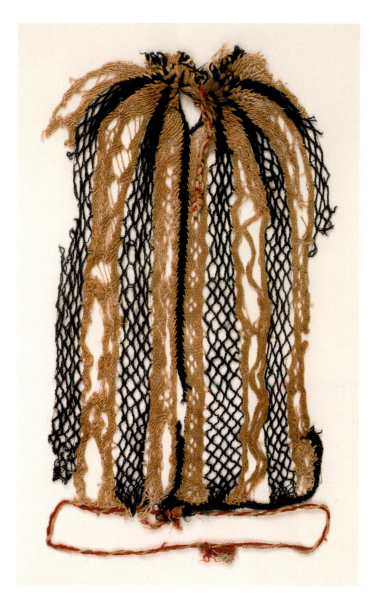

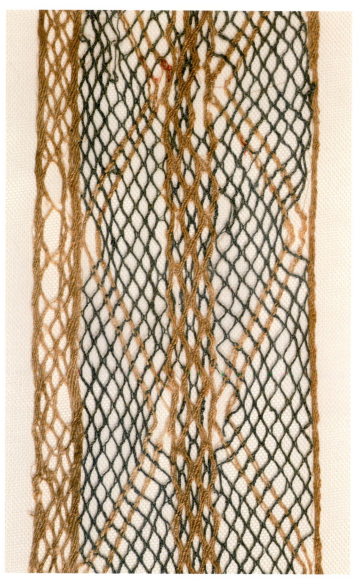

Fig 6.17, Part of a wool and linen openwork sprang cap excavated at Antinoë 1913–14, *T.1968.290*. Height: 250mm.

Fig 6.18, Detail of a linen sprang headband, *T.1968.302*. Width: 110mm.

25 J. De Boeck, 'The conservation of a Coptic sprang cap', *Conservazione e Restauro dei Tessili* (Como, 1980), pp.160–2.

26 Lorquin, op. cit. in note 12, pp.83–7, nos.15–21.

27 Linscheid, op. cit. in note 16, p.10.

from the grave of Aurelius Colluthus, which is said to date to the fifth century.[25] Other hairnets from Antinoë show further variations of the technique with narrow stripes of red or blue wool worked in basic interlinking combined with openwork panels of linen.[26]

In addition to narrow bands of sprang being added as browbands to caps, they were also worn separately as headbands. Part of such a headband, 110mm wide, is preserved from the 1913–14 excavations at Antinoë. It has an openwork mesh formed from blue and bleached linen threads but has been repaired with strands of red wool (Fig 6.18).

Different types of headbands have been recorded from Egypt in other collections, including four from Heracleopolis Magna, that are made from linen with applied strips of silk or tapestry in the centre front,[27] and there are probably many more examples that have not, as yet, been identified.

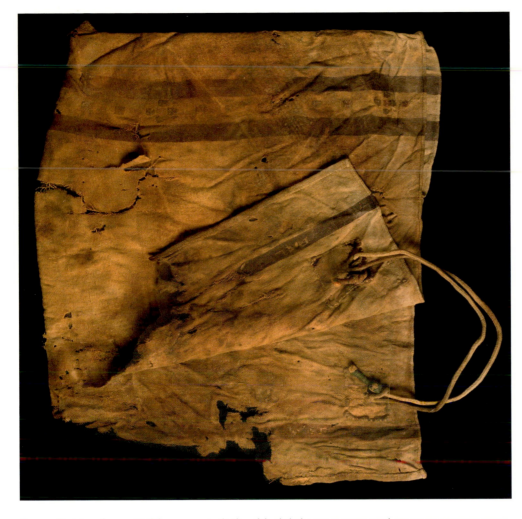

Fig 6.19(a), Wool hood, 9/47 threads per cm, *T.1978.17.* Height: 400mm.

Fig 6.19(d), Diagram of hood.

A small strip of a red tabby-woven cloth with tightly spun yarn and an open weave excavated at Antinoë in 1913–14 is all that remains of another type of woman's headwear.[28] It is probably a piece of a veiling for covering the hair, which would have been held in place by a headband. In weight and weave it foreshadows the fine wool veiling used for turbans, shawls and scarves in the ninth and tenth centuries (see chapter 5, p.125).

Hoods were another type of headwear worn in Egypt. Usually woven as an integral part of a wool cloak, or overtunic, a few lightweight examples in linen have also been preserved (see chapter 5, p.123). Separate, purpose-made hoods have been recorded less often but their simple, standard form and construction suggests that they may have been more common than has so far been noted. Made from a strip cut from a loomwidth, the cloth was folded in half and seamed along the top edge with the lower edge folded double and hemmed. An example made from linen was recovered from a third or fourth century burial at Bagawat.[29] A wool hood of this type in the Whitworth Art Gallery is probably slightly less old and the decoration woven into it suggests that it had a Christian significance and may have served a special use (Fig 6.19). Two characteristics hint at this. First, between the two upper, purple bands is a row of cruciform crosses.

28 Accession no. *T.1995.4.* It is associated with an openwork sprung cap.

29 Metropolitan Museum of Art, New York, accession number 14.1.230.

Fig 6.19(b), Detail showing position of side patch and part of inscription.

Fig 6.19(c), Detail of inside face showing chin cord with tassel and loop fastening.

In addition, woven along the lower band is a sequence of letters, which are very worn and have so far not been deciphered. Both these features suggest this hood may be associated with some narrow scarves or stoles also interwoven with crosses and sometimes including Greek or Coptic lettering (see Fig 3.7). Another characteristic of the hood is the ingenious manner in which the chin cords have been secured to the side flaps. Two square, finger-plaited cords are finished at one end with a tassel to which coloured threads have been added and bound into place. The opposite ends of each cord have been stitched to form a loop through which the other cord passes, with the tassel acting as a stop. Both loops are protected by a square patch of cloth oversewn to the inside of the hood (Fig 6.19c).

A small conical cap made from pieces of coloured felt is another distinctive type of head-wear (Fig 6.20). Four triangular pieces of contrasting red and yellow felt are butted together and stitched to a broad band of undyed felt. A narrow strip of gilded leather adhering to the cap may have formed part of a chin strap. Other caps of coloured felt, which probably date to the Roman period, are preserved in Bolton and Florence,[30] and two examples were recorded from second-century deposits at Mons Claudianus, which was a settlement inhabited mainly by quarrymen and artisans.[31] One of these caps, which had earflaps, was made from triangles of red, yellow and green felt and the other, with a broad brim, was made from green felt. However, as so few felt caps are preserved, due to the brittle character of the compacted wool, it is difficult to make any generalisations about them.

30 G. Sumner, *Roman Military Clothing (2), AD 200–400* (Oxford, 2003), p.38.

31 L. Bender Jørgensen, 'The textiles from Mons Claudianus, recorded in 1991', *Archaeological Textiles Newsletter* 12 (1991), pp.8–9.

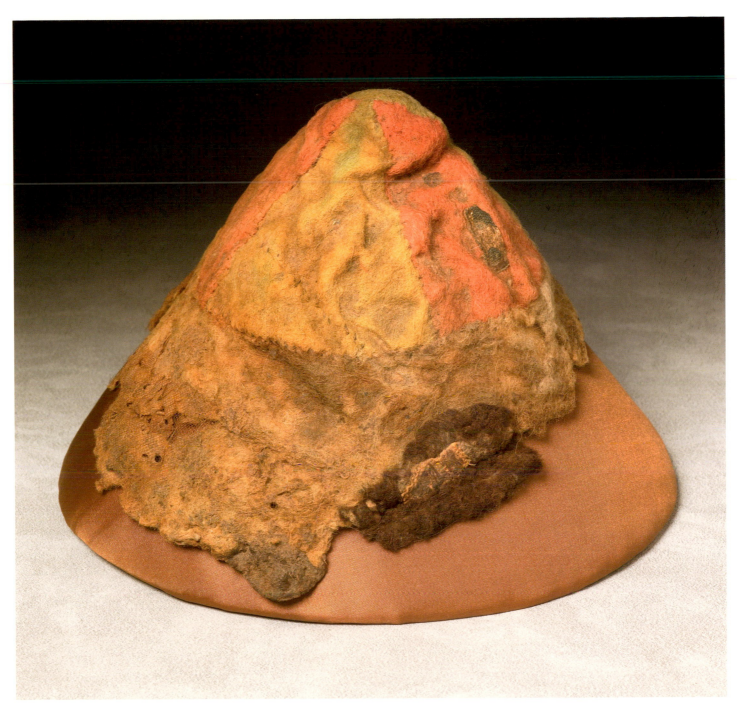

The examples of headwear discussed here are dominated by sprang caps, which must have been considered an important accessory by women of relatively high social status. Other types of headwear are less well represented, partly through problems of preservation, and partly because they were not worn for burial. This is a particular a drawback in identifying men's headwear. Nevertheless, as with other types of clothing, the pieces offer a fresh perspective and new insights into dress in Egypt in the first millennium AD.

Fig 6. 19 Felt cap, *T.8372*. Height: 150mm.

Glossary

Braiding Interlacing a group of elements by plaiting or twining in different ways to form a narrow cord, which may be flat or tubular; there is no weft. (Fig 7.1)

Brocading weft An additional weft introduced into the ground weave and limited to the area where it is required by the pattern. It does not travel from selvedge to selvedge. (Fig 7.2)

Clavus Longitudinal band on tunics extending from shoulder to waist or lower edge; identical on front and back.

Couching An embroidery stitch in which threads are laid on a fabric and sewn down with another thread.

Damask A figured textile with one warp and one weft in which the pattern is formed by a contrast of binding systems.

Darning Method of reinforcing a worn fabric or mending a tear, usually worked in running stitch. (Fig 7.2)

Dovetailing In tapestry weaving where coloured areas meet, the weft threads are turned in groups of two or more alternately round a common end. (Fig 7.3)

End An individual warp thread.

False-hatching The use of alternate light and dark weft threads in various combinations to create the effect of shading. (Fig 7.4)

Finishing border Horizontal cord made when weaving a piece is finished. (Fig 7.5)

Heddle A loop through which a warp end is passed so that it may be raised or lowered to open the shed to permit the passage of the weft.

Mordant A substance (often a metallic oxide) that helps to create a chemical bond between a dye and fibre during the dyeing process.

Pattern darning Darning using counted threads to form a pattern. (Fig 7.6)

Pattern weft Weft supplementary to the main weft, passed from selvedge to selvedge to form a pattern. (Fig 7.7)

Pick A single passage of a weft thread, or group of threads, through the shed.

Pile Supplementary threads projecting from a ground fabric. (Fig 7.4)

Plying Twisting together of two or more single yarns.

Samite See weft-faced compound twill.

Seam The joined line formed by stitching together two or more pieces of fabric. (Fig 7.2)

Seam allowance The extra width of fabric that extends outside seam lines.

Selfband Band of multiple picks in single shed; often not extending from selvedge to selvedge (ie discontinuous). (Fig 7.8)

Selvedge The longitudinal edge of a textile closed by weft loops. (Figs 7.7 and 7.9)

Shed The opening made by dividing a set proportion of the warp threads that permits the passage of each weft thread.

Slit tapestry Where weft threads of different colours are turned back around adjacent warp ends and are not dovetailed or interlocked. (Fig 7.4)

S-spun, Z-spun The letters S and Z are used to denote a yarn's direction of twist. The central stroke of the letter matches the direction in which the twisted fibres lie.

Starting border A horizontal band made during warping at the top of a fabric in order to space the warp threads and used to attach the warp to the warp beam of the loom. When weaving a garment to shape, there may be more than one starting border. (Fig. 7.9)

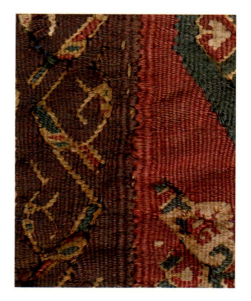

Fig 7.1, Detail of braided fringe and twining in three-ply red wool thread, T.1968.169.

Fig 7.2, Detail of brocaded cross, darning and run-and-fell seam, T.8375.

Fig 7.3, Detail of dovetailing, T.8461.

Tabby Weave based on a unit of two ends and two picks in which each end passes over one and under one pick.

Tablet weaving A type of twined-warp weaving in which sheds are formed by tablets with holes through which the warp ends are threaded. When the tablets are rotated, either in groups or singly, sheds are created for the passage of the weft.

Tapestry Weave with one warp, and a weft composed of threads of different colours or fibres, each of which is interwoven only with that part of the warp where it is required by the pattern.

Twill A weave based on a unit of three or more ends and three or more picks, in which each end passes over or under two or more adjacent picks and under or over the next one. The binding points form diagonal lines.

Twining Two, or more, weft threads are twined around each other in a S- or Z-direction as they enclose a single end, or group of ends, in turn. (Figs 7.1, 7.7 and 7.9)

Warp The longitudinal threads of a textile; those that are arranged on a loom.

Warp-face The side of a textile on which the warp predominates.

Weft The transverse threads of a textile; those that are passed through the sheds.

Weft-face The side of a textile on which the weft predominates.

Weft-faced compound twill A weft-patterned weave with complementary wefts in two or more series, usually of different colours, and a main warp and a binding warp. Through the action of the main warp ends, only one weft thread appears on the face, while the other or others are kept to the reverse. The ends of the binding warp bind the weft in passes, and the ground and pattern are formed simultaneously. The entire surface is covered by weft floats that hide the main warp ends.

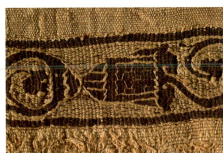

Fig 7.4

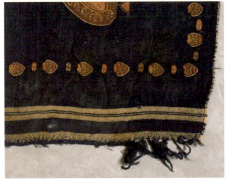

Fig 7.5

Fig 7.6

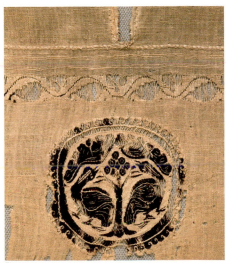

Fig 7.7

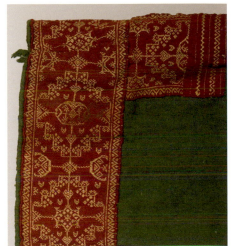

Fig 7.8

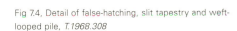

Fig 7.4, Detail of false-hatching, slit tapestry and weft-looped pile, *T.1968.308*

Fig 7.5, Detail of finishing border, *T.8564*

Fig 7.6, Detail of pattern darning, *T.8549.*

Fig 7.7, Detail of tapestry-woven roundel with selfbands and twining next to tunic neck opening, *T.1968.321.*

Fig 7.8, Detail of weft-patterned bands, at right angles to one another, and selvedge of green tunic, *T.8359.*

Fig 7.9, Detail of reinforced selvedge, starting border and twining, *T.8361.*

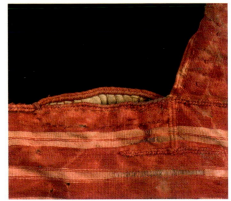

Fig 7.9

Bibliography

Abbreviation CIETA: *Centre International d'Etude des Textiles Anciens*

ABDEL-MALEK, L. H. 1993/1994. 'Deities, saints and allegories. Late antique and Coptic textiles'. *Hali* 72: 80–89.

ADAMS, N. and CROWFOOT, E. 2001. *'Varia Romana:* Textiles from a Roman Army Dump'. In P. Walton Rogers, L. Bender Jørgensen and A. Rast-Eicher (eds.): 30–37.

ALFARO, C., WILD, J. P. and COSTA, B. 2005. *Purpurae Vestes. I Symposium Internacional sobre Textiles y Tintes del Mediterraneo en época romana.* Valencia.

ALLGROVE McDOWELL, J. 1991. 'Romano-Egyptian Embroidery: Autumn and Winter'. *Hali* 57: 114–22.

BAGINSKI, A. and TIDHAR A. 1980. *Textiles from Egypt 4th–13th Centuries C.E.* Jerusalem.

BAGNALL, R. S. 1997. 'The Fayum and its people'. In S. Walker and M. Bierbrier: 17–20.

BAILEY, D. M. (ed.). 1996. *Archaeological Research in Roman Egypt, Journal of Roman Archaeology, supplementary series 19.* Ann Arbor.

BALSDON, J. P. V. D. 1962. *Roman Women. Their History and Habits,* London.

BÉNAZETH, D. 2004. 'Les tissus 'sassinides' d'Antinoé au musée du Louvre'. In C. Fluck and G. Vogelsang-Eastwood (eds.): 117–28.

BÉNAZETH, D. forthcoming. 'Trying to date the Antinoë silks with the radiocarbon method'. In C. Fluck and S. Schrenk (eds.).

BENDER JØRGENSEN, L. 1991. *North European Textiles until AD 1000.* Aarhus.

BENDER JØRGENSEN, L. 1991. 'The textiles from Mons Claudianus, recorded in 1991'. *Archaeological Textiles Newsletter* 12: 8–9.

BENDER JØRGENSEN, L. 2004. 'A matter of material: changes in textiles from Roman sites in Egypt's Eastern desert'. Tissus et Vêtements dans L'Antiquité Tardive, *Antiquité Tardive* 11: 87–99.

BENDER JØRGENSEN, L. 2005. 'Team work on Roman Textiles: The Mons Claudianus Project'. In C. Alfaro, J. P. Wild and B. Costa (eds.): 69–75.

BENDER JØRGENSEN, L., MAGNUS, B. and MUNKSGAARD, E. (eds.). 1988. *Archaeological Textiles, Report from the 2nd NESAT Symposium 1984.* Copenhagen.

BOECK, J. DE 1980. 'The Conservation of a Coptic Sprang Cap'. In *Conservazione e Restauro dei Tessili,* Centro Italiano per lo Studio della Tessuto, Como: 59–62.

BOURGUET, P. DU 1964. *Musée national du Louvre. Catalogue des étoffes coptes.* Paris.

BOURGUET, P. DU and GRÉMONT, P. 1977. *Tissus Coptes.* Angers.

BOWMAN, A. 1986. *Egypt after the Pharaohs.* London.

BOWMAN, S. 1990. *Radiocarbaon Dating.* London.

BRUNTON, G. 1930. *Qau and Bandari, Vol. III.* London.

BURNHAM, D. K. 1973. *Cut My Cote.* Ontario.

CALAMENT, F. 1989. 'Antinoë: histoire d'une collection dispersée'. *Revue du Louvre* 5/6: 336–42.

CALAMENT, F. 1996. 'Une découverte recente: les costumes authentiques de Thaïs, Leukyôné & Cie'. *La revue du Louvre et des Musées de France* 2: 27–32.

CALAMENT, F. 2004. 'L'apport historique des découvertes d'Antinoé au costume dit de 'cavalier sassanide'. In C. Fluck and G. Vogelsang-Eastwood (eds.): 37–72.

CARDON, D. 2001. 'On the road to Berenike: a piece of tunic in damask weave from Didymoi'. In P. Walton Rogers, L. Bender Jørgensen and A. Rast-Eicher (eds.): 12–20.

CARDON, D. and FEUGÈRE, M. (eds.). 2000. *Archéologie des textiles des origines au Ve siècle de notre ere. Actes du colloque de Lattes, octobre 1999.* Montagnac.

CHAVES, L. DE. 1994. ''La fuite en Egypte et le retour des mages' medallion copte de la collection du Musee Benaki'. *Bulletin de la Société d'Archéologie Copte* 33: 59–62.

COLLINGWOOD, P. 1974. *The Techniques of Sprang.* London and New York.

COOKE, B. 1990. 'Fibre damage in archaeological textiles'. In S.A. O'Connor and M. M. Brooks (eds.): 5–14.

COOKE, W. D. and TULLO, A. 1988. 'The conservation of a collection of Coptic sprang hats in the Whitworth Gallery, Manchester'. *Bulletin du CIETA* 66: 5–14.

COONEY, J. D. 1943. *Late Egyptian and Coptic Art. An Introduction to the Collections in the Brooklyn Museum.* Brooklyn.

CORTOPASSI, R. 2002. 'Un amphimallon au musée du Louvre', *Bulletin de Liaison du CIETA* 79: 33–43.

CORTOPASSI, R. and VERHECKEN-LAMMENS, C. forthcoming. 'Carbon-14 analysis of piled tunics from the Louvre and Katoen Natie'. In C. Fluck and S. Schrenk (eds.).

CROOM, A. T. 2000. *Roman Clothing and Fashion.* Stroud.

CROWFOOT, E. 1989. 'A Romano-Egyptian dress of the first century B.C.'. *Textile History* 20/2: 123–8.

CROWFOOT, G. M. 1924. 'A tablet-woven band from Qau el-Kebir' *Ancient Egypt* 4: 98–100.

DAWSON, W. R. and UPHILL, E. T. 1972. *Who Was Who in Egyptology*, 2nd edition. London.

DAY, F. E. 1952.'The Tiraz silk of Marwan'. In G. C. Miles, *Archaeologica Orientalia in Memoriam Ernst Herzfeld*. New York: 39–61.

DE JONGHE, D. and TAVERNIER, M. 1983. 'Le phénomène du croisage de fils de chaine dans les tapisseries coptes'. *Bulletin de Liaison du CIETA* 57–58: 174–86.

DE JONGHE, D. 1988. 'Aspects Technologiques'. In J. Lafontaine-Dosogne: 22–33.

DE MOOR, A. (ed.). 1993. *Coptic Textiles from Flemish Private Collections*. Zottegem.

DE MOOR, A., VAN STRYDONCK, M. and VERHECKEN-LAMMENS, C. 2004. 'Radiocarbon dating of a particular type of Coptic woollen tunics'. In M. Immerzeel and J. van der Vliet (eds.): 1425–42.

DE MOOR, A., VAN STRYDONCK, M. and VERHECKEN-LAMMENS, C. 2002. 'Radiocarbon dating of Coptic woollen caps in sprang technique'. In *Bulletin de Liaison du CIETA* 79: 27–32.

DE MOOR, A., VAN STRYDONCK, M. and VERHECKEN-LAMMENS, C. 2004. 'Radiocarbon dating of two Sasanian coats and three post-Sasanian tapestries'. In C. Fluck and G. Vogelsang-Eastwood (eds.): 181–7.

DROWER, M. S. 1985. *Flinders Petrie. A Life in Archaeology*. London.

DURAND, M and RETTIG, S. 2002. 'Un atelier sous contrôle califal identifié dans le Fayoum: le tiraz privé de Tutun'. In M. Durand and F. Saragoza (eds.): 167–70.

DURAND, M. and SARAGOZA, F. (eds.), 2002. *Égypte, la trame de l'Histoire. Textiles pharaoniques, coptes et islamiques*. Paris.

ELLIS, M. 2001. *Embroideries and Samplers from Islamic Egypt*. Oxford.

ERIKSON, M. 1997. *Textiles in Egypt 200–1500 a.d. in Swedish Museum Collections*. Gothenburg.

FLUCK, C. 2004 'Zwei Reitermäntel aus Antinoopolis im Museum für Byzantinische Kunst, Berlin. Fundkontext und beschreibung'. In C.Fluck and S. Schrenk (eds.): 137–52.

FLUCK, C. forthcoming. 'Carbon-14 analysed textiles in the Museum für Byzantinische Kunst, Berlin'. In C. Fluck and S. Schrenk (eds.).

FLUCK, C., LINSCHEID, P. and MERZ, S. 2000. Textilien aus Ägypten, Teil 1: *Textilien aus dem Vorbesitz von Theodor Graf, Carl Schmidt und dem Agyptischen Museum Berlin*. Weisbaden.

FLUCK, C. and LINSCHEID, P. forthcoming. *Textilien aus Ägypten, Teil 2: Textilien aus Krokodilopolis und Herakleopolis Magna*. Weisbaden.

FLUCK, C. and SCHRENK, S. (eds.). forthcoming. *Textiles and Methods of Dating*.

FLUCK, C and VOGELSANG-EASTWOOD, G. (eds.). 2004. *Riding Costume in Egypt. Origin and Appearance*. Leiden.

FLURY-LEMBERG, M. 1988. *Textile Conservation and Research*. Bern.

FLURY-LEMBERG, M. and STOLLEIS, K. (eds.). *Documenta Textilia. Festschrift für Sigrid Müller-Christensen*. Munich.

FRANCIA BAROCAS, L. DEL forthcoming. 'Textiles in situ: the evidence of Antinoopolis'. In S. Schrenk (ed.).

FRANK, T. (ed.). 1936. *An Economic Survey of Rome, Vol. II*. Baltimore.

FRANK, T. (ed.). 1940. *An Economic Survey of Rome, Vol. V*. Baltimore.

GAYET, A. 1902. *Antinoé et les sépultures de Thaïs et Sérapion*. Paris

GAYET, A. 1902. *Notice relative aux objets recueillis à Antinoë pendant les fouilles exécutées en 1901–1902 et exposés au musée Guimet du 5 juin au 5 juillet 1902*. Paris.

GAYROUD, R-P. 2002. 'La nécropole fatimide du Caire'. In Durand and Saragoza (eds.): 171–2.

GERVERS, V. 1983. 'Medieval Garments in the Mediterranean World'. In N.B. Harte and K.G. Ponting (eds.): 279–315.

GRASER, E. R. 1940. 'The Edict of Diocletian on maximum prices'. In T. Frank (ed.): 307–421.

GODLEWESKI, W. 2002. 'Les textiles issus des fouilles récentes de Naqlun'. In Durand and Saragoza (eds.): 100–104.

GRANGER-TAYLOR, H. 1982. 'Weaving clothes to shape in the Ancient World: The tunic and toga of the Arringatore'. *Textile History* 13/1:2–25.

GRANGER-TAYLOR, H. 1983. 'The construction of tunics'. In C. Rogers (ed.): 11–12.

GRANGER-TAYLOR, H. 1993. 'The decoration of Coptic tunics'. In A. De Moor (ed.): 15–29.

GRANGER-TAYLOR, H. 2000. 'The textiles from Khirbet Qazone (Jordan)'. In D. Cardon and M. Feugère (eds.):149–61.

HALL, R. 1986. *Egyptian Textiles*. Princes Risborough.

HAMMARLUND, L. 2005. 'Handicraft knowledge applied to archaeological textiles – visual groups and the pentagon'. *Archaeological Textiles Newsletter* 41:13–19.

HARTE, N. B. and PONTING, K. G. (eds.). 1983. *Cloth and Clothing in Medieval Europe: Essays in Memory of Professor E.M. Carus-Wilson*. London

IMMERZEEL, M and VAN DER VLIET, J. (eds.). 2004. 'Coptic Studies on the Threshold of a New Millennium II', *Orientalia Lovaniensia Analecta* 133.

JANSSEN, R. M. 1992. *The First Hundred Years. Egyptology at University College London 1892–1992*. London.

JAVER, A., EASTOP, D. and JANSSEN, R. 1999. 'A sprang cap preserved on a naturally dried Egyptian head'. *Textile History* 30/2: 135–54.

JENKINS, I. and WILLIAMS, D. 1985. 'Sprang hair nets: their manufacture and use in Ancient Greece'. *American Journal of Archaeology* 89/3: 411–18.

JONES, A. H. M. 1960. 'The cloth industry under the Roman Empire'. *Economic History Review* 13/2 second series: 183–92.

KAJITANI, N. forthcoming. 'The textiles and their context in the A.D. third to fourth century cemetery of el-Bagawat, Kharga Oasis, Egypt, from 1907–1931 excavations by The Metropolitan Museum of Art'. In S. Schrenk (ed.).

KENDRICK, A. F. 1920. *Catalogue of Textiles from Burying-Grounds in Egypt, Vol. I. Graeco-Roman Period*. London.

KENDRICK, A. F. 1921. *Catalogue of Textiles from Burying-Grounds in Egypt, Vol. II. Period of Transition and of Christian Emblems*. London.

KENDRICK, A. F. 1922. *Catalogue of Textiles from Burying-Grounds in Egypt, Vol. III. Coptic Period*. London.

KENT, J. P. C. and PAINTER, K. S. (eds.). 1977. *Wealth of the Roman World AD 300–700*. London.

KING, D. and KING, M. 1990. *Textiles in the Keir Collection 400 BC to 1800 AD*. London.

KING, D. 1996. 'Roman and Byzantine Dress in Egypt'. *Costume* 30:1–16.

LAFONTAINE-DOSOGNE, J. 1988. *Textiles Coptes*. Brussels.

LINSCHEID, P. 2001. 'Late Antique to Early Islamic Textiles from Egypt'. *Textile History* 32/1: 75–80.

LOCHHEAD, V. 1990. 'The conservation of four Egyptian tunics'. In S. A. O'Connor and M. M. Brooks (eds.): 41–8.

LOFTUS, A. 2000. 'A textile factory in the third century BC Memphis: Labor, capital and private enterprise in the Zenon archive'. In D. Cardon and M. Feugère (eds.): 173–86.

LOPES CARDOZO, A. C. and ZIJDEVELD, C. E. 1982. *Koptische Weefsels*. The Hague.

LORQUIN, A. 1992. *Les tissues coptes au musée national du Moyen Age*. Paris.

MANNERING, U. 2000 'Roman garments from Mons Claudianus'. In D. Cardon and M. Feugère (eds.): 283–90.

MARTINIANI-REBER, M. 1986. *Lyon, musée historique des tissues Soieries sassanides, coptes et Byzantines V–XI siècles*. Paris.

MARTINIANI-REBER, M. 1997. *Textiles et mode sassanides. Les tissues orientaux conservés au départment des Antiquités égyptiennes*. Paris

MUSÉE DOBRÉE, 2001. *Au fil du Nil. Couleurs de l'Égypte Chrétienne*. Paris and Nantes.

MUTHESIUS, A. 1997. *Byzantine Silk Weaving AD 400 to AD 1200*. Vienna.

NAUERTH, C. 1989. *Die koptische Textilien der Sammlung Wilhelm Rautenstrauch im Stadtischen Museum Simeonstift*. Trier.

O'CONNOR, S. A. and BROOKS, M. M. (eds.). 1990. *Archaeological Textiles UKIC Occasional Papers* 10. London.

PETRIE, W. M. F. 1889. *Hawara, Biahmu, and Arsinoe*. London.

PFISTER, R. 1951. *Textiles de Halabiyeh (Zenobia)*. Paris.

PRITCHARD, F. and VERHECKEN-LAMMENS, C. 2001. 'Two wide-sleeved linen tunics from Roman Egypt'. In P. Walton Rogers, L. Bender Jørgensen and A. Rast-Eicher (eds.): 19–29.

RATHBONE, D. 1996. 'Towards a historical topography of the Fayum'. In D. M. Bailey (ed.): 51–6.

RIZZARDI, C. 1993. *I tessuti copti del museo nazionale di Ravenna*. Rome.

ROGERS, C. (ed.). 1983. *Early Islamic Textiles*. Brighton.

RUTSCHOWSCAYA, M-H. 1990. *Coptic Fabrics*. Paris.

RUTSCHOWSCAYA, M-H. 2001. 'Résurrection des tissues coptes: un choc et une tentation'. In Musée Dobrée, *Au Fil du Nil. Couleurs de l'Egypte Chrétienne*: 177–8.

SARJEANT, R. B. 1972. *Islamic Textiles. Material for a History up to the Mongol Conquest*. Beirut.

SCHRENK, S. 2004. *Textilien des Mittelmeerraumes aus spätantiker bis frühislamischer Zeit*. Bern.

SCHRENK, S. (ed.). forthcoming. *Textiles in Situ, Riggisberger Berichte* 13. Bern.

SHEFFER, A. and GRANGER-TAYLOR, H. 1994. 'Textiles from Masada – a preliminary selection'. In Masada IV. The Yidael Yadin Excavations 1963–1965. *Final Reports.* Jerusalem: 149–255.

SHURINOVA, R. 1967. *Coptic Textiles. Collection of Coptic Textiles State Pushkin Museum of Fine Arts Moscow.* Moscow.

SCARCE, J. 1987. *Women's costumes of the Near and Middle East.* London.

SHEPHERD, D. G. 1981. 'Zandaniji revisited'. In M. Flury-Lemberg and K. Stolleis (eds.): 105–22.

SOUTH, K. H., KUCHAR, M. C. and GRIGGS, C. W. 1998. 'A preliminary report of the textile finds, 1998 season, at Fag el-Gamus.' *Archaeological Textiles Newsletter* 27: 9–11.

SPRING, C. and HUDSON, J. 1995. *North African Textiles.* London.

START, L. E. 1914. *Coptic Cloths.* Halifax.

STAUFFER, A. 1992. 'Un soierie 'aux amazones' au Musée Gustav Lübcke a Hamm: a propos de la diffusion des cartons pour la production des soies figurées au VIIe/Xe siècles'. *Bulletin du CIETA* 70: 45–52.

STAUFFER, A. 1996. *Textiles of Late Antiquity.* New York.

STAUFFER, A. 1996. 'Cartoons for weavers from Graeco-Roman Egypt'. In D. M. Bailey (ed.): 223–30.

STAUFFER, A. 2000. 'The textiles from Palmyra: technical analyses and their evidence for archaeological research'. In D. Cardon and M. Feugère (eds.): 247–52.

SUMNER, A. 1989. 'Sir John Charles Robinson: Victorian collector and connoisseur', *Apollo* 130, No. 332: 226–30.

SUMNER, G. 2003. *Roman Military Clothing (2) AD 200–400.* Oxford.

THE WHITWORTH ART GALLERY 1988. *The First Hundred Years.* Manchester.

TRILLING, J. 1982. *The Roman Heritage. Textiles from Egypt and the Eastern Mediterranean 300–600 AD.* Washington.

VAN STRYDONCK, M., BORG, K. VAN DER, and DE JONG, A. 1993. 'The dating of Coptic textiles by radiocarbon analysis'. In A. De Moor (ed.): 65–71.

VERHECKEN, A. and WOUTERS, J. 1988/89. 'The coccid insects dyes: historical, geographical and technical data'. *Bulletin Institut Royal du Patrimoine Artistique* 22: 207–39.

VERHECKEN-LAMMENS, C. 1994. 'Two Coptic wool tunics in the collection of the Abegg-Stiftung: a detailed analysis of the weave techniques used'. *Riggisberger Berichte* 2: 73–103.

VOGELSANG-EASTWOOD, G. 1993. *Pharaonic Egyptian Clothing.* Leiden.

VOGELSANG-EASTWOOD, G. 1995. *Fra Faros Klaedeskab: Mode I Oldtidens Ægypten.* Amsterdam and Copenhagen.

WALKER, S and BIERBRIER, M.1997. *Ancient Faces. Mummy Portraits from Roman Egypt.* London.

WALTON ROGERS, P., BENDER JØRGENSEN, L. and RAST-EICHER, A. (eds.). 2001. *The Roman Textile Industry and its Influence. A Birthday Tribute to John Peter Wild.* Oxford.

WILD, J. P. 1963. ' The *Byrrus Britannicus*'. *Antiquity* 37: 193–202.

WILD, J. P. 1994. 'Tunic No.4219: An archaeological and historical perspective'. *Riggisberger Berichte* 2: 9–36.

WILD, J. P. 1997. 'Cotton in Roman Egypt: some problems of origin'. *Al-Rafidan* 18: 287–98.

WILD, J. P. 2000. 'Textile production and trade in Roman literature and written sources'. In D. Cardon and M. Feugère (eds.): 209–14.

WILD, J. P. 2002. 'The Textile Industries of Roman Britain'. *Britannia* 33: 1–42.

WILD, J. P. and BENDER JØRGENSEN, L.1988. 'Clothes from the Roman empire. Barbarians and Romans.' In L. Bender Jørgensen, B. Magnus and E. Munksgaard (eds.): 65–98.

WILSON, L. M. 1933. *Ancient Textiles from Egypt in the University of Michigan Collection.* Michigan.

WILSON, R. J. A. 1983. *Piazza Armerina.* London.

WINTER, J. G. 1933. *Life and Letters in the Papyri.* Ann Arbor.

WIPSZYCKA, E. 1965. *L'Industrie Textile dans l'Egypte Romaine.* Warsaw.

YADIN, Y. 1963. *The Finds from the Bar Kokhba Period in the Cave of Letters.* Jerusalem.

Acknowledgements

This book would not have been written without the help and support of a great many people. Fundamental to its completion was Jennifer Harris, Deputy Director, who had the vision and concept for the book and the accompanying exhibition. In addition, a J. Paul Getty Curatorial Fellowship was instrumental in enabling the project to be achieved.

I am grateful to the following curators and specialists for showing me textiles in their collections and discussing technical points: Dominique Bénazeth (The Louvre, Paris), Lise Bender Jørgensen (NTNU, Vitenskapsmuseet, Trondheim), Edward Bleiberg (Brooklyn Museum), Roberta Cortopassi (The Louvre, Paris), Cäcilia Fluck (Museum für Byzantinische Kunst, Berlin), Hero Granger-Taylor, Jennifer Houser Wegner (University of Pennsylvannia Museum of Archaeology and Anthopology, Philadelphia), Sumru Krody (The Textile Museum, Washington), Stephen Quirke (Petrie Museum of Egyptian Archaeology, University College London), Christina Riggs (Manchester Museum), Marie Schoefer (Musée Historique des Tissus, Lyons), Sabine Schrenk (formerly of the Abegg-Stiftung, Riggisberg), Chris Verhecken-Lammens, Helen Whitehouse (Ashmolean Museum, Oxford), John Peter Wild, Terry Wilfong (Kelsey Museum of Archaeology, University of Michigan), Linda Woolley (formerly of the Victoria & Albert Museum). Dye analyses were undertaken by George Taylor and Penelope Walton Rogers, Textile Research Associates, York, and the carbon-14 dating, which was generously funded by the Friends of the Whitworth, was carried out by Dr Mark Van Strydonck, KIK/IRPA, Brussels. Ann Tullo and Ann French, the former and current Conservators of Textiles at the Whitworth Art Gallery, provided many insights into the material in the course of their work, while Christine Woods cajoled me through the project in the nicest possible way.

The publication is as much the work of the illustrator, Christina Unwin, photographer, Michael Pollard of G-Ten, and designer, Shawn Stipling of aquarium, as the author; all have been generous with their skills. A grant from the British Academy enabled the book to be fully illustrated.

Lastly, I should like to thank my family and friends, who encouraged me from a distance.

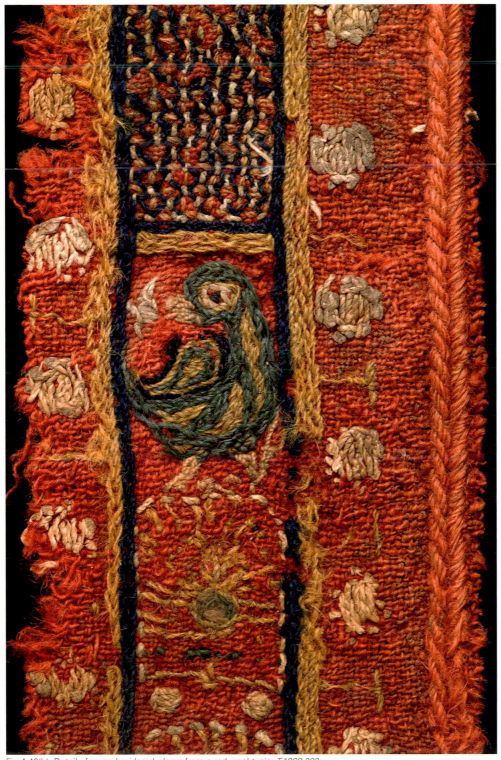

Fig 4.40(b), Detail of an embroidered *clavus* from a red wool tunic. *T.1968.283*.

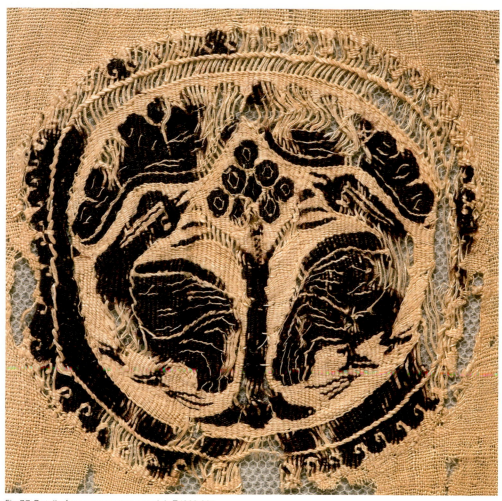

Fig 7.7, Detail of tapestry-woven roundel, *T.1968.321*.

Clothing Culture
Dress in Egypt in the First Millennium AD
20 May–10 September 2006

The Whitworth Art Gallery
The University of Manchester
Oxford Road, Manchester M15 6ER
0161 275 7450
www.manchester.ac.uk/whitworth

© Photography: Michael Pollard of G-Ten except where already credited.
© The Whitworth Art Gallery, The University of Manchester
Designed and produced by aquarium graphic design limited 01244 398004